SONG FROM THE EARTH

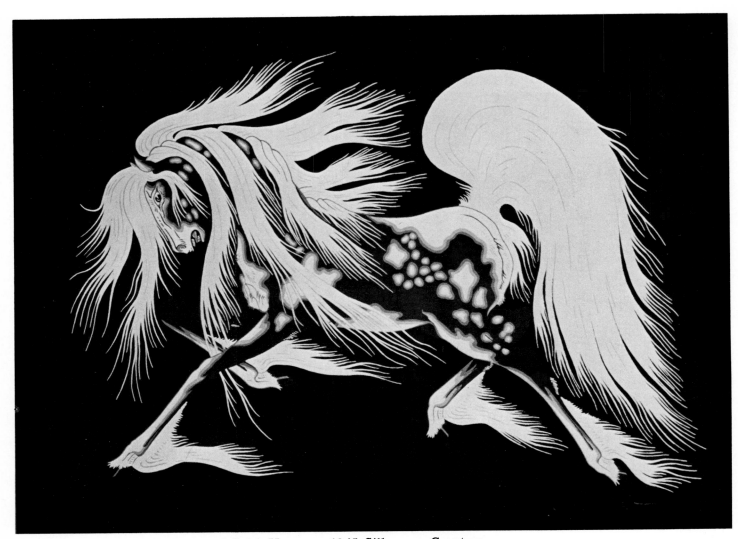

Woody Crumbo, Creek-Potawatomi. Spirit Horse, ca. 1945. Silkscreen. Courtesy private collection. "Destiny" is not one concept but many: for the artist it is the foundation of his style; for the Indian it is the basis of his "separate reality." The horse, not known by native Americans until the Spanish introduced the animal, became for them an object, even a "being" of extraordinary idealization. The Indian took to the horse immediately becoming an excellent rider, breeder, and — once armed with this powerful animal ally — the ruler of the plains. It is no wonder that in Indian reality the horse is seen as a spiritual being of vast power and beauty.

SONG FROM THE EARTH

American Indian Painting

Jamake Highwater

New York Graphic Society / Boston

First Edition

LIBRARY OF CONGRESS CATALOGING IN PUBLICATION DATA
Highwater, Jamake.
 Song from the earth.

 Bibliography: p.
 Includes index.
 1. Painting, Indian—North America. I. Title.
ND238.A4H53 759.13 75-37201
ISBN 0-8212-0698-2

Designed by Janis Capone

New York Graphic Society books are published by Little,
Brown and Company.
Published simultaneously in Canada by Little, Brown and
Company (Canada) Limited.

Printed in the United States of America.

FOR RUTH SCHWAB

Muse of my Childhood

The imagination is that which is least human in
man . . . it wrenches him away from himself and
plunges him into ecstasy; it puts him into secret
communion with the powers of nature. *"Who speaks
to me, with my own voice?"* From himself comes a
marvelous stranger called Art.

— Mikel Dufrenne

ACKNOWLEDGMENTS
Opening the Doors

IT IS TERRIFYING TO SET OUT IN THE CREATION OF A BOOK ABOUT AN immense and vital subject, especially when that book is to be the first popular work on its subject. Add to this the fact that Indian painting is like a long corridor with many closed doors behind which are strong, often angry, and always genuine partisans, and the author's task becomes more fearsome. And worst of all, as the author and photographer travel across the United States they uncover in museums and galleries, as well as in very unlikely places such as bars and backrooms, so many truly excellent paintings by so many well-known, little-known, and unknown Indian artists that it seems impossible to select the relative few that are to be included in this book.

If I am making the task seem unduly difficult, let me immediately assure you that I'm doing so only to emphasize my expression of utter gratitude to a small group of incredibly generous and helpful people without whose cooperation I could not have gone the whole length of that complex and troublesome corridor or have had the courage to open *all* the doors and face the storms of partisan dogma that were often lurking behind them.

Indian painting is our subject; it is a field which has been ignored for far too long. Its experts and enthusiasts have trod a rather solitary way, without much encouragement or compensation. As for the artists, they have been lucky if they haven't been forced to take jobs as janitors, as the great pioneer painter Julian Martinez did when he was a young man. Without the collectors and the few museums that have concerned themselves with Indian art, who knows how much of it would

still be available for us to see, now that we've finally taken our heads out of the Museum of Modern Art long enough to notice that there is a truly American art that dates from a time when the museum on West Fifty-third Street in Manhattan was still part of a serene forest!

I welcome the chance to march some heroes before you, because they are an impressive part of the history of Indian painting. They have always been anxious to stay out of sight in the hope of promoting the Indian artists they admire. In this book I have tried to do the same: to light up the artists and keep the patrons, researchers, and experts in the background. But I must indulge my sense of indebtedness in this foreword and in the annotated bibliography listing a few of the excellent authors whose works have lent so much to my story and whom I recommend highly for anyone wanting to pursue further the topics of this introductory book about Indian painting.

The prime mover of my efforts, a very fine gentleman and an outstanding commentator on Indian painting, is the first benefactor to come to mind ... Arthur Silberman and his wife Shifra, whom I thank most fondly.

Lloyd New and Charles Dailey of the Institute of American Indian Arts were indispensable in putting me in touch with young painters, in patiently answering my questions, and in trying — vainly I fear — to bridge the way between me and the Great White Fathers Who Art in Washington.

I am equally in the debt of Dr. Donald G. Humphrey, formerly of the Philbrook Art Center of Tulsa, for his unlimited generosity, interest, and kindness.

Another source of the glorious art that graces this book is Edward B. Danson, director of the Museum of Northern Arizona in Flagstaff, where a treasure of Indian painting was opened to me.

Brother C. M. Simon of the Red Cloud Indian School on the Pine Ridge Reservation in South Dakota lent his own considerable expertise and then did me the favor of introducing me to the little-known Ethnic American Art Slide Library of the University of South Alabama in Mobile, whose staff, under Professor James E. Kennedy, opened their archives to me.

I am grateful to George H. Ewing, director of the Museum of New Mexico, and his hospitable staff for their considerable cooperation and generosity. They are the custodians of one of the primary collections of Indian painting, and without their help I would have failed in a major area of my work.

Another essential source of help and cooperation was Gary Lantz of the Oklahoma Department of Tourism who quite literally opened up the entire state to me and spent a great deal of time and effort in doing so. His associate in welcoming me to Oklahoma and putting me in touch with Oklahoma artists was Beverly Baum, who directs the Tribal Arts Gallery in Oklahoma City.

Jeanne O. Snodgrass provided ideas and suggestions and a good deal of solace too, and I feel lucky to have had her help. Though I didn't have personal contact with Clara Lee Tanner or J. J. Brody (who have done groundbreaking research in the field of Indian art), my debt to them is everywhere visible in this book. I did have the very generous cooperation of Dorothy Dunn, whose work in Indian art is legendary.

My thanks also go to R. W. Jones of the Oklahoma Historical Society; to Alice C. Simkins of the Marion Koogler McNay Art Institute of San Antonio; to Peggy Tiger, the widow of the late Jerome Tiger; to Sam Olkinetsky, director of the Museum of Art of the University of Oklahoma; to Frederick J. Dockstader, formerly of the Museum of the American Indian, Heye Foundation, New York City; as well as to the Peabody Museum, Harvard University; the Museum of Fine Arts, Houston; and Peggy Denton of the Five Civilized Tribes Museum in Muskogee, Oklahoma, who introduced me to the works of Jerome Tiger a few years ago.

I have left the painters for the end, but I will not apologize since I intend to devote myself to them entirely, following this page. And with good reason: the greatest of them have answered my hundreds of questions and opened themselves to me as no celebrities I have ever interviewed. The young artists in small villages with addresses that consist of two lines (a name and a town) have sent their slides and their biographies. Even the rebels who are being chased by the police somehow managed to forward their paintings to me! Painters unknown to anybody came out of the woods via special delivery mail in response to a very helpful paragraph in that peerless Indian newspaper, *Akwesasane Notes*.

So here we are, at the end of the corridor and still in one piece . . . with all the doors flung open!

To Richard Thurn for research and reassurance, and to publisher Donald Ackland, I most affectionately tip my hat and turn to that rarest of privileges: introducing a superb world of art to those for whom this may very well be a bright new discovery.

JAMAKE HIGHWATER
Zurich, 1975

CONTENTS

SONG FROM THE EARTH

1. WHO SPEAKS TO ME, WITH MY OWN VOICE?
The Otherness of Indians

IT IS USUALLY ASSUMED THAT ALL MANKIND HAS A COMMON HERITAGE and a common destiny. But there are many ways of understanding an event; and the very way we understand it changes the event which has been understood. The events of history are subject to interpretation. It is the form of that interpretation — its dogma — which provides a culture with its sense of destiny. All peoples possess this framework for looking at the world and its events, but Europeans, convinced of the absolute right and virtue of their culture, have self-righteously set out to convert all other peoples with whom they came in contact. Their immense impact on the cultures they overran does not mean that all the people influenced by Europeans were necessarily heading toward the same cultural, sociological, and political destiny as their invaders.

There are alternatives to the European experience. This is not a new notion, but it needs repeating because it is constantly overwhelmed by the ethnocentricity of Caucasians. The American anthropologist Carlos Castaneda calls it "a separate reality" — a wholly alien but perfectly valid *other* way of seeing the world, suggesting that there are many shapes and not just a single shape to history. There aren't many people who would consciously reject this concept, but there are few who actually apply it. The American Indian has been a prime target of the ethnocentricity of Europeans and white Americans. He has been both trivialized as a savage and deified as a noble savage. In the one case he is seen as subhuman and therefore divested of everything on the basis of a credo that envisions white dominance as the will of God. On the other hand his every action and artifact is seen as highly exotic and gloriously symbolic. People make too much or too little of Indians.

Nothing exemplifies what I have been saying so clearly as the Anglo

(non-Indian) attitude toward Indian arts and crafts, a phrase that in itself carries the implication that such efforts are somehow utilitarian and therefore outside the concept of fine art. When the medium of an Indian art object is a substance like sand or bark, which isn't a usual one for art in Europe and America, the effect is essentially neutral; the viewer has no special preconception of what the art object should look like, and isn't tempted to make value judgments. In the case of this sort of alien art, the Anglo usually doesn't expect it to "say" anything he can understand. It is pure exotica.

But when encountering a painting or a carving by an American Indian, most people automatically look at it as if it were a work of Anglo art. One may like it or dislike it, but in either case judgment is based on an awkward assumption that the Indian artist is trying to say the same sort of thing that Anglo artists wish to convey, and that he does so by using the same symbolic and dramatic conventions as those which are the core of European-American tradition. Viewers expect to be able to understand Indian art as a variant of Anglo art, and they have even worked hard to construct theories which try to justify this approach by contending that the Anglo influence on Indian art has fundamentally changed it into a tourist industry and has left no real residue of pre-Columbian aesthetic values.

Art is an integral part of all cultures — although contemporary industrial societies have usually viewed art as the idle product of a leisure class: an ornamentation; a projection of taste, privilege, and affectation. That is the interpretation of a mercantile mentality and the result of the aristocratic domination of art prior to the rise of the merchant princes and the middle class. That idea of art is a sad devaluation of human expressiveness by a civilization that has gradually separated its sentience from its daily necessities. But history does not uphold that antagonism to art which has made it into something "difficult and serious" and beyond the grasp of the man on the street. Nor does it confirm the misuse of art by a pretentious elite, which clings to the idea that man's arts have something to do with aristocracy — the aristocracy that was destroyed by those same burghers who now opt for all things aristocratic.

Art is a staple of mankind — never a by-product of elitism. It can serve as a class distinction but it does so unwillingly. In fact, art has fundamentally the opposite relation to society insofar as it can function for any economic, intellectual, or social group. Art is so urgent, so utterly linked with the pulse of feeling in man, that it becomes the singular sign of life when every other aspect of civilization fails: in concentration camps, among the brutalized and dispossessed, the mad and the too mighty. Like hunger and sex, it is a disposition of the human cells — a marvelous fiction of the brain which recreates itself as *mind*. Art is consistent with every aspect of every day in the life of every people. It even

projects their grotesqueness when they recognize their own failures and frustrations.

The dwellers of caves in the early morning of this human world built scaffolds in the dark interiors of their rock caverns and with pigments made from ground roots and bark and minerals painted an amazing world upon their ceilings by the meager light of oil lamps. They were creating "art" before it existed, spending their time drawing when some would say that they should have been out finding food and facing the tremendous improbability of their survival.

American Indian life perpetuates the primary idealism of those uncommonly common people who scaled scaffolds to invest the rocks with their story: their myths, their achievement, their totems. That peculiar act of expression (which has become known to us as Art) makes visible much of the unique sensibility of Indians. Before the final subjugation in the 1880s, they heard singing in the wind not as poets but as ordinary men who perfectly grasped the *wholeness* of things — a concept which has vanished from the minds of scientists who claim to be in search of it. This red race, regarding the world as a community and the earth as a marvelously generous mother, realized an ancient and impossible myth of western civilization: living in a garden without fences or boundaries, taking from the trees and sharing their bounty before there was need for a word like "sharing." Indians spoke of the other creatures as equals, as "people in the form of animals." That is such a fundamental difference in viewpoint from that of western mentality that it is hard for Anglos to grasp fully. Indians understood both life and the necessity of death as nonparadoxical, devising a code of behavior to which they were equal instead of a morality impossible to realize. Of course they were not "perfect." One tribe fought against another; some used slaves; others practiced horrendous torture of captives. But they possessed a transcendent view of the world which is only now rising into the consciousness of other races. Rather than seeing themselves as superior to other creatures and attempting to dominate and change the world, Indians sought harmony with all things around them and had no notion of their specialness in the universe. Innocent of all the categories into which the universe has been divided by men seeking one truth, they spoke of a marvelous painted pottery not as "art" but as another object of nature, and referred to its achievement not as something "beautiful" but rather as something "good" in the sensual meaning of that word. They were wondrously remote from western man's artistic self-consciousness. All this is reflected in Indian painting.

In Anglo societies the arts are conceptually discrete. People have come to think of both the practice and the enjoyment of art as private endeavors. But in Indian society, privacy was not a virtue; the arts were simply aspects of public life which brought together dancing, poetry, and the plastic and graphic arts into a single function: ritual as the all-

embracing expression. As for the "artist" himself, he simply did not exist; the notion of "artist" is strictly a non-Indian creation.

Anglos look upon the artist as distinct from the craftsman. Even the most hostile critic would hardly describe Henry Moore as a stonemason, Louise Nevelson as a carpenter or Diego Rivera as a housepainter.

For Indians before Columbus this distinction did not exist. Even today the phrase "Indian arts and crafts" suggests a unity of artist and craftsman: the master carpenter and the master sculptor are often one and the same person. Part of the Indian nonchalance about "art" comes from their seemingly great number of gifted makers of artistic objects — a prevalence not so remarkable when this artistic ability is understood as a form of aesthetic "literacy." Anglos' literacy is the product of long training and a precise muscular control in handling pencils, pens, and typewriters, which, to the illiterate, seems uncanny. In contrast, at the age when an American or European child starts using a pencil to write, an Indian child is learning to make pottery, carve with a knife, or express himself in graphic images and tribal symbols.

Such symbolism, like artistic mastery, results from the fact that Indians have an oral rather than a written tradition. Whereas Anglos are trained to think scientifically, Indians are trained to think poetically. The Anglo deplores ambiguity while the Indian strives for a faculty to make and comprehend ambiguity in the form of metaphor and symbol. Even when he has forgotten his tribal symbols (as in the case of the Indian painters of the 1930s and thereafter who sought to revive their rites, dances, and religious metaphors in their paintings), he is part of a persistent tradition that teaches him to think in terms of metaphor rather than in terms of concrete reality. The older Indian painter believes adamantly in the perpetuation of the past — perhaps an unfactual idealization of history but unquestionably a valid personal view of reality, which is one of countless transformations of the event which actually happened into something we call "our history."

The graphics and art objects produced in North America represent a distinctive native art, filled with alien influences after Columbus, of course, but distinctive nonetheless. It is through these objects produced by the Indians of North America that we glimpse an alternative world view unique to Indians. This otherness of Indians is intrinsic and nothing has successfully dismantled or dispossessed it — not years of attempted assimilation; not the cruel premise of white superiority held up to Indian children at boarding schools; not the childish rapture of missionaries who called Indians "their children"; not even the wrong-mindedness of "converted" Indians who would lead their own people into a Promised Land that never fulfills its promises.

These thoughts are intended to suggest that the paintings of American Indians are unique and exceptional and good. But they are also works subject to nothing but themselves, products of the same work that goes

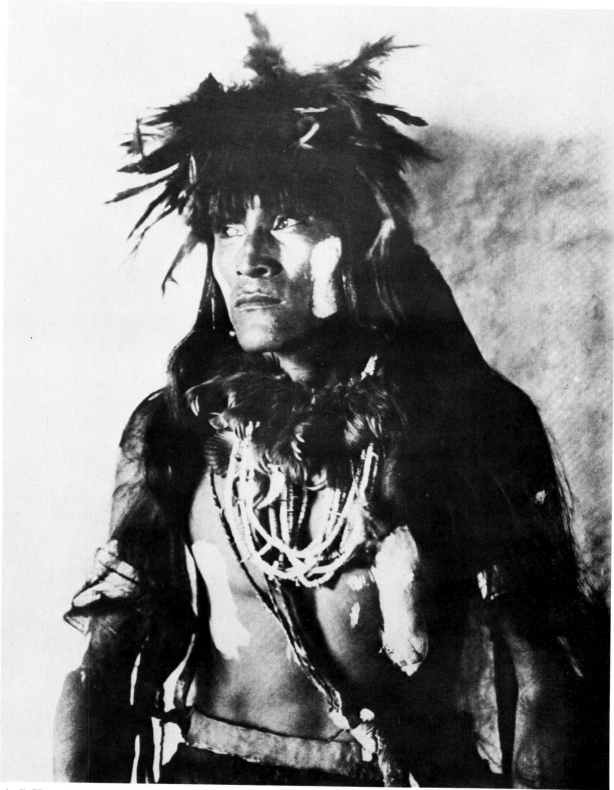

A. C. Vroman. Hopi snake priest, ca. 1901. Courtesy New Mexico Department of Development, Santa Fe. Sacredness makes its appearances in many styles; the majesty of this priest is understood in spite of the fact that his gods, ceremonies, and objects of faith are alien. Indian painting begins as an intrinsic part of such alien sacredness and, through imagery, conveys the ineffable that divides aliens from one another.

into growing crops, cutting wood, hunting animals, or conducting rituals. They are the things that result when Indians offer the correct efforts to the proper elements. They are as pertinent to Indian civilization as the greatest European art is to the greatest European cultures. But there is also poor painting. You will often discover that in his work an Indian painter has combined the best of his culture with the worst of the white man's culture: the profound ideal of animal nobility is depicted in Disney-like clichés or the outrage of dispossession is expressed through a sophomoric notion of surrealism.

The white man may be more successful in transcending cultural barriers than the Indian, for he seems to move with ease from his admiration of Matisse to his appreciation of a modern Indian painter like Fritz Scholder. Yet it is doubtful that he can grasp the premises upon which Indian sensibility is founded, and that must be an embittering experience for people who insist that mankind is both uniform and equal. We are indeed equal, but man is in no instance uniform — not superficially and not at the core of the mentality from which thought and feeling emerge.

It is that core which I wish to illuminate, to convey something of the otherness of Indians as it is depicted in painting. There are many ways in which this might be accomplished. The historical perspective will not be neglected in this book; however, it would be both redundant and presumptuous for me to attempt to duplicate the achievements of historians of Indian art like Dorothy Dunn, Clara Lee Tanner, Miguel Covarrubias, Frederick J. Dockstader, and Frederic H. Douglas, among others, whose works have lent so much to this book. And it would be somewhat irrelevant to repeat the polemic views of authors like J. J. Brody who concern themselves with the effect of white patrons upon Indian painting. It seems to me that the best way to accomplish my purpose of illuminating the intrinsic nature of Indian painting is through the painting itself — which is virtually unknown to Europeans and Americans outside the world of collectors, museum curators, and trading post operators. When I visit New York, London, Vienna, Paris, or the other art centers, I am always astonished that beyond a casual familiarity with traditional Indian crafts, most art lovers haven't seen Indian painting and don't know anything about it.

This book is intended to provide a glimpse of some of the best painting by native Americans, from pre-Columbian antecedents (in the form of painted crafts) to the works of the Traditional painters who produced a renaissance shortly after the turn of the century, and the Contemporary artists who have steadily emerged since Oscar Howe introduced elements of European experimentation into Indian graphic art in the 1950s. And though they are often in great debate with one another and sometimes at odds with facts as they are reported by historians, it seems to me that no one can better tell us about Indian painting than its own masters. So I have attempted to combine an historical perspective of American Indian

painting with an examination of some of the central debates about the nature of Indian art and with interviews of many of the leading artists.

These Indian painters perfectly represent the kind of imagination that wrenches us away from ourselves and plunges us into ecstasy, into secret communion with the powers of nature. Their paintings are an iconography of this land named America which few of us have discovered. In a crucial way, it seems possible that these paintings depict a more startling and revealing discovery of America than the accidental one that took place in 1492.

2. THE INDIAN IN HISTORY
Indians Discover America

IN THE ORAL TRADITION OF EVERY TRIBE THERE IS THE STORY OF "the original human beings" and the belief that all the other tribes descended from them and went off to build their own villages in the age before the destruction of the monsters who once ruled the earth. There are many histories of creation among the tribes. These stories of how the world came to be as it is today are central to the ceremonial life of Indians.

There is also the scientific viewpoint, which tells us of another kind of history: one that contemporary Indians understand in conjunction with their own chronicles. Both stories of the Indian habitation of America are important to Indian painting. This information concerning Indian origins and pre-Columbian arts and crafts can infuse the formal shape of Indian painting with a scheme that tells us how Indian artistic values arose, from what native influences and from what alien influences.

The current anthropological theory is that North America was settled slowly by groups of people who crossed from Siberia into Alaska. They discovered a vast, uninhabited landmass rolling from the frozen ice cap in the extreme north to the lush tropics of Florida. Before the coming of these peoples no human child had been born here, nor had a single man or woman lived or died here. Today most anthropologists believe that there were only two major migrations: the Eskimo, Aleut, and Athapaskans as one group and all the other tribes as another. Probably no human population which has expanded over such a huge area has remained so uniform. The first people to arrive found no other people with which to interbreed. Except for the late-arriving Eskimo, Aleut, and Athapaskan peoples, the genes of the early Americans were not mixed with those of any other people.

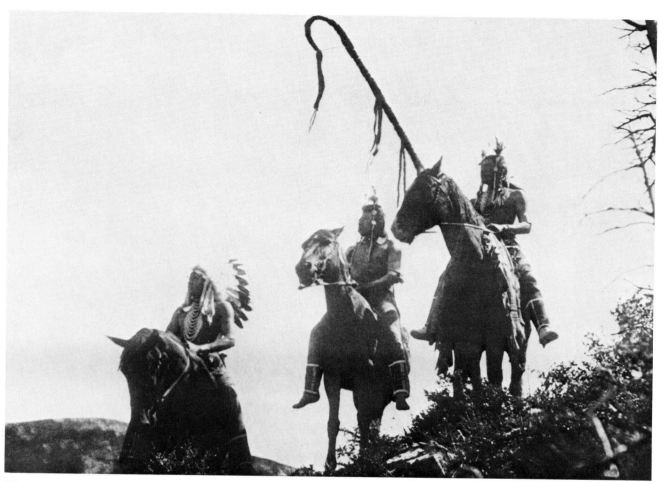

Warriors of the Northern Plains, ca. 1885. Courtesy United Tribes Agency, Bismarck, North Dakota. Horsemen appear to us from out of our sense of legend, but the legend is not our own. They seem to be unreal only because they have always been so remote from our world and our ways. Their art — like their appearance, their ornaments, and their uncommon harmony with nature — comes to us from somewhere farther out than we have ever ventured, closer to the stars at the same time that it is closer to the earth.

It is thought that the languages among the first inhabitants derive from a small number of parent languages — perhaps as few as six — but there is still much debate about this. There were probably about two hundred or three hundred mutually unintelligible languages originally spoken by the native peoples of North America alone.

There is little relationship between the various language groups and cultures of the American Indian. Often tribes that speak entirely different tongues will have similar cultures, while others, speaking languages derived from a common root, will have completely different cultural patterns.

No pre-Columbian Indian tribe developed an alphabet, but the Maya, Aztec, and some of the other groups of Central America created various writing systems. Many of the eastern tribes of North America had

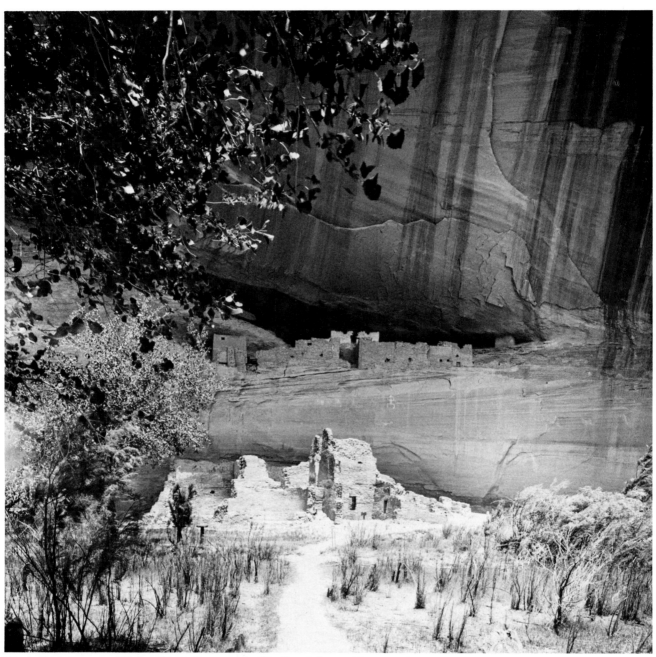

The White House cliff dwelling, Canyon de Chelly, Arizona. An excellent example of the remarkable Pueblo architecture, in an area which was inhabited as long ago as 2000 B.C. by people of the basketmaker culture.

mnemonic systems, such as the wampum belts of the Iroquoian peoples, which were used as aids to recall events. Here and there a simple form of picture writing was used, like the Ojibwa bark painting which depicted various sequences of events. But in general the tradition of Indians was oral, entrusted to those with special memory gifts.

The social structure of many tribes was based on clan groups or family units. The clans were often named for animals known as totems, an Algonquian word meaning "brothers." The totems were the holy ancestors and spiritual guardians of the clan. These segments of society were important to the daily life of the people; often the entire social life of the tribes was dominated by the intricate ceremonies and intertribal opposition of the clans which divided the people.

The Indian was much preoccupied with supernatural forces, which were the bridge between him and the living universe. The "Great Spirit" and the "Medicine Man" are largely the creation of white men and are misconceptions. There were tribes for whom each animal and tree was a marvelous embodiment of a great, natural force with whom a mortal could, with great discipline and effort, gain contact. In some societies, a highly complicated metaphysical ideal was upheld, whereby the com-

Navajo hogan and summer house, Canyon de Chelly, Arizona, 1970. In the incredible valley of the Canyon de Chelly, about four hundred Navajos still live in their pre-Columbian houses made of logs and dirt and in their airy shelters of branches, which they occupy in the summer months. They raise corn, melons, and squash in the rich alluvial bed of the canyon, surrounded by the ancient ruins of the Old Ones whose lives here predate the coming of the Navajos. To the Navajos the ancient world that rings their hogans is haunted with antiquities that reach beyond all memories.

bined total of the people's spiritual forces was the invisible power. The Iroquois called this power *orenda;* the Sioux called it *wakan;* the Algonquians used the word *manitou.*

Some tribes believed in gods, ghosts, and demons. Some believed in spirits who were personal guardians. The supreme being which caught the interest of the invading whites was worshiped by many of the tribes, but many of them thought of this force as distinct from human affairs and therefore disassociated from daily life. The so-called Great Spirit was, therefore, not the highly anthropocentric God brought by the Anglos to America. In fact, there are tribes which believe that the "power" that created all things eventually grew old and died many long years ago. In this case we must think of the greatness of the spirit not in terms of western immortality but in terms of the vastness of his creative works.

The shamans, or holy people common to most tribes, were persons with special powers. Their role varied greatly from place to place: healers, prophets and soothsayers, mediums, magicians, and makers of curses and charms.

Prominent among the figures in the histories of Indians are the hero and the trickster. The hero normally was the character in a primordial epoch who taught the people their way of life. The clown-god was usually half divine and half human, a being at great odds with himself, getting into trouble but having the license to do or say things forbidden to others. Both figures sometimes merge, as in Coyote of the Navajo people.

Warfare was a principal preoccupation of many tribes, but not all Indians were highly motivated as warriors; in fact, there were no standing armies among Indians in the sense that white men serve as professional soldiers. Yet much of the tradition of chronicle painting among the Plains Indians centered upon achievement in battle. Most tribes were more attracted by courage than by killing. "Counting coup" (touching an enemy and escaping unharmed) was the highest glory of war — far more glorious than killing a person. Warfare was very ritualized and served as a major subject for the design and decoration of tepee linings, hide-covered shields, and buffalo robes.

What is most curious about Indians is the fact that they separated from the main body of Homo sapiens before the earliest inventions of mankind. They were alone in America with almost no chance of influence from Asia or Europe until 1492, when Columbus came from what was an entirely different world — he might have come from a different planet. It seems possible that some Indians are direct descendants of the inhabitants of America of 15,000 to 25,000 years ago. They are therefore the oldest known race on earth, since there is little evidence that any of the other modern races — Mongolian, Caucasian, or Negro — existed at that prehistoric time in Europe or Asia. The Indian discovered fire for himself, roasted meat, and worked stone before the first trace of Homo

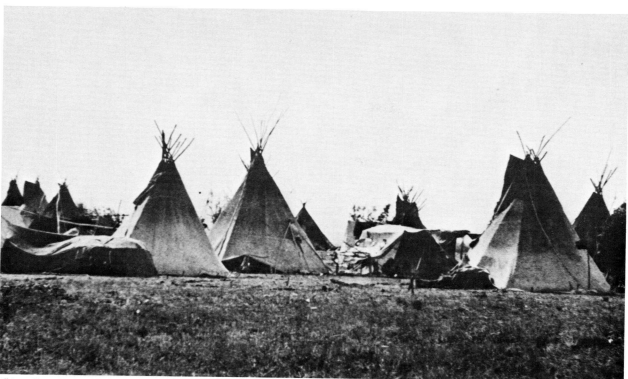

Standing Rock Sioux encampment, ca. 1870. Courtesy State Historical Society of North Dakota. The first inhabitants of America discovered a vast, uninhabited landmass rolling from the frozen ice cap to the lush tropics of Florida. Between the two great mountainous ridges were vast stretches of alluvial plains and the great rivers now called by Indian names: the Missouri, meaning "large canoes," and the Mississippi, meaning "father of waters."

sapiens can be found in Europe. He made beads and used paint taken from a red oxide and drew pictures that marvelously glorify nature, at a time when the people of Europe had not yet evolved to their present racial form. It is not surprising that Indian sensibility represents an entirely different viewpoint from that of the other peoples of the world.

The relation of most tribes to nature was direct, profoundly simple, yet, to the western mind, extremely complex. It was the breakdown of this natural harmony which was the worst result of the invasion of Anglos. The Indian kinship to the natural order has been very greatly mystified by both Anglos and modern Indians, culminating in the romantic exaggeration of the "noble savage." Although the notion of the Indian as an innocent living in an eternal Eden is perhaps overly winsome, there is some truth in it, and it is important that this affiliation of man and nature be understood in Indian terms since it plays a central role in the ancient and modern iconography, style, and form of Indian art.

The impact of the Asian heritage of American Indians is fundamentally expressed in an attitude of synthesis — in terms of a gestalt or wholeness — whereas most Anglos are concerned with analysis — thinking not of the whole but of the parts in a more or less scientific fashion.

Carl Sweezy, Arapaho. Buffalo Hunt. *Courtesy Oklahoma Historical Society. Sweezy was born about 1879 on the old Cheyenne-Arapaho reservation near Darlington, Oklahoma. At fourteen, he returned from boarding school to the reservation with newly acquired watercolor paints, which an Anglo woman at the Indian agency had taught him to use. His most prolific period as an entirely self-taught painter was during and after he worked for James Mooney of the Smithsonian Institution as an illustrator of Indian daily life and an anthropological informant. To the end of his life, May 28, 1953, he continued to paint in what he called "the Mooney way."*

The entire world is seen by Indians as a natural order which is perfect. Therefore ancient as well as many contemporary Indians are content with their world and try to live harmoniously in it rather than to alter it (a major preoccupation of Anglos). Indians are also not inclined to make vast philosophical judgments or to create the elaborate systems of thought that typify western ideology and that ultimately see the world in a way that places some things in a superior position to others. Thus, among the Plains Indians the fox is a brother who possesses a soul — a soul that could never be afforded him by European dogma.

The Asian influence does not end with the animistic view of nature. It also affects the mode of expressing attitudes about the world. Most

Indians favor subtlety and poetic understatement. To Indians, Anglos seem to conceive everything as a gross exaggeration. Because of the "wholeness" attitude, Indians derive meaning from context while Anglos think in terms of separate entities with separate meanings.

With these differences in mind, it becomes a bit easier to grasp the expressive nature of American Indian painting. For one thing, most Indians regard art as an element of a larger activity — as part of life but not as a form of utilitarianism — and not as a separate aesthetic ideal. Art emerged very slowly as a self-contained form and only in recent decades has it assumed the general form which clearly relates it to Anglo art. For Indians, painting is an organic process rather than an end product. It is generally thought that Indian art is functional, that it is used as part of the other, nonpainterly activities of life. But this is simply the result of an analytical, non-Indian viewpoint, especially in regard to Indian crafts, which to Anglos seem to involve nothing more than decorated utensils. The Indian sees his painting as indistinct from his dancing and his dancing as indistinct from his worship and his worship as indistinct from his living.

Because of the inclination to understate, most Indian art is reminiscent of Japanese haiku and painting, where symbols have been minimized and meaning has been obscured, conveyed by the merest suggestion. Art is highly valued for its magical power and there is a rather mystical basis for aesthetic judgment among Indians, in comparison to Anglos. If the art is well made it is "good spirit" rather than "beautiful," an aesthetic term that seems highly superficial and artificial to the Indian viewpoint. When Indians speak of art and its iconography, they are expressing an experience of such homogenous relationship to the cosmos that it is almost impossible to express in non-Indian languages. Art is indispensable to ritual. And ritual is the Indian concept of the whole life process. It is that process translated into human experience. Indian art is that process and that experience made visible.

The history that charts the archaic manifestations of Indian painting is both fragmentary and intermittent. Art historians who are inclined to see native Americans in a romantic light usually stress the continuity of Indian artistic development, but it is doubtful that any fundamental link exists between the earliest Indian art and the painting achieved in the twentieth century. The archaic art — the pottery, skin painting, sand painting — remains a valid place to begin, if only because it has been, at least in this century, a persistent source of inspiration, education, and speculation for modern Indian painters and their teachers. There is another reason to discuss pre-Columbian art, as I shall do in the next chapter. If a people do, in fact, produce an art that reflects (like language) both the group's traditional temperament and its values, then the ancient art can tell us something about the way ethnic values were conveyed through "art" in prehistory and therefore indicate how the residue

of these same values are being communicated in the American Indian painting of this century. It can also tell us something about the persistent metaphors (iconography) which are unique and specific to Indian art.

Whatever it is that creates the notion of national and racial character (and it has been attributed to everything from racial memory and genetics to diet and emotional environment), all the democratic philosophy in the world won't change the fact that people have distinctive ways of behaving and responding to experience depending upon the culture by which they were imprinted and raised (but not necessarily born). This is true whether people are socially isolated in ghettos or whether, like Jews, they are scattered and are dealt the most dreadful condemnations for exactly the ideals and temperament that Jews apparently recognize in each other as "Jewishness."

It is not surprising to say that there is something fundamentally Indian about Indians. Even after the continuity of their cultural legacy had been wrecked by invaders and missionaries, that unique Indianness developed over hundreds of centuries is not likely to vanish in a century of attempted assimilation and extermination.

So Indian artistic tradition is not a straight line, but it nonetheless exists. At first this unromantic historical view of Indian painting as an erratic and broken flux rather than an evolutionary process might seem to indicate that Indian art is not sufficiently consistent and continuous to reveal any overriding character. But the discontinuity of the technical side of Indian art is not unique to Indians. The same situation existed in western civilization where it appears that the artists of the Middle Ages had little awareness of the art of the Greco-Roman epochs. Yet this enormous chasm in the continuity of European art should not prevent us from seeing a single line of human *expressive* development where a continuous *technical* process did not clearly exist.

In short, what is typical of mankind is not necessarily dependent upon art techniques and artifacts. It is something more fundamentally human that bridges the distance between one generation and the next. *Art* is only the outward manifestation of that sensibility of Homo sapiens (in the largest context) and of civilizations (in a smaller and more specialized context).

Despite the isolation, possibly the *total* isolation, of Indians from the rest of mankind from 25,000 years ago until 1492, it remains that Indians are fundamentally the same as all other people to the extent that any quality of mankind may be called fundamental. What this means is that American Indian painting is both unique and universal at the same time. I could say the same of Fra Angelico or Jan van Eyck or Pablo Picasso. We uncover what is unique through tradition and history, and we discover what is universal through ourselves in conjunction with the paintings themselves.

3. SONG FROM THE EARTH
Pre-Columbian Art and the Rise of Painting

Most of the Pre-Columbian forms of the Indian pictorial tradition are found in specific cultural areas and are regional in character. The exception is rock art, which exists throughout the continental United States and has very similar general features everywhere that it has been discovered. It is easy to jump to the conclusion that these emblems represent a continent-wide artistic impulse. But as early as 1893 Garrick Mallery, the chief authority on picture-writing in America, suggested the contrary:

> To start with a theory, or even a hypothesis, that the rock writings are all symbolic and may be interpreted by the imagination of the observer or by translation either from or into known symbols of similar forms found in other regions, is a limitless delusion. Doubtless many of the characters are genuine symbols or emblems, and some have been ascertained through extrinsic information to be such. With certain exceptions they were intended to be understood by all observers either as rude objective representations or as ideograms, which indeed were often so imperfect as to require elucidation, but not any hermeneutic key.*

Pre-Columbian rock art is of two distinct types: *petroglyphs,* drawings on stone that are pecked, carved (incised), scratched, or abraded into the surface; and *pictographs,* which are usually painted in shades of red on the surface. The four main concentrations of rock art are in California, the Columbia Plateau, the Great Basin region, and the Southwest. There

* Garrick Mallery, *Picture Writing of the American Indians,* U.S. Bureau of American Ethnology, Annual Report No. 10 (Washington, D.C., 1893).

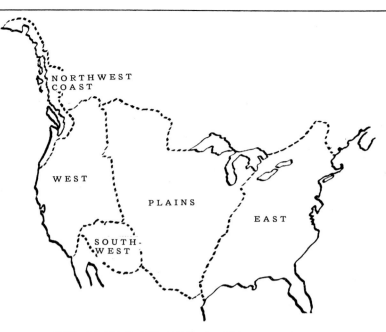

ART AREAS OF THE UNITED STATES

The art/cultural areas of the United States are normally used to designate the regional evolution of American Indian culture. Since only an overview of the aboriginal world of the United States is necessary for the purposes of this book, only five art areas have been defined.

The East — including all of the Atlantic Coast as its eastern boundary, and bordered on the west by the Great Plains or roughly the Mississippi River.

The West — including three subareas, California, the Great Basin, and the Plateau: all of the United States west of the Rockies with the exceptions of the Northwest Coast and the Southwest.

The Northwest Coast — including the Pacific Coast from southern Alaska to northern California.

The Plains — the boundaries of this area have shifted over the centuries. Generally speaking, it is a funnel-shaped region, narrowing to the south, with the Rockies as its western boundary. It includes the prairies of the Midwest, most of the

present states of Michigan, Illinois, and Missouri, and the western flank of Arkansas and Texas.

The Southwest — including most of Arizona and New Mexico, southeastern Nevada, southern Utah, and southwestern Colorado.

Note: These art areas serve as the framework for an overview of the pictorial traditions of the American Indian prior to the twentieth century. Knowledge of the earlier centuries comes of necessity from archaeological data. Discussion must be limited to the minimum necessary for an understanding of pictorial developments which occurred from the period (1880) of the subjugations of the tribes and the beginning of the modern revival of Indian art. It is helpful to realize at the outset that only two art areas, the Southwest and the Plains, figure in an important way in the pictorial tradition before the twentieth century, so these regions will be given most of the focus of the survey of pre-twentieth-century graphic evolution.

is, however, hardly a geographic area of America where these images on rock do not exist. No one knows exactly what they are or why they were created or precisely when they were made. There is no question that they were made by American Indians, and it is speculated, using various dating methods, that the rock art was produced for several thousand years and that it persisted until recent times in certain areas, well into the post-Columbian epoch (*ca.* 1860–1900). The earliest examples may be found in the Great Basin region of eastern California and southern Nevada; the most recent, the Kwakiutl paintings from British Columbia. There is currently no evidence that rock paintings or carvings were made during the early millennia of man's first wanderings in North America.

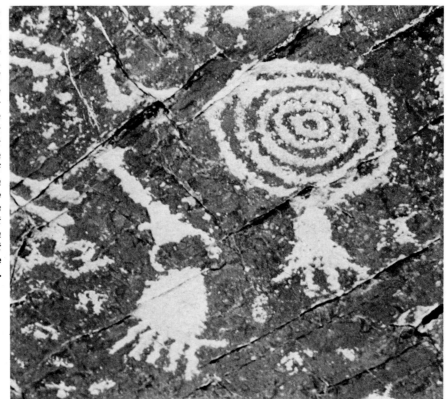

Petroglyph, Nevada, date unknown. It is doubtful that the rock art of pre-Columbian America was created for the sake of self-expression. Most archaeologists see petroglyphs and pictographs only in terms of the ceremonial use that their creators intended. Art historians take exception to this viewpoint and point out that most ancient arts were motivated by religious purposes. But the tendency of the "artists" to ignore each other's work and superimpose their images upon prior ones makes the concept of art, at least as we know it, remote from whatever impelled the ancient Americans to paint or incise their imagery on the rocks.

There are, as J. J. Brody has shown, two good reasons why rock art is not really "art." First of all, little concern is shown for the spatial arrangement characteristic of unified compositions. The surfaces are undefined and unlimited, ranging from the smooth walls of enormous caves to the uneven sides of boulders. Figures are placed totally at random and are often superimposed over earlier designs, seemingly without the slightest concern for those visual results we assume would preoccupy an "artist." Second, it is doubtful that making "pictures" was a primary or central purpose of these pictorial efforts, any more than the making of an IBM perforated card is essentially concerned with aesthetic results.

Since self-serving aesthetics was clearly not the essential purpose in the creation of rock art, many archaeologists insist that the artistic aspect of rock pictures is secondary at best, or nonexistent. This has caused debate among art historians who take strong exception to this nonaesthetic attitude and argue that most ancient art was motivated by religious purposes rather than a doctrine of "art for art's sake." The two objections just mentioned, however, to accepting rock art as a conscious beginning of graphic expression seems to preclude any debate. Only during rare periods of prosperity did the American Indian have the inclination to produce recognizably expressive images, whether self-contained or related to a larger ritual. Whatever the exact purpose of rock painting, it was utilitarian in some distinct manner that permitted many overlays of one image upon another without detriment to whatever function the images served (clearly not an artistic procedure as we now understand it).

The iconography of rock art is a source of fascination since it exhibits various styles and imagery which persist throughout North America to this day. The appearance of someone with original ideas and talent who inaugurated new forms and style was extremely rare. The curious fact that the nomadic people of North America did not achieve the perfection and excellence of the Paleolithic cave painters of southern France and northern Spain can be explained only by the fact that the European artists were essentially sedentary and their paintings were made over a very long period of time during the last great ice age. The American rock painters had to follow the migration of herds in order to survive and could not improve their abilities by comparison with their prior paintings since these were necessarily left behind.

Except for rock art there are no pictorial efforts which range over the whole continent. Among the Indian tribes of the Eastern Art Area (see map) there is little evidence that a pictorial tradition existed during any period of history. Body-painting and tattooing were widely practiced after 1492, but the material culture of prehistory left little behind to indicate wide use of painting. There was, however, a highly developed sculptural tradition in the East around 800 B.C., when the culture of the Adena people of the Ohio River valley reached its first peak. Throughout the Mississippian mound-building periods, a Woodland culture flourished (A.D. 700) which produced three-dimensional burial sculpture of stone. It is possible that painting on hide and wood might have also existed during Temple Mound times (A.D. 1000), but no remains have been found.

The pictorial traditions of the Western Art Area (see map) were concentrated on basketry and pictographs. In the Northwest Coastal area, art reflected the great importance that rank and wealth had in the social structure. There were rich pictorial works, but they were secondary compared to the far richer sculptural achievements. The Northwest Coast tribes supported artists who produced objects intended to increase the prestige of the consumers. The most familiar works of art are the monumental wooden sculptures that celebrated the legendary family history of their owners, as well as elaborate masks used in ceremonies. Architectural carvings such as totem poles, house posts, and mortuary posts were also created. This Northwest Coast culture was destroyed by a combination of stupendously wasteful competitions of wealth (*potlatches*) and by the diverting of interest from traditional arts to the superior economics of the fur trade. By the end of the nineteenth century the foundations of Northwest Coast groups had collapsed. Traditional art came to an end as the traditions which made use of art were discarded.

Before the turn of the century, the most important surviving centers of Indian painting were in the Great Plains and in the Southwest. The fundamental differences between these two areas explain their creation of entirely individual pictorial traditions.

Among the Plains Indians great stress has always been placed on in-

dividuality, not only in terms of personal courage but also in the private vision on which a person builds his metaphysical life. Men seek a personal guardian spirit without which they are, tribally speaking, as good as non-existent. Most men also accumulate a personal group of sacred objects that possess power. These medicine bundles are privately owned and epitomize the fact that power is personal rather than derived from a body of community ritual.

In contrast, the tribes of the Southwest (I speak now essentially of the Pueblos) are organized around a highly ritualistic life pattern in which originality and individuality are prime evils. Religious ceremony is regarded as a secret property of the tribe or, sometimes, of a clan within the tribe. To divulge the details of rituals or to act in ways which do not support the group identity results in being criticized through gossip or even in being cast out. Social pressure is a strong weapon in a situation that, at least in pre-Columbian times, was the equivalent of getting along in the group or being sent out to die. The result is great conformity both in the actions of the individual and in the structure of the tribe itself.

Of the Indian art areas of America, only the Southwest is known for certain to have had a rich pictorial tradition in prehistoric times. Many remnants of that tradition have survived due to the favorable climate, the low population density during prehistory, and the relative permanence of the architecture of the Southwest. By A.D. 300, three agricultural groups were prominent in this area: the Hohokam, the Mogollon, and the Anasazi. With the probable exception of the Hohokam people, the prehistoric peoples of the Southwest were indigenous, rather than migrants. By the time of the European invasion, the Navajo had migrated and settled into the region and developed into a variety of Anasazi. Both the Navajo and Apache came to the Southwest late, arriving about A.D. 1500. Both groups were hunting-gathering peoples, Athapaskans from the far Northwest whose ancestors were probably latecomers to North America. The Apache were not much changed by their new homeland, but the Navajo borrowed many elements from the native cultures of the ancient Southwest. Of particular importance were the art forms which the Navajo developed from Pueblo iconography, especially from sand paintings. Prior to the nineteenth century, however, very little is known of the pictorial tradition of the Navajo and Apache.

A great deal has been revealed about the pictorial past of the three prehistoric groups that occupied the Southwest before the coming of the Navajo and Apache, mainly from the evidence of painted pottery and murals painted on the walls of ceremonial chambers called *kivas*. The Southwest region (Nevada and New Mexico) is the most important pottery location in North America. The tradition is ancient and descends from a series of cultures representing three major prehistoric periods: the Mogollon (pronounced "Muggy-own"); the Hohokam, and the Anasazi.

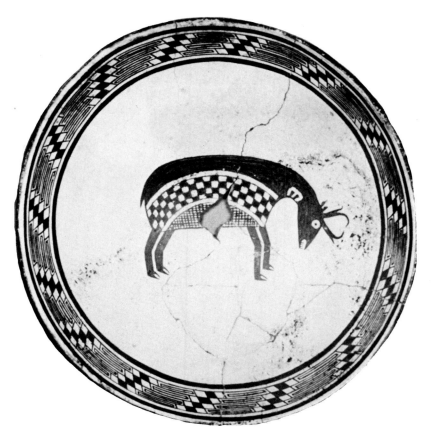

Painted Bowl: Deer Figure, Mimbres, New Mexico, ca. A.D. 1050. In a remarkably short time the culture which produced this pottery developed what many consider to be the finest ceramics of the prehistoric Southwest. Due to the unusual consistency of technique and imagery in Mimbres pottery, it is generally assumed that a single artist created the style. The deer pictured on this vessel is a persistent image in pottery decoration in the Southwest.

Mogollon culture (100 B.C.–A.D. 1400) began with the Cochise culture (5000 B.C.) and acquired agriculture and pottery. About 5,000 years ago, in Ecuador and Colombia, pottery seems to have come into existence quite suddenly and unexplainably, and its various styles spread over the continent from tribe to tribe, entering the Southwest via Mexico.

Hohokam culture (100 B.C.–A.D. 1400) coexisted at the time of the Mogollon culture, from which it received its first influences. It was both racially and geographically distinct from the Mogollon, being concentrated in southern Arizona where it developed irrigation canal systems unique to the Southwest. The Mimbres style in pottery is part of the larger Mogollon culture but is unique insofar as it introduced what has become the predominant zoomorphic and anthropomorphic decorations of the Southwest iconography. It is generally speculated that a single great artist structured the style of Mimbres pottery-making sometime between A.D. 1000 and 1300.

Anasazi culture (a Navajo word meaning "the old ones") began with the Basketmakers (A.D. 100–700) and developed into the modern-day Pueblo Indians (1540 to the present).

The *kiva* murals, which are a foundation of Southwest imagery, date from the Mimbres period, circa A.D. 1000, although the most extensive development of wall painting probably took place about A.D. 1300–1500.

Hohokam potters used red lines on a buff background and generally filled the entire surface with continuous designs: meanders, scrolls, and other linear motifs. Life forms appeared as stick figures in repeated patterns. White surfaces with decoration painted in black were prevalent in Anasazi pottery, but by the mid-thirteenth century polychrome pottery became widespread. Mogollon pottery resembled that of the Hohokam. Mimbres narrative pictures on pottery seem to be the earliest controlled pictorial compositions of the Southwest. They appear on the interior of bowls so that the entire composition is visible. Animals, human beings, and mythical figures appear together in scenes that probably illustrate ceremonies, domestic activities, and hunting. The drawing is exceptionally fluid for the period — precise, active, and realistic. The Mimbres black-on-white pottery is perhaps the highest achievement of potters of this early time and remains both distinctive and appealing for its pictorial elements.

The *kiva* murals are unavailable to nonmembers of the pueblo, but we know that they were dry fresco on plastered walls. The range of color was applied in flat, even tones to discrete areas separated from each other by overlaid neutral or contrasting lines. The modeling, shading, perspective, scale, and textural effects are extremely limited, achieving a flat, channeled surface on which three-dimensional illusion was sometimes depicted by the use of overlapping figures.

The style of the murals is representational and includes animals, human beings, fantastic creatures, plant life, and astral forms. Landscape painting (in the sense of a realistic background covering the surface) is unknown in the murals, although environment is sometimes suggested by clouds, rainfall, or lightning. The earliest and most elaborate murals (*ca.* A.D. 1000) are located in three sites: Awatovi and Kawaika-a near present-day Hopi First Mesa, and Pottery Mound in the Rio Grande valley between Isleta and Laguna pueblos. The wall art contains communal rather than personal subjects and imagery. In the more than five hundred recorded images, few repetitions of iconography or theme have been found. There has been great speculation about this curious fact, generally concluding that the motive behind the painting escapes us: there was apparently no desire to formulate a symbolic language of images or a consistent style, but the diversity of subjects seems to indicate a form of iconography that strived for unique, singular representations rather than a system of symbols as they have come to be understood in glyphs and other forms of pictographic expression.

Despite this heterogeneous figuration, these murals have a curious similarity of appearance and there seems to have been minimal change in either the visual effects or the techniques used to achieve them over the five-hundred-year period prior to 1492. These murals are a veritable window into the soul of the Pueblos.

Today it is not possible for outsiders to enter the *kivas,* with the

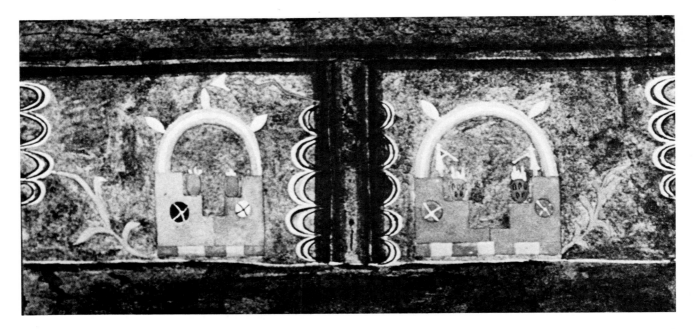

exception of the site now called Coronado State Monument (near Bernalillo, New Mexico), where the murals have been restored. A few government surveyors and army officers were among the first non-Indians to gain entrance to a native *kiva*. Their sketches are among the only records of the murals. In 1849, Lt. J. H. Simpson was at Jemez Pueblo in New Mexico, where one of his men made reproductions of *kiva* drawings. In one of the most fascinating renderings, a four-color rainbow arches above a double terrace, one to the right and another to the left. On the left terrace are various figures enclosed by the rainbow, including humans and jars with something coming out of them, possibly fire or growing plants. This reproduction offers a rare glimpse of *kiva* art. (See page 26.) It is likely that the style has degenerated during the historic period, but it is also possible that new elements have been introduced to mural painting after the Spanish invasion. We don't know this for certain. The *kivas* are the center of Pueblo ceremonial life to this day. Any mention of the chambers or the rituals that take place within them is considered an offense by Pueblo Indians.

The history and origin of Navajo dry painting (sand painting) baffle us. The sand paintings were probably borrowed from the Pueblos and are a central part of the Navajo curing ceremonies by which harmony with the universe is regained and maintained. There are more than one thousand different kinds of sand paintings, all made to be destroyed immediately after their use. They are not left intact for fear of holding captive the powers that they attract and embody. Recently, permanent records of some of the pictures — intentionally reproduced with slight inaccuracies — have been made by Navajos. There is no part of sand painting without content and meaning; conscious aesthetic expression, however, is not one of its purposes. The composition is normally centrifugal and radial, for the sand painting is executed on the ground and is surrounded by the participants of the curing ceremony. A framing figure

Jémez Pueblo, New Mexico, 1849. From Simpson, "Report of an Expedition into the Navajo Country," U.S. Senate, 31st Cong., 1st Sess., Senate Executive Document 64. The native kiva is a place of great and abiding mystery to this day. It is currently impossible to enter such sacred underground chambers, but in the mid-nineteenth century, Lt. J. H. Simpson became one of the first whites to enter a kiva, and there one of his party made reproductions of what was no doubt kiva drawing. One style of watercolor painting later created in San Ildefonso, like that of Fred Kabotie, was probably inspired by this kind of kiva mural.

Awatovi Mural Reproductions made by the Peabody Museum of Harvard University (quarter-scale), date of original unknown. Courtesy Museum of Northern Arizona. In 1936 a series of earth-pigment paintings was discovered in kivas in a region near the present Hopi villages. The excavations revealed a vast range of art styles, with each layer overlaid by another. The kiva murals became a major source of inspiration to young painters such as Fred Kabotie (see Chapter 9) who were just beginning to paint at the time of their discovery. Even though Awatovi is still in many respects an enigma and no one is certain how to interpret the iconography of the murals, over twelve hundred years of buried history have been unearthed through extensive excavation by the Awatovi Expedition of Harvard University.

Sand painting, Navajo, 1969. Courtesy Museum of Northern Arizona. A ceremonial painting used in curing rites and created by a specialist and his assistants, using various ground elements that produce colored powders. The subject lies in the sand painting at the height of the ceremony, at which time the images manifest the power of those deities or yei depicted. Since these powers must be released by destroying the iconography which attracts and embodies them, sand paintings are not preserved and may not be drawn or photographed unless some detail is omitted or some slight error is made. This example is such an incomplete sand painting.

almost always partially or totally encloses the painting. Carefully controlled lines isolate the color masses, which are made up of various ground materials. Motifs are angular, although curved forms occur as circles. The subjects are highly stylized and may include plants, animals, astral bodies, or supernatural beings. The treatment of the figuration is conventionalized in such a manner that an overall unity is achieved.

The imagery of painted pottery and *kiva* murals has been sustained in the Southwest not only by the traditional resistance of the people to change but also by the revival of secular crafts. This renaissance was brought about by proprietors of trading posts in the 1880s with the coming of the railroad. The first interest of tourists were Navajo blankets. In 1895 the anthropologist J. Walter Fewkes, working at Sikyatki (present-day Yellow House in the Hopi province of Tusayan), un-

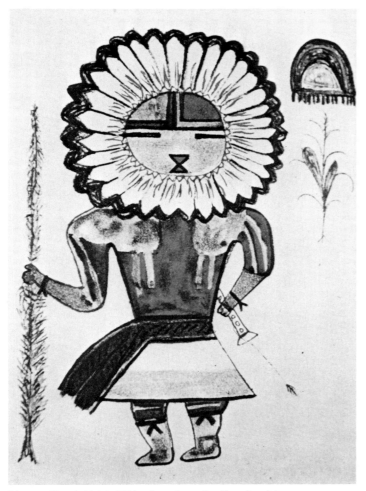

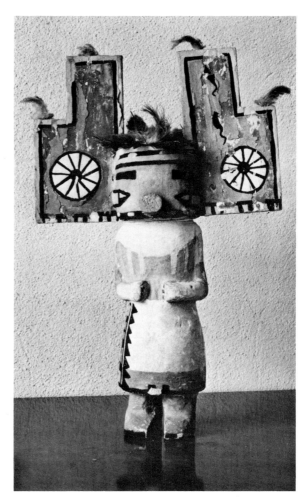

Tawa, *Hopi 1900. This drawing of a Sun kachina was commissioned by the pioneer ethnologist J. W. Fewkes, who asked several Hopi men to attempt to use white man's crayons, pencils, and paper to render a series of drawings of Hopi kachinas. From "Hopi Katchinas Drawn by Native Artists," U.S. Bureau of American Ethnology, Annual Report, No. 21, 1903.*

The Sun kachina has a disk-shaped mask, which is divided by a horizontal black band into two regions, the upper being subdivided into two smaller portions by a median vertical line. The left lateral upper division is red, the right yellow, the former being surrounded by a yellow and black border, the latter by a red and black. In the lower half of the face, which is green, appear lines representing eyes, and a double triangle of hourglass shape representing the mouth.

Around the border of the mask is represented a plaited corn husk, in which radiating eagle feathers are inserted. A string with attached red horsehair is tied around the rim of the disk. In his left hand Tawa carries the flute that is associated with him in certain Hopi solar myths. It will be found that this type of sun symbolism is easily detected in various kachinas of different names, which have the same symbolic markings and are doubtless also sun powers under different names.

To the upper right of Tawa is a symbolic depiction of a rain cloud and beneath it a corn plant.

Kachina, *Hopi. Courtesy University of Colorado Museum at Boulder, UCM 16219. The kachina, carved from wood and painted, is an elaborate traditional toy made by the Hopi for their children so they may learn the great hierarchy of deities or kachinas.*

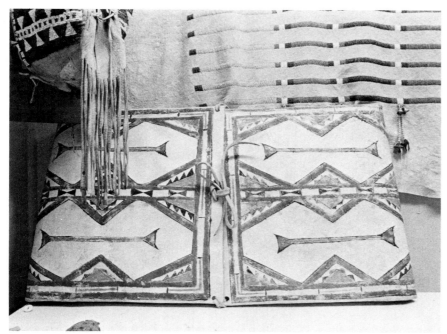

Parfleche. Cheyenne, nineteenth century. Powdered pigments on dried hide. Courtesy Oklahoma Department of Tourism and the Southern Plains Indian Museum, Anadarko, Oklahoma. Made from rawhide and folded into containers that hold various objects, these Indian "suitcases" were used throughout the Great Plains region.

earthed pottery which gave the impetus for the Hano potter Nampeyo to initiate the revival of Sikyatki ware. A bit later, about 1900, Fewkes also commissioned several Hopi men to make drawings of *kachinas,* which are among the first sponsored arts of the Southwest. These marvelously naïve drawings indicate that the three hundred and sixty years of contact with Europeans had had surprisingly little impact on the Hopis' graphic imagination. Some of the drawings Fewkes got from his "artists" are remarkably similar to the ancient Pueblo murals that were not uncovered until several decades later.

In most North American tribes, specialization by the artist's sex and role in the group determined the kind of object to be decorated and the style to be employed in creating the decoration. Men almost exclusively produced compositions depicting life forms as well as supernatural beings. Men were the representational artists. Women, on the other hand, traditionally made abstract, geometric compositions. This specialization persists in a general way even today.

Among Plains Indians the abstract designs that were the prerogative of women have survived in greater number than those with figures which were painted by men. This geometric art was probably older than the figurative, coming out of such antecedents of Woodland culture as were later evolved into weaving, quillwork, and beadwork. The patterns were classical in form — circles and arcs, triangles, rectangles, and hyperbolas. Colors were primarily red, yellow, blue, and green, applied evenly and

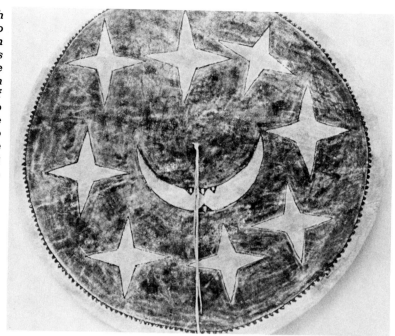

War shield. Comanche, nineteenth century. Powdered pigments on buffalo hide. Courtesy Department of Tourism of Oklahoma and the Southern Plains Indian Museum, Anadarko. Warfare involved the use of a shield painted with the individual's personal emblem of protection. Women were not allowed to touch the shields, and special protective covers of deerhide were often used to keep the shields from profane view, since they were embodiments of great protective power.

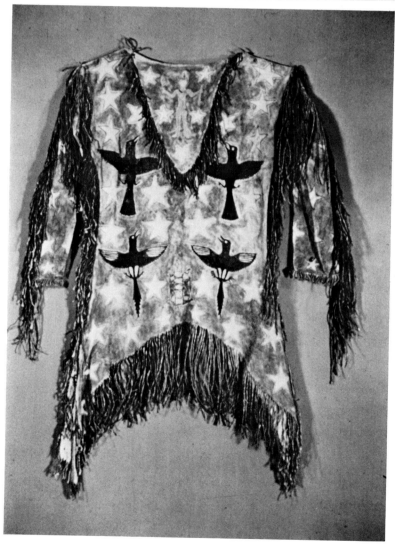

Buckskin Ghost Dance shirt. Pawnee, Oklahoma, ca. 1890. Made from skins and painted with the characteristic symbols of the Ghost Dance, this garment was worn to give magic protection against the white man and to assure the efficacy of the ceremonies. The emblems and painting techniques shown here survived through the childhood of some of the early Oklahoma painters, like Stephen Mopope and Monroe Tsatoke, who were influenced by the traditional art of their forebears by direct contact with their graphically decorated crafts and garments.

flat, and usually outlined with glue size. The women's geometric art appears on many objects, but principally on hide robes and parfleches (boxes, bags, and other utilitarian receptacles made out of stiff dried hides). Abstract designs, which were very numerous and were made in great numbers — possibly explaining their abundant survival — were outlined on these parfleches and painted with bold, flat colors.

The most influential Plains art form was the narrative composition, which was created to tell a story, often heroic or highly personal, celebrating a deed of courage. These representational works were generally drafted by a group of men — often the individuals who had performed the deeds being recorded — who drew on untailored hide robes and tepee liners made of skins. The paintings usually filled the entire field; often they were conceived from time to time as separate pictorial vignettes which documented specific actions. In relationship to each other, these vignettes suggest a narrative. The images superficially resemble rock art, which probably is due to the primal form in which graphic expression appears among people without an elaborate concept of art. The figures are scattered on an unmodified surface, though most hides and tepee linings do not superimpose figures and thus have a fundamental unity, which is not found in rock art. Composition was focused on the center of the skin, where the action was depicted and the figures were larger and more numerous. Often the composition is centrifugal, without top or bottom, suggesting that the hide was painted to be shown on the ground surrounded by viewers.

The earliest known hide paintings (*ca.* 1700), like the emblems painted on horses, shields, and other tools of war, were highly individualistic and were revealed to the artist through his vision quests and dreams. Among Plains tribes the initiation into adulthood of the male was linked to his discovery of a personal omen or "medicine" through visions, dreams, and hallucinations. The result of these very important quests were images which were protective against both natural and supernatural enemies. The images were not only mystical but might also relate to specific life or dream events which supported the importance and identity of a male. The emblems thus obtained (they could even be bought by those impoverished of visions) were painted in a flat, highly stylized manner in which perspective and volume were suggested by the overlapping of planes. This narrative and religious style developed from a private iconography to something new in the early nineteenth century when encounters with Anglos brought both new materials and subject matter. The confrontation also gave rise to a previously unconscious expression of Indian group solidarity. Cloth came into use as a substitute for animal hides; and the focus of Plains art on the group rather than the individual became emphatic.

"Winter counts" — which were calendrical records — were unique to the Teton Sioux and the Kiowa of the High Plains; however, they even-

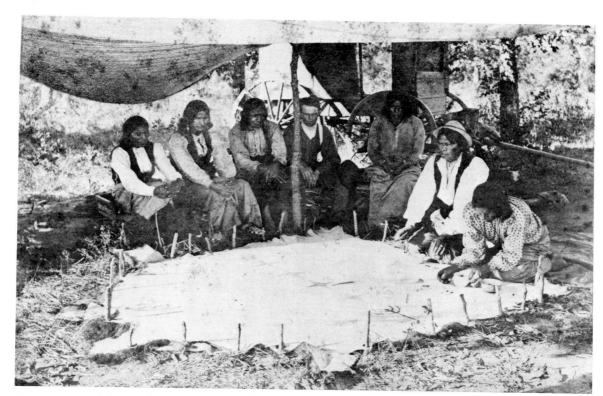

Comanche and Kiowa Indians painting history on a buffalo robe, Indian Territory (Oklahoma), 1875. Courtesy Oklahoma Historical Society. One of the rarest and most interesting early photographs depicting the men's collaborative art of historical painting on buffalo skin. Symbols for star and dragonfly are visible.

Tepee lining, ca. 1880. Powdered pigments on buffalo hide. Courtesy Oklahoma Department of Tourism and the Southern Plains Indian Museum, Anadarko, Oklahoma. War exploits of Chief Red Bird, Southern Cheyenne. A highly refined military art devoted to the battles of an individual warrior whose heroic encounters with the U. S. Cavalry and his Indian enemies are portrayed in vivid detail. The lining for the chief's tepee seems to have been the work of several artists who collaborated in creating the biographical scenes on behalf of Chief Red Bird.

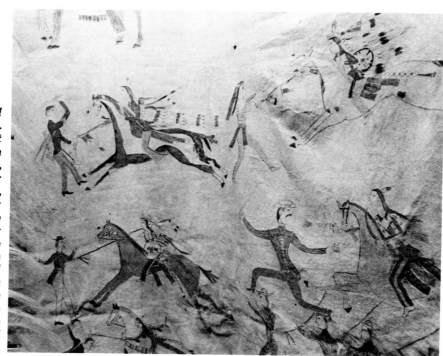

tually had a lasting influence on the narrative style of Indians who were thrown together in the so-called Indian Territory, now Oklahoma, as well as in the prison at Fort Marion, Florida. The "counts" were comprised of a continuous series of simple images, each image representing an important event in the tribal history for the year. Subjects for the annual "counts" were chosen in council or by common agreement and were then added to the rawhide history of the tribe. The "counts" were mnemonic symbols organized in strict chronological sequence that did not allow room for creative imagination. They were perhaps not decorative or expressive in an artistic sense but they did, like rock art, give rise to a formative pictorial metaphor among Plains Indians.

Nearly all that is known of Plains painting has been uncovered since the beginning of the nineteenth century. Essential to that century of Indian history were the buffalo and the horse which had been accidentally brought to the southwestern and Plains tribes by the Spanish. Until the introduction of cloth, buffalo hides were the chief surfaces for painting. And the mounted Indian, who had achieved mastery of the horse in a spectacularly short time, was to become one of the pervasive images of Plains painting. The most marvelous examples of the kinship of Plains Indian and horse are seen in paintings in which horse-stealing scenes depict more than one hundred horses on a single hide.

The narrative intent of hide painting culminated in ledger drawings made by Indians displaced by imprisonment or removal, who nostalgically recreated the traditions of their homelands in ledger books provided by their Anglo guardians. The history of these ledger drawings is fascinating and brings to the forefront some exceptionally fine art that marks the real beginning of Indian painting as we now know it. It also focuses on the names of individual Indians who for the first time signed their work and consciously created it as art.

In 1875 more than seventy young warriors of the Southern Plains were reluctantly designated by their elders to stand punishment for tribal insurgencies, as demanded by the United States government. These Indians were transported to prison in Fort Marion, St. Augustine, Florida, where they remained until their release in 1878. The three years of imprisonment demonstrate that a people can be subjugated and yet achieve a kind of cultural victory. The young men's jailer, Captain Richard H. Pratt (who later founded the Carlisle Indian School in Pennsylvania), recognized their interest in painting. He provided them with paper, pencils, and colors, and suggested that they create art for sale to whites. More than a third of the Indians participated in Pratt's program, resulting in more than six hundred ledger drawings and paintings created by the Arapaho, Cheyenne, Kiowa, and Comanche prisoners.

The ledger drawings were made on paper and usually outlined in pencil and colored in crayon or watercolor. It is debatable whether they were created for an Anglo public, which was eager to purchase them, or

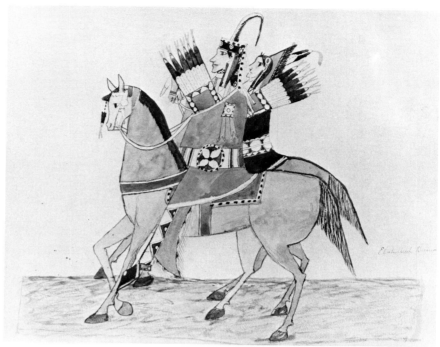

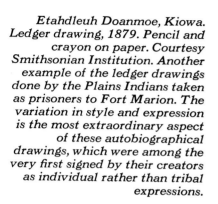

Etahdleuh Doanmoe, Kiowa. Ledger drawing, 1879. Pencil and crayon on paper. Courtesy Smithsonian Institution. Another example of the ledger drawings done by the Plains Indians taken as prisoners to Fort Marion. The variation in style and expression is the most extraordinary aspect of these autobiographical drawings, which were among the very first signed by their creators as individual rather than tribal expressions.

for the artists themselves. It is possible that the art impulse sprang from defiance and nostalgia, a recollection of the old days and a protest against the process of assimilation. But whatever the motivation, these remarkable drawings and paintings were something new in Plains Indian art. They were not made for tribal display like the hide narrative paintings, nor for utilitarian purposes like the "counts." They were private expressions by individuals who seemed adrift in a world no longer Indian and not yet Anglo.

Some of the drawings are anonymous, but many are leaves from consciously autobiographical ledger books. The earliest style of drawings on paper, especially those which recount the battles of Indians against U.S. soldiers, are closely related to nineteenth-century narrative hide paintings. But gradually, especially in the drawings of Buffalo Meat (Cheyenne), Etahdleuh Doanmoe* (Kiowa), Howling Wolf (Cheyenne), and Zo-Tom (Kiowa), a distinctive and highly original imagery began to develop.

Etahdleuh Doanmoe's style is vivid and somewhat reminiscent of Middle Eastern court painting. Buffalo Meat often used a similar style, but the result is more ritualistic, revealing bright-blanketed processions of sharply outlined figures whose bodies are depicted in contrasting planes of color that suggest Cubism, especially where he presents both profile and front of the same figure. Zo-Tom produced the most astonishing results from a pictorial point of view. Although he was a prisoner

* Pronunciation of Indian names can be found parenthetically following individual entries in the index.

and could not have seen the events he drew from afar, he nonetheless filled an entire ledger book with curiously distant and rather sorrowfully remote landscapes describing his journey to prison and his life there. These are among the most charming and disarming of the ledger drawings. They express, like the drawings of children in Nazi concentration camps, an innocent response to tragedy, which makes the depicted events more tragic.

When many of the prisoners returned to Oklahoma in 1878, the Kiowas were especially jubilant. It is impossible to overestimate the influence of this group of young Kiowa ex-convicts on the future of Plains painting. Not only had their drawings become highly evolved, but the artists themselves, who had been celebrated in the press by visiting journalists, had become aware of the great interest of tourists in buying their art. The success of individual Indians as "artists" was entirely new to the tribal mentality and was certainly a major force in the exciting renaissance of Plains Indian painting which began after the turn of the century.

What had happened in a relatively short period was vital: the emergence of the potential of art as ideology. It was a process that would continue with the formation of what is called Traditional Indian art and would continue, with a great deal of debate and stress, with the abandonment of the Traditional in favor of the Contemporary idiom of Indian art. This process from anonymous ritual and tribal artistic expression to the self-expression of an individual artist is so central to the history of Indian painting that we need to understand how it works and how it has altered the tribal sensibility of all primal people — from Egyptians to early Christians — undergoing the transformation of ceremony into art.

An Egyptian or Christian artist had an ideology that acted as the unquestioned basis of content in his work. He didn't have to justify his moral viewpoint; he simply worked in a unified process of thought and production. His audience existed with the same world view. In his painting there was in the truest sense nothing to understand.

Today, when the content of a painting or any work of art has lost its traditional ideological function, we look at it as an historical document or as a totally independent creation of expressive forms — or, I think ideally, as a combination of both art form and historical tradition. We need not be Christian to respond to the paintings of Grünewald, Memling, or Lucas Cranach. Their religious works persist in their appeal to us not because of, but in spite of their Christian ideology.

There is an Indian ideology that is, like the Egyptian or Christian world view, bound up in rituals, dances, taboos, and other aspects of an elaborate oral tradition. For Indians who lived prior to the final subjugation of the native peoples of America, roughly at the turn of the century, this ideology was a commonplace and is everywhere apparent

Zo-Tom, Kiowa. Ledger drawings, 1876. Pencil and crayon on paper. Courtesy private collection. These ledger drawings were made by one of the several Kiowa youths imprisoned at Fort Marion when he first came in contact with Anglo art media. These young prisoners are recognized as the founders of modern Indian painting.

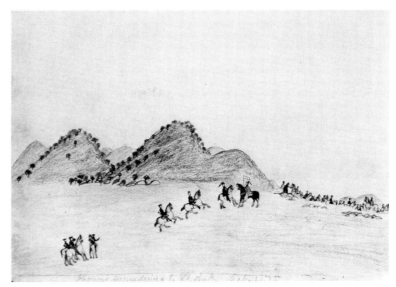

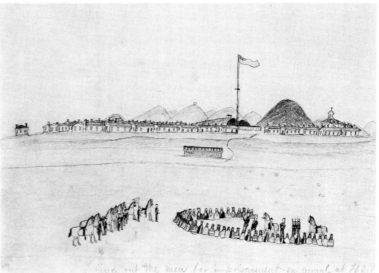

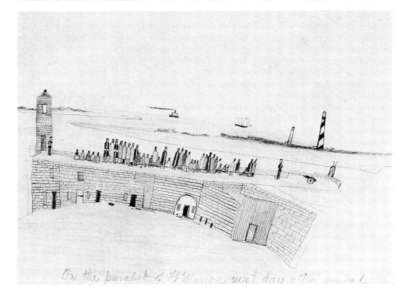

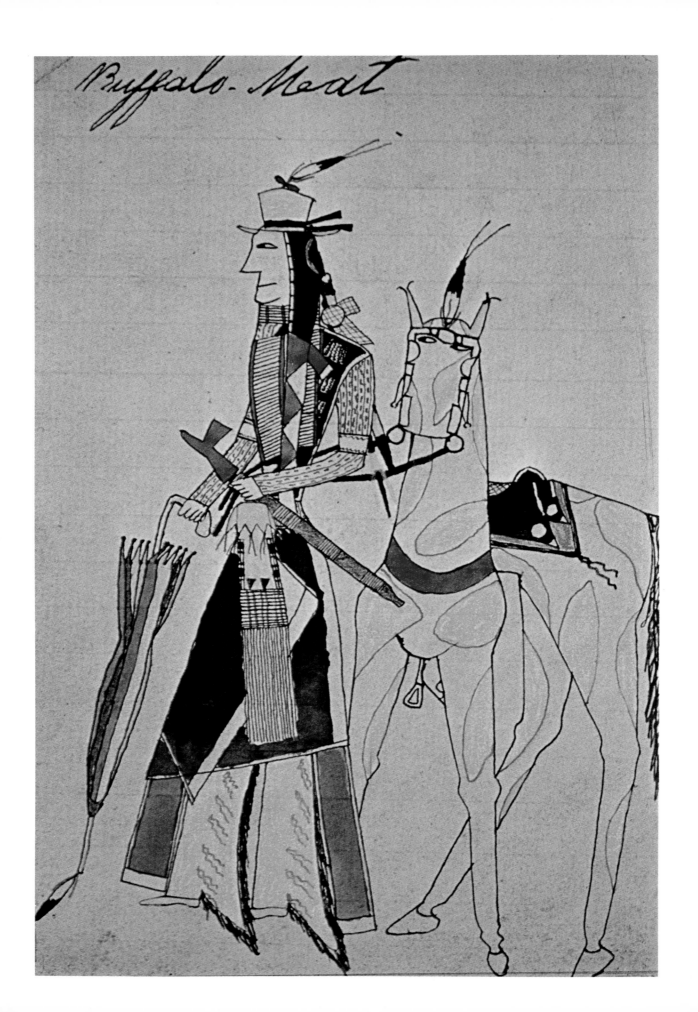

Buffalo-Meat

in their arts. For the Indian artist at the middle of the twentieth century there is often a gap between his identification with Indians and his identity as an Indian. Many Indians have made an effort to rediscover what it is to be Indian: in language, ritual, and values. This revivalist theme is a central one of this book; its importance here is the conscious attempt of Indian painters to revive their tradition through their paintings. In effect, they have delved into the same mythologies, histories, and rituals that concern us here.

There is nothing artificial in this conscious revival of the past or in the painter's projection of a tradition that is almost entirely lost to him. There is a sufficient cultural residue even among Indians who have never seen a reservation to justify their preoccupation with Indian subjects and themes. This is equally true of non-Indian ideologies. For instance, despite the decline of Judeo-Christian orthodoxy there is in western society sufficient residue of its myths, ideals, axioms, and dramatic personalities to permit its use as serious or satirical material in twentieth-century arts. Even to non-Christians and non-Jews the Judeo-Christian motifs of Fellini, Joyce, Bruckner, and Matisse are not lost.

Curiously enough, the Indian is not really an alien to the white world: he has a vivid position as a curiosity. He was a handy symbol for the European reaction against formalism which bloomed in the romantic movement. The Noble Savage epitomized the natural man, that idealized person who was envisioned as free of the chains of industrialization and rationality at exactly the time when romantic revolutionaries were reacting against industry and scientific logic. Through the writings of Karl May who created the Winatu books in Europe and James Fenimore Cooper in America, the Indian became a symbol of innocence and nobility wrecked by avarice and intellect. The Boy Scouts carried this idealization to the point of no return: seeing in the outdoor hero and the Eagle Scout patterned after Indians nothing fundamentally Indian. The motion picture flaunted a violent version of the red man which nonetheless provoked most children leaving the Saturday matinee to prefer to be wild Indians rather than heroic cowhands when playing Cowboys and Indians. This high regard for the Indian (though he is essentially a mystery to most Americans) permeates everything American: the names of states, rivers, towns; the folklore and legends; and the entire notion so central to Americans of the frontiersman, pioneer, and free soul. This preoccupation with Indians in America as well as throughout the world is unquestionably part of the vast appeal of the paintings in this book.

For whatever reason the Indian became the powerful symbol of the natural man, it remains that Indians represent a cultural residue not unlike the dramatic dust left on every theatrical prop of the West by the Judeo-Christian tradition. People *recognize* something about Indians. There is something immediately recognizable about the *Indianness* of

Buffalo Meat, Cheyenne. Indian with Horse, *1875. Pencil and crayon on paper. Courtesy Oklahoma State Historical Museum. Another Fort Marion drawing showing yet another style of expression: this time ironic (the hat and the umbrella) and astonishingly cubistic insofar as the horse is seen both in profile (the body) and full face (the head).*

Indian painting whether it is concerned with the revival of the past among so-called Traditional painters or a satirical projection of the present among Contemporary Indian artists. Both forms of painting function through a dualism of history as it is known to Indians and history as it has been rewritten by non-Indians; a duality not unlike the unresolvable contrast between the popular notion of Judeo-Christian genesis and Darwinian evolution.

By 1900, the Indian of the Plains had come a long way from his pre-historic painting. And yet the pre-Columbian crafts had contributed a very important combination of styles, media, and colors. The geometric designs of women had sustained the frame of reference that would later appear in Contemporary Indian painting, outlining and reinforcing the shape and form of objects.

From the many long epochs of crafts came the form of twentieth-century Indian art called Traditional painting. Though vitally connected to the history of decoration and limited and shaped by the stern sense of tradition, the Traditional "school" was a direct response to the influence of the white man and his institutions. If there is any single instance in which Indians have shown an open interest in the suggestions of con-cerned Anglos, it has been in the field of fine arts — probably because art is the most humane product of the white race that Indians observed, and because the motives of whites interested in art were usually benign and generous. It is from the combination of the Fort Marion experience and the efforts of white teachers in charge of Indian students in Okla-homa that the flowering of Plains painting took place.

4. A RENAISSANCE OF INDIAN PAINTING
The Revival Begins

IN NOVEMBER 1892 FATHER ISIDORE RICHLIN OPENED ST. PATRICK'S
Mission School in Anadarko, Oklahoma, and enrolled thirty-five students
from the Comanche, Kiowa, and the Kiowa-Apache tribes. Until then,
very few Indians had received any type of instruction in Anglo art. Only
a few individuals, like the Arapaho named Wattan ("Black"), who later
called himself Carl Sweezy when he became one of the first self-taught
artists, and the Kiowa Indian Haungooah (or Silverhorn), another
primitivist who began painting as early as 1874, plus the prisoners at
Fort Marion, had been introduced to the materials of Anglo art (paper,
watercolors, crayons, pencils) and some of its basic techniques. Accord-
ing to the descendants of the early art students at St. Patrick's, Sister
Olivia and other teachers instructed them in proportion, depth, and
anatomy without insisting on European stylistic dogma and without
attempting to change their characteristic "naïve" technique or subject
matter.

Later in the Southwest another sign of a new Indian art emerged in
1902 when the anthropologist Dr. Kenneth Chapman of Santa Fe was
visiting the Navajo region, where he heard stories of an Indian "who does
nothing . . . for he is an artist." The doctor was both amused and amazed
by this exceptionally nonuseful member of a tribe that glorified con-
formity and communal activity. So he scouted out the "artist." Even-
tually he came to the hogan of Apie Begay, in the Pueblo Bonito area
of western New Mexico. What he found was a man who was anything
but idle. He was sitting on the dirt floor of his home with his legs
stretched out under a low, makeshift table on which he was arduously
and not very successfully trying to reproduce a traditional sand painting.

Crescencio Martinez, San Ildefonso Pueblo. Deer Dance, *1917. Watercolors.
Courtesy Museum of New Mexico. Crescencio was encouraged to draw in 1910
when Dr. E. L. Hewett found the boy using the ends of cardboard boxes for his
art and gave him paper and watercolors. The depiction of ceremonial dances was
the first major subject of the San Ildefonso painters. Here two men impersonate
deer while a third is dressed as a hunter.*

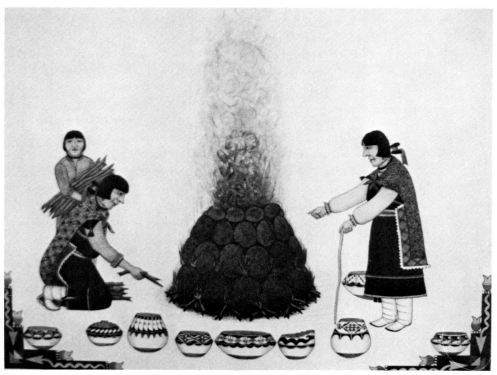

Awa Tsireh, San Ildefonso Pueblo. San Ildefonso Girls Firing Pottery, ca. *1924.
Watercolor on paper. Courtesy Museum of New Mexico. The celebration of daily
activities in the pueblos in an entirely unself-conscious naïve style is the high
mark of the paintings of Awa Tsireh.*

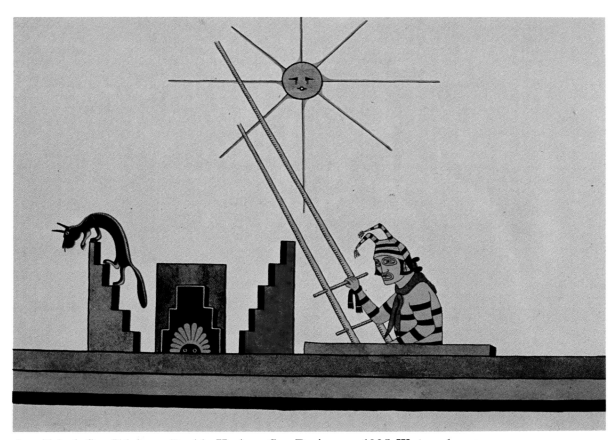

Awa Tsireh, San Ildefonso Pueblo. Koshare Sun Design, ca. *1925. Watercolor on paper. Courtesy Museum of Northern Arizona. This early painter, also known as Alfonso Roybal, painted daily with Fred Kabotie and Velino Shije Herrera at the Santa Fe School of American Research. This work, which recalls* kiva *murals, depicts a clown emerging from the* kiva, *an underground chamber reached only by ladder through a hole in the roof.*

Such an effort was virtually unheard of among traditional Indians, not only because Apie Begay was using Navajo ceremonial subjects as public property, but also because he was translating a nondecorative, utilitarian symbol of the curative ceremony into a nonutilitarian decorative image. The uniqueness of the situation was made apparent to Dr. Chapman by the "artist's" inability to explain why he was transforming a holy image into an abstract creation. Apie Begay had a problem: he was trying to recreate the colorful sand painting with only two tones, red and black. So Dr. Chapman offered him a box of children's crayons. Apie Begay was excited but not overwhelmed by the abrupt gift of color. He continued to interpret his own idea of form but with a somewhat richer palette. He penciled in the outlines of figures, but he also added blue, red, yellow, and green to make his depiction of the sacred forms more color-true to the original sand painting.

Gradually Apie Begay began to change the customary rigidity and repetition of Navajo deities or *yei* figures in sand painting. But his alteration of tradition was slow. He appears to have accepted only minimal

influence from Dr. Chapman and from his own closer and more ob-
jective observations of nature itself. What this means is that he resisted
sophisticated art concepts and retained the primitive view of the world
that is reflected in his art.

Across the continent the Carlisle Indian School was founded in
Pennsylvania in 1879 by the same Colonel Pratt who had directed the
Indian artists at Fort Marion. In 1911, Moses Stranger Horse, a Brule
from the Rosebud Reservation, studied art there. During the First World
War he served in France, where he remained after the armistice to study
the formal technique and composition of oil painting. His work is not
at all Traditional in the sense of having the appearance of Indian
painting of the 1920s, but was rather like Frenchified nineteenth-century
American landscape painting, with a watercolor transparency despite
his use of oils. Returning to the United States, he toured the West as
a camp follower on the wild west show circuit, demonstrating his
artistic abilities for the crowds and making a modest living selling his
art to curious tourists on the midway. He inspired other young Indians
who were fascinated both by his work and also by the astonishing fact
that it earned him a livelihood.

Between the years 1900 and 1910, Elizabeth Richards, a young Anglo
teacher with a strong interest in art, was working at the San Ildefonso
Day School and allowed her students to paint as they wished. She col-
lected the best pencil and crayon sketches and in February 1911 sent
them to a little-known artist, Barbara Friere-Marreco, in England. These
student works — some of the first native American artistic efforts to be
seen abroad — helped foster the small but growing European interest
in Indian art which would soon culminate, as we shall see, in the first
serious folio of Indian paintings to be published — not by Americans
but by a French publisher in Nice. Among the works sent to Miss
Friere-Marreco, anthropologist Bertha Dutton has identified a painting
by Alfredo Montoya, who with later members of his pueblo was part of
the so-called San Ildefonso school of painting, which is generally credited
with being the beginning of Indian watercolorists.

Between 1910 and 1920 there was a great deal of artistic activity
among several groups of southwestern Indians. Most painting during
these formative years was Puebloan in origin — created by artists from
San Ildefonso plus two from Hopi and one from Zia. This period marks
the conscious renaissance of modern Indian painting, a cultural awaken-
ing not unlike the Renaissance of Europe. This re-emergence of Indian
artistic identity was no less self-conscious and certainly no less arbitrary
than the events of the fifteenth century.

If there was a single influence in the Southwest that propelled the
reawakening of Indians to their own cultural legacy, it was probably
that of Edgar L. Hewett. A man of power and expertise, he was, at the
time (ca. 1915–1917), director of the School of American Research at

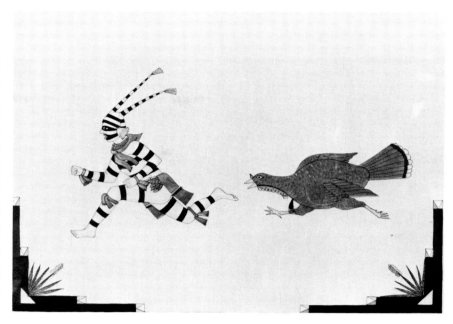

Awa Tsireh, San Ildefonso Pueblo. Koshare and Turkey, ca. *1920–1930. Watercolor on paper. Courtesy Museum of Northern Arizona. The formal terraces and plant motifs are contrasted in this painting with a comic scene: the ceremonial clown with his characteristic bands of black and white body paint is hotly pursued by the native American bird, the turkey. The koshare, like the "contrary" of the Plains tribes, is a pueblo figure of privilege, permitted liberties during ceremonial events that are strictly prohibited of others, acting like the trickster with outrageous manners and repeating blatantly the bits of tribal gossip which have been suppressed during the days before the ceremony.*

the Museum of New Mexico, a professor at the University of Southern California, and chairman of the Department of Anthropology of the University of New Mexico. He was unquestionably inspired by the work of Fewkes. Unlike Fewkes, however, Hewett was less interested in anthropological research than in Indian art as art. He commissioned a San Ildefonso Indian, Crescencio Martinez, to paint tribal ceremonies and dances, but he was not particularly concerned with accuracy as Fewkes had been and he did not press informants for secrets, as is clear from the fact that none of Martinez's paintings in this series illustrates secret dances. Hewett was fully sensitive to the Rio Grande Pueblo reluctance to discuss religious life with outsiders and aware that he was dealing not with aboriginal graphic curiosities but with art.

Crescencio Martinez was the first in a line of Pueblo artists to work for Hewett and the School of American Research of the Museum of New Mexico. Most of these artists had been drawing before their contact with Hewett (as Fred Kabotie has indicated in his interview in Chapter 9), but the sponsorship of a man with Hewett's prestige guaranteed the attention of a growing art-conscious community of Anglos in the Southwest.

The interest in the revival of painting and the adaption of watercolor as a new medium centered in the pueblo of San Ildefonso and in the work of Crescencio Martinez and Awa Tsireh, and of two Hopis, Fred Kabotie and Otis Polelonema, and a Zia, Velino Shije (later called Herrera, Má Pe Wi).

At Hopi and a few of the other pueblos, conservative religious factions condemned the painting of pictures, but this seems not to have been a factor at San Ildefonso where a religious schism in 1918 divided the pueblo into North and South Plaza groups. Painting, however, was not part of the argument, and it had become an active part of San Ildefonso

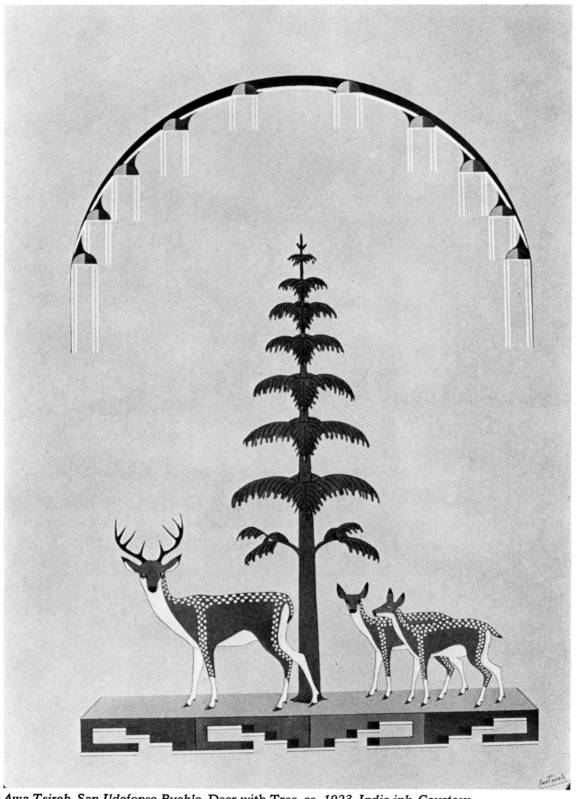

Awa Tsireh, San Ildefonso Pueblo. Deer with Tree, ca. *1923. India ink. Courtesy Museum of New Mexico. One of the artist's favorite compositions was a combination of animal, plant, and abstract forms under a rainbow. He painted many variations of this theme, such as* Deer with Tree, *which presents striking formal, static beauty in a highly stylized design which was no doubt influenced by the geometric and animal forms of early pottery decoration.*

life by the time of schism. Some of the most active painters became political and religious leaders in both San Ildefonso groups, while in other pueblos they were cast out. It is reasonable among tribal people that the benefits of being a painter were few; outside their pueblo, San Ildefonso artists became somewhat known by name and respected for their works, but their status in the outside world did not mean much at home. And it is doubtful that painting was much of an economic factor to the painters. (For all his fame as a ceramic decorator and artist, when Julian Martinez brought his family to Santa Fe about 1916 it was not to bask in glory, but to work as a stable hand and to live in the stables at La Fonda Hotel.)

Martinez had a preference for pale and grayed colors with bright hues in the small detail. Unlike the other Pueblo artists, he did not trace outlines in black paint but drew them in pencil. Detail is delicate; blacks are usually grayed and the surface is treated casually, with figures placed in naturalistic arrangements against the blank background. Though Martinez's painting has been compared to the mystic images of Carolingian art, this is perhaps an idealized view. His work has a naïve charm and contains a curious sort of revelation, but it cannot be compared with the graphic mastery of Awa Tsireh (Alfonso Roybal) whom Dr. Hewett commissioned around 1917 to do some paintings. The nephew of Crescencio Martinez, Awa Tsireh had been inspired to paint by his uncle even before meeting Hewett. His sublimely simple art is of several distinct styles: semirealistic pictures which resemble the kind of stiff drawings often produced by talented children, Traditional paintings in the now-popular sense of that word as it pertains to Indian art — flat, two-dimensional, and concerned with tribal life — and finally an abstract style in the sense that Mayan figurative sculpture is thoroughly designed and almost abstract though it retains its general reference to nature. Awa Tsireh's work is highly decorative in the best sense of that term, achieving the impersonal, stylized spirit of the Pueblo ceremonial life. His figures are not real people with elements of portraiture, but ritual actors. The faces are angular, with square jaws and birds' eyes on oversized squarish heads. In the large ceremonial paintings where many figures are depicted, Awa Tsireh is masterly in creating repetitions which rhythmically unify the surfaces and focus on a ritualistic orderliness without regimentation. He achieves this by fine detail in line and color on the individual figures.

As early as 1925 the *New York Times* ran a story about Awa Tsireh that stated: "His drawings are, in their own field, as precise and sophisticated as a Persian miniature. The technique that has produced pottery designs as perfect as those of an Etruscan vase has gone into his training."* The influence of geometrical painting on Puebloan pottery ap-

* *New York Times*, September 6, 1925. No by-line indicated.

Velino Herrera (Velino Shije; Má Pe Wi), Zia Pueblo. Woman with Kachina. *Watercolor on paper. Courtesy Museum of New Mexico. This portrait is exceptional for its rich planes of color and for its likeness and depiction of an individual rather than the tribal stereotype more common in Pueblo portraits. Herrera was one of the few early Pueblo painters whose art was disapproved of by his people. When the State of New Mexico adopted the sun symbol of the Pueblo Indians as its official insigne, Herrera was accused by his people of betraying them by giving the design to non-Indians.*

pears in Awa Tsireh's combination of animal or human figures and abstract shapes under an arching rainbow above which, at either side, are cloud terraces. These formalized paintings under a rainbow dome — whether depicting skunks, deer, or dancers — have a curiously theatrical effect, and their stylized figures frequently appear in later painters' works. That knowledge of pottery decoration, however, was Awa Tsireh's only formal training beyond the primary grades.

Awa Tsireh was fond of vivid color, which he achieved with brilliant hues of India ink. His paintings have an immediate appeal, perhaps because they possess extremely sure and exquisitely clean line and a compositional unity that is at once primitive and sophisticated. His drawings are generally two-dimensional and flat. Sometimes he combined three-dimensional with two-dimensional effects without apparent clash: he often used technically accurate foreshortening along with a rather unusual kind of his own, producing a sophisticated two-dimensional elaborateness. Action and motion do not play an important part in his imagery since they are largely incompatible with the impersonal, unified, and decorative stylization of his painting.

In his mature years, Awa Tsireh's eyesight became very poor. His hands were shaky, even for silversmithing and various other jobs unrelated to art that he pursued for a time, and so he abandoned painting; he died at about the age of 60, around 1955.

Another Pueblo artist was Velino Herrera (Má Pe Wi)* of Zia who

* Velino Shije Herrera adopted his childhood nickname *Má Pe Wi* as a nom-de-plume, but it is not often used by the public that knows Indian painting. The name was a pun, meaning both "oriole" and "bad egg."

divided his painterly efforts between the mythic and naturalistic. Herrera's figures are the result of accurate portraiture; they are filled with warmth and life — people from the pueblo involved in their daily work and conducting their ceremonies. His early work is perhaps more direct and naïve, but it is also awkward in comparison to the flawless brushwork, realistic detail, and perfect rendering of textures in his later paintings where technique may at times overwhelm the richness of content. For all his imaginative use of naturalistic detail, it is in the interpretation of Pueblo legend and viewpoint in symbolic terms that Herrera excelled. Much of his best painting makes use of the symbolism of forest, sky, and field in which stylized plants and animals exist in a purely imaginary world. It is in these images that there is an astonishing similarity to the expressionist approach to painting that Anglo artists have developed out of an entirely different tradition: the emphasis of subjectivity which permits the interpretation of outer forms in relation to the life of feeling in the artist's private world.

Herrera credited Hewett for getting him started around 1917 as an artist. A fellow-painter, José Rey Toledo, described Herrera as a "singing artist" — you could tell which ceremony he was painting by the song he sang at the drawing board. But his song did not remain sweet for long. When the State of New Mexico adopted the sun symbol of the Pueblo Indians as its official insignia, Herrera was accused by his own people of betraying them by giving the design to the whites. He was cast out and never regained tribal sanction. Later, in the 1950s, his wife was killed in an auto accident in which he was injured for life. He has never painted since.

Fred Kabotie is without any question the most versatile and accomplished of the early Pueblo painters. A Hopi, he excels in painting Hopi ceremonials though he is also extremely gifted in naturalistic illustration. In 1906, when Kabotie was six years old, his family tried to escape the efforts of the United States government to compel them to abandon their customs. They joined other people of old Oraibi and established the village of Hotevilla on Second Mesa. They eventually had to return to the newer villages of Oraibi and Shungopovi, where, in 1913, the children were forced into schools. Kabotie himself was sent to Santa Fe Indian School as a disciplinary measure. It was at the school that his gift was recognized and encouraged by Mr. and Mrs. John D. DeHuff.

Kabotie is proud of his village's approval of his symbolical paintings and the fact that he has never been criticized for divulging secrets in his depiction of ceremonies. This is no small achievement since Kabotie is more adroit than any of the Southwest painters in conveying to the viewer something of the mysticism of Hopi ceremonial life. His performers are clearly not mortal men disguised as deities. They are gods. It is difficult to find in the work of any other modern Indian artist a better portrayal of the relationship of the supernatural to the natural. This

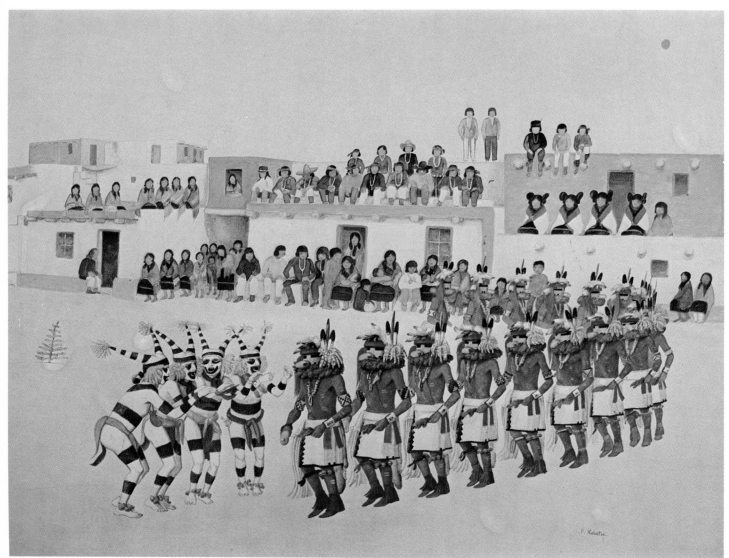

Fred Kabotie, Hopi. Hopi Ceremonial Dance, *1921. Watercolor on paper.*
Courtesy Philbrook Art Center, Tulsa. Here the koshare, or clowns, taunt the
kachinas, or "power centers," in a Hopi ceremony. The people are positioned
characteristically around the dance plaza of the pueblo. The ceremony seems
to be a Corn Dance. Additional paintings by Kabotie are found in Chapter 9.

Otis Polelonema, Hopi. The New Bride Woman, ca. 1930. Watercolor on paper. Courtesy Museum of Northern Arizona. A portrait of great warmth and monumental style by one of the very early self-taught Pueblo artists. Like Fred Kabotie, he went to the Santa Fe Indian School and was encouraged in his art by Mrs. John D. DeHuff.

metaphysical drama is no doubt Kabotie's enormous appeal as a painter; his works are grotesque and mysterious, buoyant and strange. For all the exoticism of the *kachina* figures or the incredible zoomorphic creatures, there is something powerful and familiar in his painting.

Though clearly not an academically trained artist, Kabotie possesses an unmistakable mastery of draftsmanship, proportion, and the kind of anatomical drawing that is considered "correct" by academic standards. His work proves, as did that of Velino Herrera, that Indian artists were capable of naturalistic realism when they were inclined to use traditional perspective and foreshortening instead of painting flat.

Whereas Kabotie evolved a personal style of great complexity and daring, his Hopi clansman Otis Polelonema (born 1902) painted with rugged naïveté. That is the charm of his art; it is the work of a true primitive with nothing more intended than a straightforward presentation of the world he knows and the life he lives, in a graphic style he filled with a completely unconscious and stunning mysticism not unlike the humanism of the Nerezi paintings done in Macedonia in the twelfth century.

The only woman painter in the generation which produced the Traditional Indian watercolor movement was self-taught Tonita Peña (1895–1949) of San Ildefonso Pueblo. Her ceremonial figures — unlike those of Kabotie — are not spirits but men in costume. She painted scenes of pueblo life without mysticism or illusion. And that, finally, is the intrigue of her paintings: they depict the coming and going of lusty people, fat women dancing, drummers pounding their drums, and potters going about their business without complication or symbolism.

Julian Martinez (1897–1943)* painted geometrically stylized figures, especially birds. Although his watercolors were secondary to his achievements as the decorator of pottery made by his very famous wife Maria, and though entirely self-taught, his influence on succeeding painters was not small, due to his popularization of a San Ildefonso Deer Dance style in which he depicts the dancers bending forward. It is a frequently encountered image; the *style* has had many interpreters among Pueblo painters. He also introduced into painting the *Avanyu,* a serpent figure which he used in its classic form on pottery. The serpent underwent fantastic improvisations in Julian Martinez's watercolors, being combined with magical birds, dragons, and all variety of strange creatures. The effect is highly decorative but sufficiently restrained and designed throughout to produce a harmonious surface.

Thus far the painters discussed have been largely or wholly self-taught and have perfectly represented the growth of Indian art out of crafts and other forms of decorative crafts during the period 1910 to 1920. The

* Martinez and Maria's son Popovi Da has become a painter of some interest. Julian Martinez is not related to either Richard or Crescencio Martinez — each of whom is also unrelated to the other.

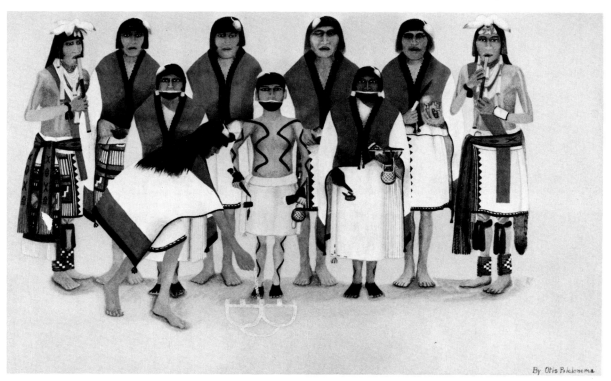

By Otis Polelonema

Otis Polelonema, Hopi. Flute Ceremony, ca. *1930. Watercolor on paper. Courtesy Museum of Northern Arizona. Another ceremonial painting by Polelonema. Unlike other Pueblo artists of the period, Polelonema embodies his figures with distinctive portraiture so each person is distinct. Such individuation is extremely rare among the highly communal Hopi. The symbol being made on the ground with cornmeal is the traditional raincloud.*

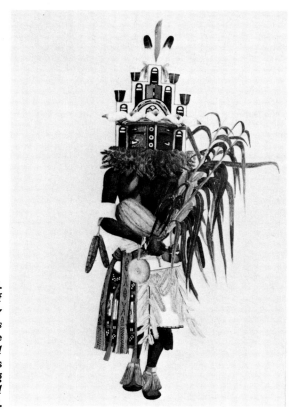

Otis Polelonema, Hopi. Kachina, ca. *1930. Watercolor on paper. Courtesy Museum of Northern Arizona. A favorite subject of the early Pueblo artists was the kachinas, sacred dancers of the Hopi who represent different powers. The dancers, who wear elaborate costumes and masks, are not thought to imitate the kachinas but to be transformed into them during ceremonies, or, more correctly, to be possessed by the kachina spirit.*

Tonita Peña, San Ildefonso Pueblo. Gourd Dance, ca. 1930. Watercolor on paper. Courtesy Museum of New Mexico, Santa Fe. Peña, or Quah Ah, painted with greater detail, delicacy, and tranquility than her fellow Pueblon artists. She was not as theatrical as Kabotie or Awa Tsireh but rather musical, with complete authenticity and unpretentiousness. She was the mother of Joe H. Herrera, an important painter.

Julian Martinez, San Ildefonso Pueblo. Hunter and Deer, ca. 1925. Tempera. Courtesy Museum of Northern Arizona. Julian Martinez's watercolor painting was not as important as his brilliant achievements as the decorator of the pottery of his wife, Maria, yet it is impressive for its influences and has virtues in its own right.

transitional artist who linked that decade with later developments is Richard Martinez, who was born in 1904 in San Ildefonso but who outlasted his contemporaries as an active painter and bridged the gap between naïve and sophisticated Indian painting. Richard Martinez was one of the original students at the Santa Fe Indian School where many of the founders of the Pueblo watercolor school received their basic education and little if any art instruction. Martinez absorbed the tradition of the self-taught San Ildefonso painters (a unified attitude toward technique and imagery which developed in a remarkably short time) and by the mid-1930s his decorative abstraction had evolved to the point where it overwhelmed realistic detail.

The early San Ildefonso painters strongly influenced each other and developed a group tradition. Their visual goals were initially illusionist, representational, and realistic. Sometime between 1920 and 1925 there was a major shift toward abstract decoration, for no apparent reason. That mode, however, became dominant. Richard Martinez is generally regarded as the pioneer in this rapid transition: his mature paintings were characterized by strong lines and use of bold arbitrary flat color fields in a thoroughly decorative and abstract manner. These elements typify the movement which he led: although his subjects were explicit and descriptive, the realistic details are overwhelmed by the decorative ones. By the time that such effects were apparent in Indian art the formative decade of 1910–1920 was over and many of the leaders of that period had already retired from painting to search out a more secure occupation.

The pioneering generation of southwestern Indian painting had come and gone in less than a decade. Its founder, Crescencio Martinez, had a career which lasted only two years. He died of influenza in 1918. But this was a period so rich in artistic developments that its impact was not fully realized until ten to fifteen years later when most of the paintings characteristic of and indebted to the innovative decade were produced by subsequent artists.

In 1910 Indian art had been a naïve form of naturalistic representation of familiar tribal scenes. It did not have the semireligious intent found in most pottery decoration, but it made use of symbolism and a point of view that was uniquely Indian. Though these early paintings were made for Anglo buyers, they rarely offended the tribal standards of dignity, good taste, and secrecy; they were clearly painted out of a relationship to the tribe even if they were not painted for members of the tribe. Then quite suddenly, within five years after 1920, the work of the founders of the Pueblo school of painting changed dramatically, so that backgrounds and other elements of childlike primitive representation disappeared. Edges of figures were further hardened and colors were selected for reasons other than representation. To some art historians this change suggests that the influence of white teachers and patrons

Richard Martinez, San Ildefonso Pueblo. Plumed Serpent. *From*
Pueblo Painters Folio, *courtesy Dr. and Mrs. Byron C. Butler. The
Avanyu, or Plumed Serpent, is coiled around itself in such a manner as
to give it a stylized flavor of the Hopi image. Though one of the very
early American Indian painters, Richard Martinez did not achieve the
great control of color and exquisite or refined detail which is so apparent
among his fellow artists.*

Julian Martinez, San Ildefonso Pueblo. Conventional Design of Symbols,
ca. 1922. *Watercolor on paper. Courtesy of Museum of Fine Arts,
Houston. Martinez's introduction of the Avanyu, variously interpreted
in watercolor painting, was another influential innovation. He had used
the motif of the serpent in classic form on pottery, but in his painting the
snake figure became fantastic, incorporating other mythic animals like
birds and dragonlike monsters. Several San Ildefonso artists painted
variations of these themes until they became a part of Traditional imagery.*

turned naïve representation into a form of decorative tourist painting. But other experts see the change as a spectacular evolution from naïve illustration to a new form of pictorial art — largely self-taught, but perhaps also influenced by Anglos who wanted painting that was "distinctly Indian." It is true (as in Richard Martinez's paintings, which have been over-stressed to make the point) that what had begun as painting using color to shape and depict form became instead drawings using color to decorate and fill outlined areas. It is perhaps beside the point to argue about the impact of white buyers on Indian painting. There is much evidence that Indians as often ignored the suggestions and tools of Anglo art as assimilated them. As early as 1902 Dr. Kenneth Chapman noticed that Apie Begay, the first Navajo painter he encountered, resisted sophisticated art concepts and retained the primitive view of the world that was reflected in his art. Begay's methods led later critics who obviously favored the Angloizing of Indians to say, "Apie Begay illustrates well the difficulties a primitive artist has in breaking away from established tools and materials and in attempting to use equipment and techniques which are partially or even totally strange to him."* That was a rather condescending conclusion, especially for 1973. The rapidity with which Indians adopted the horse, silvercraft, and metalwork shows this kind of judgment of primitive artists to be an ethnocentric belief that one's own superior culture should automatically overwhelm other cultures. The Indian has maintained a different idea of adoption. He is hesitant to change his world since it serves him well as it is. He is not intent upon progress to such an extent that it drives him to "improve" things which he doesn't really want or need to improve. A culture is not only expressed through methodologies, it is also founded in the way a people see the world. It is that idea of the world which art is supposed to serve. Viewpoint is the basis for the differences, for instance, between the Pueblo tribes and the other Southwest groups. The relatively impersonal outlook of the Pueblo peoples comes out of the fact that each member of the group is an intrinsic part of a functional whole; a situation that creates a viewpoint very different from the individualized Navajo-Apache.

For all these reasons, the art education afforded Indians commencing around the turn of the century cannot be thought of as a method of pouring Indian folklore into old European artistic molds. There were aspects of Indian life — prehistoric ideals and attitudes — that simply could not be divorced from the young artists' sensibilities. Indians were influenced by every aspect of Anglo graphic tradition. Older Indian painters even now seem extremely naïve about Anglo art and do not seem to have at their command the strictures of taste which are expected of painters in relation to their tradition. In other words, some of the old-

* Clara Lee Tanner, *Southwest Indian Painting* (Tucson: University of Arizona Press, 1973), p. 66.

timers mixed both the brilliant native forms and color with strident elements of calendar and catalog illustration. It is not clear if the "greeting card" trappings and sentimentality — or, for that matter, the resemblances to art nouveau and art deco — were directly derived from Anglo art or were simply a reflection of examples of popular illustration available to reservation Indians.

One of the most surprising revelations in the interviews with older Indian painters in Chapter 9 is that they have little basis for making value judgments about any art but their own. There was nothing elitist about Indian crafts and art. You didn't need the printed program to enjoy the work of artisans and craftsmen. As the American archaeologist and anthropologist Adolph F. Bandelier has written, "The Indian does not *say* anything about his culture, does no real *instructing* about it [he] just *lives* it."* There was no avant-garde in Indian "artistic" life. Unlike the white man, who seems to produce vulgar results whenever art becomes popular, the pre-Columbian Indian of North America largely admired art without regard to class and produced it on an amazingly high level of accomplishment. It takes an unusually discerning Anglo to devote himself to aesthetic selectivity. Nothing in Indian culture was based on this elite notion of those who "know" and those who "don't know." There was no sorting out of tastes. When the Indian found the white man's illustrative art, he reacted to it indiscriminately. In one way or another, perhaps in subtle ways, these encounters with popular illustration made a lasting imprint on Traditional Indian painting that would persist for more than three decades until a new generation of Indian artists, which grew up with influences hardly different from those of any Anglo college student, began to criticize and to alter the imagery, sentience, and techniques of painting to conform with their newly acquired idea of what it is to be Indian.

From 1920 until about 1950 the development and influence of Traditional painting continued to grow. It was not until 1971 that J. J. Brody imagined that he saw in the marketing of Traditional Indian paintings something which necessarily diminished the artistic motives of the painters who created them. "The products were made for and purchased by Whites, but they were produced by Indians, mostly for financial gain but also with pride in the skill that produced them," is the fairest judgment Brody makes in his book on the impact of Anglo buyers on Indian artists.† That comment, however, assumes a very different connotation — or perhaps a lack of one — when applied to Picasso or any other great painter of the white tradition, whom it fits just as well as it does

* Adolph F. Bandelier, *Indians of the Rio Grande Valley* (Albuquerque: University of New Mexico Press, 1937).

† *Indian Art & White Patrons* (Albuquerque: University of New Mexico Press, 1971).

Indian artists. Patronage has had an enormous influence on the content and intent of all art, whether the patron was the pope or white tourists. It would seem that what is important is the way in which the artist rises to the shaping demands of his patrons and not whether he exists in an ivory tower where he sings songs to please himself.

5. THE EARLY KIOWA ARTISTS
The Flowering of Art in Oklahoma

DURING THE FORMATIVE DECADE OF ART IN THE SOUTHWEST, ANOTHER branch of the modern school of Indian painting was emerging in Oklahoma. In 1916, Mrs. Susie Ryan Peters arrived in Anadarko to work as field matron for the Kiowa Agency. Born in Tennessee, she had come with her father to the Oklahoma Territory in a covered wagon, so she was no stranger to the frontier. In the Anadarko area, she worked primarily with members of the Kiowa Indian tribe who were destined to be the pioneers of Plains Indian artists.

Susie Peters became progressively interested in art instruction. She was convinced that Indians possessed "inherent" artistic talents and that the value of Indian tradition could have an important influence on the dominant white culture. These attitudes, idealized and romantic though they may have been, were nonetheless exceptionally progressive for a period when many whites, in keeping with official government policy, were doing everything possible to eradicate Indian culture.

Susie Peters was a remarkable teacher. Her absorption in Indian life was not analytical as it was in the case of Fewkes, nor motivated by Hewett's purely aesthetic admiration of Indian art. She had certain social ideals in mind, especially in regard to the policy of the Administration of Indian Affairs (as the B.I.A. was known in those days) which banned all teaching of art to Indian children or any instruction in their native culture. She was a devoted believer in art in education, especially in relation to Indian children who were often more gifted in drawing than in reading and writing English. But her extraordinary lack of ethnocentricity was not well rewarded. Those who judged a child's ability to

read and write in a lovely hand as vastly more important than artistic talents disapproved of Susie Peters. She was assigned to give general training in home economics to Indian women — an education well suited to the government insistence upon turning Indians into housewives and clerks.

She did not let her official position deflect her primary interest in Indian art. In 1918 she made arrangements for a Mrs. Willie Baze Lane of Chickasha to come to Anadarko to teach art to Indian children. These classes, which lasted only three or four months in all, were conducted unofficially. The students included artists-to-be Monroe Tsatoke, Stephen Mopope, Spencer Asah, James Auchiah, and Jack Hokeah. Mrs. Peters paid for the private lessons with her own funds and continued staunchly to encourage her protégés, who became the original "Five Kiowa Artists," the founders of a dominant style of Indian art.

Susie Peters and Sister Olivia of St. Patrick's Mission School, where young Indians had been encouraged to draw as early as 1892, worked together and somewhat interested the Anglo community in their art students. Around 1923 Susie Peters tried to gain academic training in art for her students at the University of Oklahoma in Norman. There was, however, no provision for scholarships for Indians and the five Kiowas did not have the necessary scholastic prerequisites for regular enrollment. Finally the group was admitted with the help of Father Aloysius Hitto of the St. Patrick's Mission School, who brought their work to the attention of Professor Oscar B. Jacobson, head of the school of art of the university. The first Indians to obtain university training in art were Jack Hokeah, Spencer Asah, and Monroe Tsatoke, who were taken to the university by Susie Peters in 1926. Stephen Mopope arrived later, roaring up in his Model T Ford. James Auchiah and the lone girl in the group, Louise Smoky, joined the artists in 1927. All these artists were rather mature by college standards, in their early to late twenties. Two of them, Auchiah and Tsatoke, were married and brought their wives with them.

In 1927 Jacobson organized a traveling exhibition of their work and sent it to the First International Art Exposition in Prague, Czechoslovakia. A portfolio of serigraphs based on the exhibition was published in France in 1929. Indian artists were beginning to be known internationally.

Jacobson and his assistant, Edith Mahier, looked after the Kiowas with deep concern and interest. They set them up in a room in the art department where they painted in relative privacy but at the same time encouraged them to mix with the Anglo art students. Little effort was made, however, to direct them toward formalized European art. Although they studied composition and anatomy to some extent, the main advantage of their classes was the availability of first-rate materials and the freedom to learn to use them imaginatively.

The Indian artists were not isolated from their tradition. As Arthur Silberman, an outstanding commentator on Plains Indian art, has pointed out, they had many opportunities to become acquainted with the elements of Indian art all around them. The Ghost Dance, with its special symbolic imagery painted on clothing, was still being performed as they were growing up. The peyote religion with its designs and color visions was prevalent in Oklahoma. And there were the old people who had skill in drawing both on paper and on hide in the style of the ledger drawings. During the childhood of the Kiowa Five, a new tribal calendar was being kept, with drawings that depicted the significant events of each year. The young artists sought the company of the old ones and listened eagerly to their stories by the hour. These Indians, who came from families distinguished for famous chiefs and holy men, were legitimate heirs to a long and rich tradition of ceremonial knowledge and designs.

The Indian tradition was to be found not only in their past but also all around them. Among them were fine singers and skilled dancers who took an active part in the social and ceremonial life of their people. They were also part of the inner circle, members of honor societies: *O-ho-ma,* as well as the Gourd Clan, *Ton-kon-go,* and *Tia-pia;* some also became active in the Native American Church which surrounded its quasi-Christian ceremonies with vision-quest rites associated with the hallucinogenic drug peyote.

The paintings of the Kiowa Five were largely inspired by a nostalgic attitude toward ceremonial dances, such as the War Dance, the Dance of the Dog Soldiers, the Eagle Dances, and the Hoop and Feather Dance. The peyote cult also figured as an important source not only of symbols (the waterbird, peyote fan) but of color visions. Peyote is an hallucinogen which when ingested evokes brilliantly colored images. In association with the teachings of the peyote cult — which combines Christian and pre-Christian rites — the hallucinations are often related to ascending colors, the waterbird streaking into the sky, and the aura of some ultimate heavenly secret which is revealed through geometric design. Various efforts to revive the pre-Anglo past played a large part in the thrust and subject matter of Kiowa art: war and hunting parties; figures out of legend, ritual, and messianic dreams; flutists, drummers, and the singers of old songs — all of these elements of Indian life welled up in the paintings of the five young Kiowas at the University of Oklahoma.

There is an immediately apparent difference between the paintings of the Southwest artists and those of the Plains Indians: the Kiowa art was highly coloristic and emphatically interested in motion even when the ability to depict it was primitive, as with Jack Hokeah. Although the strong color suggests a highly decorative motive, in the best of the Kiowa paintings color was the foundation of compositional integrity. Strong color was a means of relating lines and masses so the elements within a single figure became interrelated, and subjects within small groups of

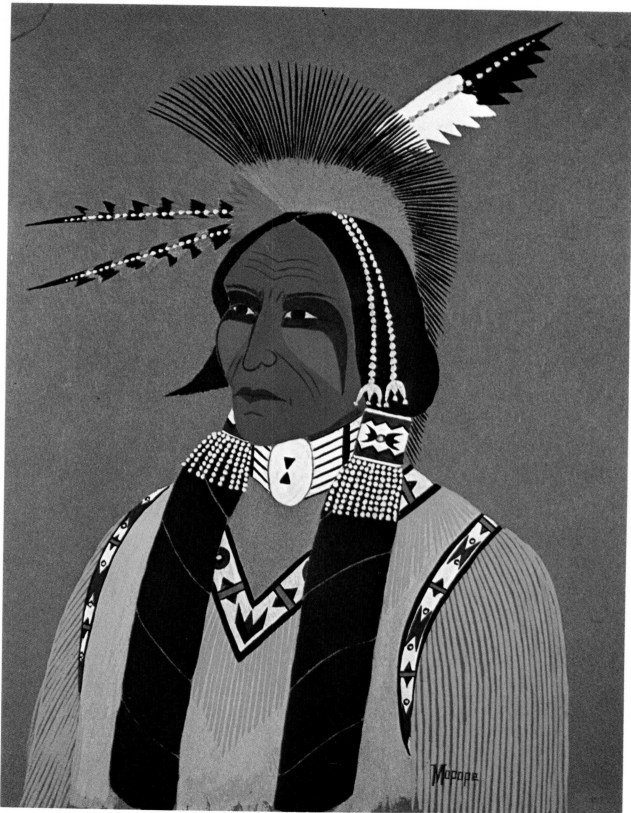

Stephen Mopope, Kiowa. Portrait, 1928. Casein on paper. Courtesy private collection. Mopope, one of the original Kiowa Five, was a painter and dancer throughout his life. At his best, as in this fine portrait, he is among the greatest American Indian painters. The color, in particular, and the formal structure depart entirely from illustration. The impact is not unlike the combined qualities of theme, color, and form that are balanced in the pseudo-primitivism of Gauguin.

figures merged in terms of harmonious hues and in terms of related line and balance of masses. This is marvelously apparent in a painting like Tsatoke's rendering of two robed and seated figures entitled *Kiowa and Comanche.*

It is unique to Kiowa and later Plains painting that small groups and single figures are emphasized rather than large ceremonial compositions. Some of the best Kiowa work portrays seated and rear-view figures, as well as portrait-style heads, subjects rarely found in the paintings of other tribes.

There is a certain similarity in the works of Mopope, Auchiah, Hokeah, and Asah. Mopope moved from rather mundane paintings to extremely controlled and expressive works; his was an uneven style that emphasized emotion. Auchiah had a more consistent output of very strongly colored paintings which often lack the grace of the best of Mopope's work. Hokeah tended to paint rather stiffly, so much so that his work has been compared to the bold line and simplicity of detail of Mexican codices. The rigidity of this style verges on stenciled monotony, which is startlingly ornate at its best, and brashly decorative at its worst.

Tsatoke was unquestionably the master, standing apart in his highly sophisticated individuality. His paintings possess the kind of precision and depth which is seen in the primal imagery of Paul Gauguin: a curiously unreal realism, a pervasive sense of mystery arising out of the simplest detail, and an extraordinary sense of color which, though the hues are familiar, blends to create an entirely unexpected and vivid harmony. Tsatoke was an Indian painter whose work would astonish us if we saw it without the least information about his race, training, tradition, or place in history.

Around 1929 four of the Kiowa Five were commissioned to paint the murals for the memorial chapel to honor Rev. Father Isidore Richlin at St. Patrick's Mission. Though the quality of the drawing is not mature, it is one of the first important community projects in America involving Indian artists. The artists donated their efforts. In the northwest corner the first of the eight panels depicts the arrival of Father Isidore in Anadarko on September 8, 1891. Jack Hokeah reported that the artists worked on four scaffolds. Each scene was painted on a piece of celotex approximately 22 inches wide by 57 inches long. There is little documentation about these murals, although it is generally assumed that the painting was done while the artists were students at the mission school. This is not true. They were in the last year of their special studies at the University of Oklahoma and returned to execute the murals at the mission school where Father Isidore had been their first and most enthusiastic critic and teacher. The murals remained in place in the memorial chapel until 1968 when the building was demolished and the panels were donated to the Indian Arts and Crafts Board's Southern Plains Indian Museum in Anadarko where they may be seen today.

James Auchiah, Kiowa. Beadwork Designs, *1921. Watercolor on paper. Courtesy private collection. Auchiah joined the Kiowa Five in their special classes at the University of Oklahoma in the fall of 1927. This study for beadwork was painted while he was under the tutelage of Susie Peters. The actual beading was carried out with imported seed beads which Plains Indians started using about 1675 when introduced by European traders.*

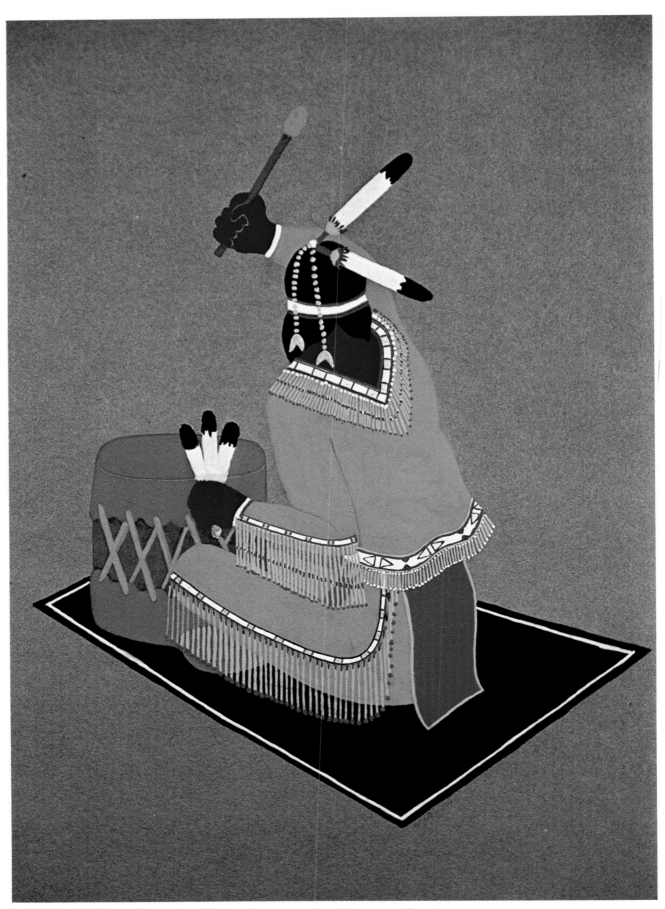

Jack Hokeah, Kiowa. Drummer. *Watercolor on construction paper. Courtesy Oklahoma State Historical Society, Lew Wentz Collection. Probably the best painting by Hokeah, the most compositionally and coloristically imaginative and the least illustrative of his works.*

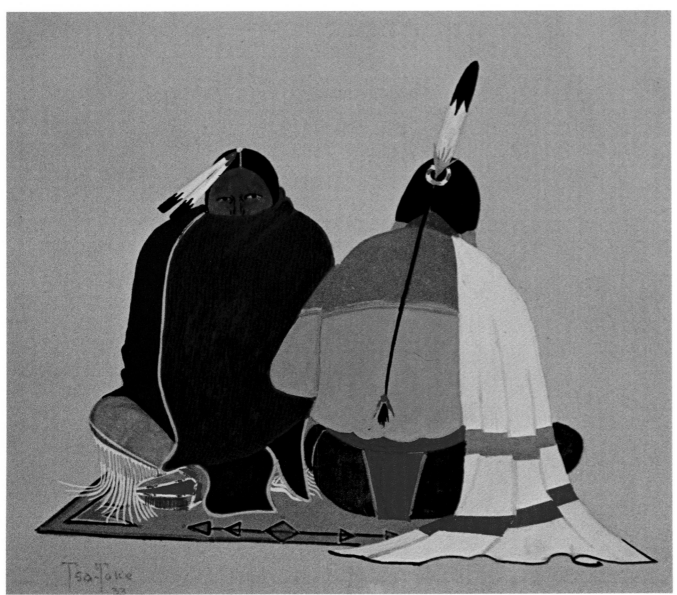

Monroe Tsatoke, Kiowa. Kiowa and Comanche, *1933. Casein on paper. Courtesy private collection. It would be difficult to find a work that more perfectly epitomizes the virtues of Indian painting than this masterful composition of color and line by Tsatoke, one of the Kiowa Five. Of all Traditional artists his work is probably the most consistently refined and masterful. He took great delight in his art and painted the things he knew firsthand, though there is nothing merely illustrative in his paintings. While seriously ill with tuberculosis, he joined the peyote faith, becoming a member of the Native American Church, and began a series of paintings expressing his religious experiences. He loved to sing and was for many years a chief singer at Kiowa dances.*

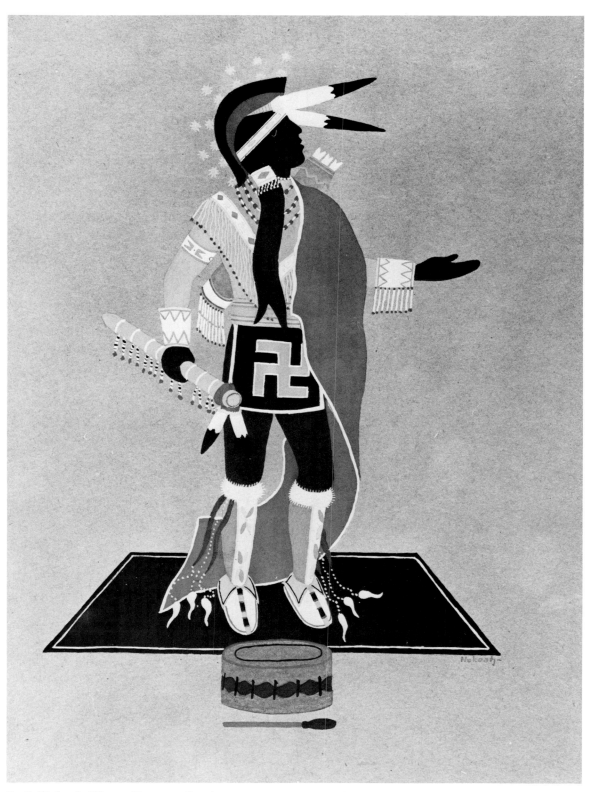

Jack Hokeah, Kiowa. Dancer. Casein on paper. Courtesy Oklahoma State Historical Museum. One of the original Kiowa Five, Hokeah was not as refined in his painting nor as seriously involved in art as a way of life as his colleagues. His work contains elements of the so-called stencil style, which was the Kiowa Five's weakest artistic mode and which many critics denigrate because of its purely decorative accent.

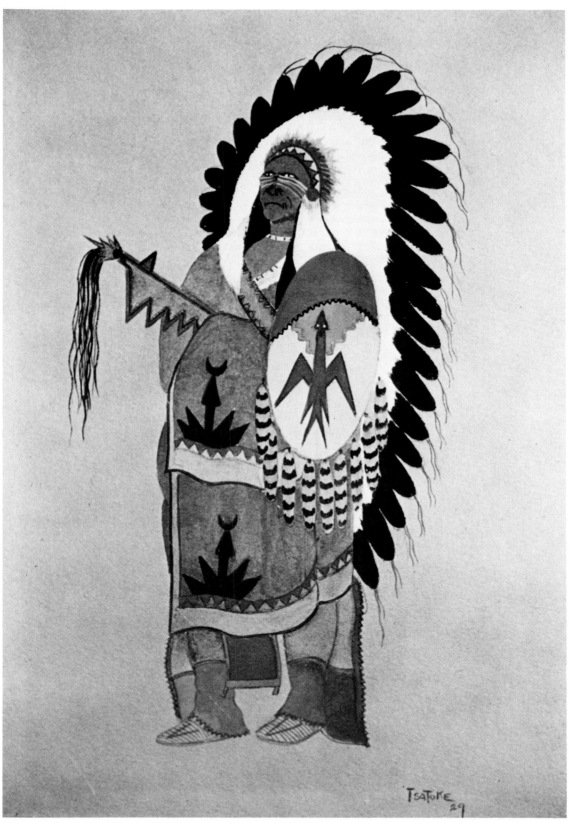

Monroe Tsatoke, Kiowa. Old Hunting Horse, *1929. Tempera on paper. Courtesy Museum of Art of the University of Oklahoma. Another painting by Tsatoke, this time slightly illustrative in the fashion of heroic portraiture, but hardly less accomplished in the use of color and the formal realization in terms of line and planes.*

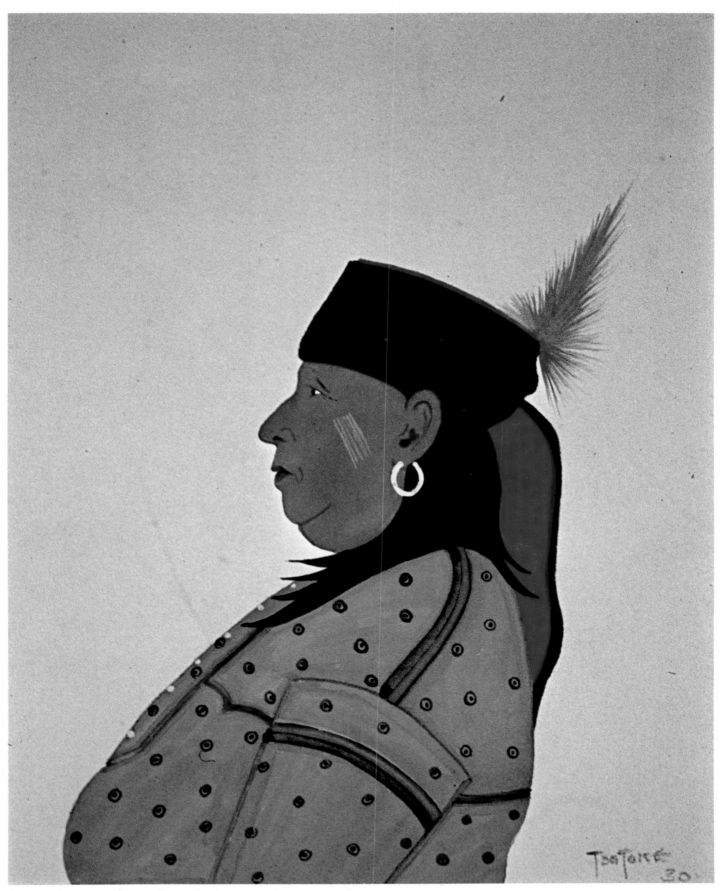

Monroe Tsatoke, Kiowa. Osage Indian Portrait, ca. *1921. Casein on paper.*
Courtesy Museum of New Mexico. This portrait departs from the heroic mode
and instead tends to recall the genre paintings of Frans Hals, Brueghel, and their
sixteenth-century Flemish contemporaries. It is unlikely that Susie Peters,
Tsatoke's teacher, was even aware of such folkloric masters of European painting,
but the mood of this fine portrait achieves a similar mastery normally outside the
realm of Indian painting.

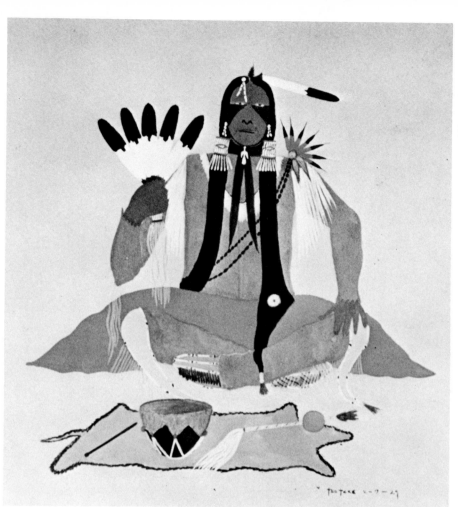

Monroe Tsatoke, Kiowa. Member of the Peyote Clan. *Casein on construction paper. Courtesy Oklahoma Historical Society. Tsatoke reveals his mystic conversion, after an illness, to the peyote cult in this formal painting of the peyote chief, the ritual fan, rattle, and water-drum.*

Acee Blue Eagle, Creek-Pawnee. Man with Fan, ca. 1931. *Casein on paper. Courtesy private collection. Though not a member of the Kiowa Five, he studied with their teacher, Jacobson, at the University of Oklahoma and worked, early in his career, in the Kiowa manner, as evidenced by this little portrait of a shy gentleman with a fan.*

Spencer Asah, Kiowa. Asah Dancing. *Casein on paper. Courtesy private collection. Another of the original Kiowa Five, Asah divided his time between farming and painting. He was an expert dancer and many of his works depict the dances of the Plains tribes.*

While the Kiowa Five were in high school, about 1920, the artists of the Southwest and those of the Great Plains became aware of each other for the first time. Hearing of the developments in New Mexico, Susie Peters visited San Ildefonso Pueblo to see for herself what the painters were doing. Fred Kabotie remembers meeting her and showing her his work. Afterward she arranged several trips for the Kiowa Five to the annual Inter-Tribal Ceremonials in Gallup, New Mexico, where they promoted and displayed their works.

Around 1930 Jack Hokeah went without his fellow artists to Gallup with a dance troupe. After his work as a ceremonial dancer was completed, he traveled to Santa Fe to attend a fiesta and there met the famed potter Maria Martinez and wound up staying with her as an adopted son for ten years.

6. THE FOUNDING OF THE STUDIO IN SANTA FE
Institutionalism Begins

JACK HOKEAH'S SOJOURN IN NEW MEXICO COINCIDED WITH A MAJOR development in the evolution of Indian art education: the founding of The Studio in Santa Fe. Many of the Anglo residents of Santa Fe had become deeply involved with Indian painting during the 1920s. For instance, in 1923 a group organized itself as the Indian Arts Fund with the purpose of collecting and preserving southwestern Indian arts, including painting. Then, in 1932, a group of artists was commissioned to paint murals on the walls of the Indian school in Santa Fe. Late that same year Dorothy Dunn founded an experimental studio in that same Santa Fe Indian School where she guided forty young students in art instruction. Toward the end of the 1920s, she had been an Indian Service teacher at the Santo Domingo Pueblo Day School near Santa Fe. She was an adventurous teacher who used art as an aid in teaching English; at the same time she looked upon art as more than a method of illustrating lessons. She also hoped to use it to create respect among her students for their own cultural traditions which were much neglected in schools for Indian children prior to the Reorganization Act of 1934. Then she left the Indian Service and returned to Illinois in 1928 to complete her own formal education at the Chicago Art Institute.

A government report of 1928, called the Meriam Report, grew out of the increasing Anglo concern for the poor results of white-Indian relations. Part of that report recommended a fundamental change in government attitude toward training Indian children in their native arts. The Santa Fe Indian School became the first center where arts and crafts were taught. There was, however, no training in Indian painting. Here is

where Dorothy Dunn returns to the picture. She was determined to establish a studio devoted to native painting and, after graduating from the Chicago Art Institute, she arranged to see Superintendent of Indian Affairs Chester E. Faris in Santa Fe and outlined her plan to him. As a result of their mutual efforts, on September 9, 1932, a new painting studio opened in the Santa Fe Indian School. Here Dorothy Dunn remained until 1937, becoming the single most influential teacher for an entire generation of Indian painters. The Studio — headed by a non-Indian — was the first federal recognition of Indian painting.

The Studio soon became a center for ideas and projects. Olive Rush, a non-Indian artist, assisted in the 1932 mural project at the Indian school in Santa Fe. Jack Hokeah had also been invited to participate in that project. So The Studio brought together Dunn, Rush, and representation from both the Kiowa Five and the Southwest painters. The Studio also boasted the enrollment of Plains Indians who eventually achieved considerable fame: Oscar Howe, Cecil Dick, and George Keahbone.

Both Olive Rush and Dorothy Dunn did much at The Studio to encourage the art students as did another teacher, Lloyd Kiva New (Cherokee), who was then engaged as a teacher at the Indian school in Phoenix.

Few artists from the Plains tribes attended The Studio, but thanks to intertribal exchanges and the increasing travel of Indians from one powwow to another, the Indian painters in Anadarko were well aware of artistic developments in Santa Fe, which became a spiritual center for Indian painters. Many of the Pueblo artists resettled in the small city which was already famous for its colony of Anglo intellectuals. (The American heiress Mabel Dodge had by this time married her fourth husband, Tony Luhan, an Indian of Taos Pueblo. There is evidence of her enthusiasm for Indian painting, although no specific artists seemed to have won her patronage.) A tradition of painting evolved quickly in Santa Fe, fostered by the new school and by the presence of some of the older painters like Awa Tsireh, Julian Martinez, and Velino Herrera.

The tradition of The Studio came out of historical factors, some quite realistic and others frankly romantic in the fashion of the "Noble Savage." It has been suggested that the Santa Fe Studio was a one-woman school that should have been a first step in a student's training, but for the most part was the only training young Indian artists of the period received. The notion of what an Indian painting should or should not be is a subject which constantly comes up in the interviews (Chapter 9) with the now-famous artists who were directly or indirectly associated with The Studio. Another influence merged with Dunn's to formulate The Studio attitude about Indian painting. In the mid-1930s seventeen layers of wall paintings were recovered from the prehistoric Pueblo site at Kuaua (Coronado State Monument), New Mexico. This was the first time that anything approaching a complete pre-Columbian Pueblo

Harrison Begay, Navajo Weavers, *1938. Watercolor on illustration board.
Courtesy Philbrook Art Center, Tulsa. Easily the best known of the Navajo
painters, Begay was a prominent member of Dorothy Dunn's Studio classes in
Santa Fe. This classical depiction of the Navajo upright loom with its
quasi-oriental mood is among the artist's most distinguished and personal
paintings. The Navajo are still the most accomplished weavers among Indians,
and so Begay's homage to his tribe's craftswomen is most appropriate.*

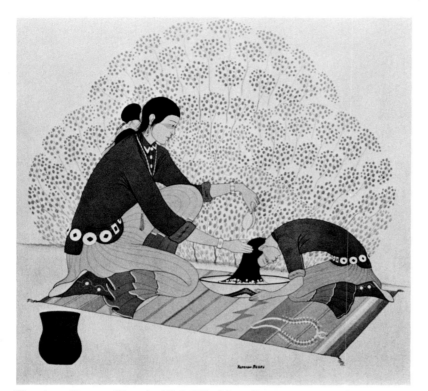

*Harrison Begay, Navajo. Hair Washing. Opaque watercolor on paper.
Courtesy Philbrook Art Center, Tulsa. Another example of Begay's
concern with daily activities on his Navajo reservation in Arizona,
this painting is perhaps the best of his genre works, most subtle in
coloration, effective in design, and uncluttered with stylized motifs.*

painting was actually seen. The rediscovery had an immediate and
dramatic effect on the teachers and students at The Studio. By 1937
the character of Dunn's visual theory was firmly set: disciplined brush
work, particularly a firm and even contour line; the flat application of
opaque, water-based paints; and the lack of shadowing except for the
barest sculptural detail. The murals also suggested the use of nonspecific
backgrounds, modified perhaps by a cloud terrace or some other land-
scape motif that gave a semblance of reality.

Until now San Ildefonso artists had dominated Pueblo painting just
as Kiowas had risen into a special position of achievement among the
Plains painters. The Studio, however, was a stage for the Navajos. Of
the twenty-nine significant painters from thirteen tribes trained at The
Studio, seven were Navajo. Four of these — Harrison Begay, Gerald
Nailor, Quincy Tahoma, and Andrew Tsinajinnie — painted and sold
more pictures than all of the other Studio alumni combined.

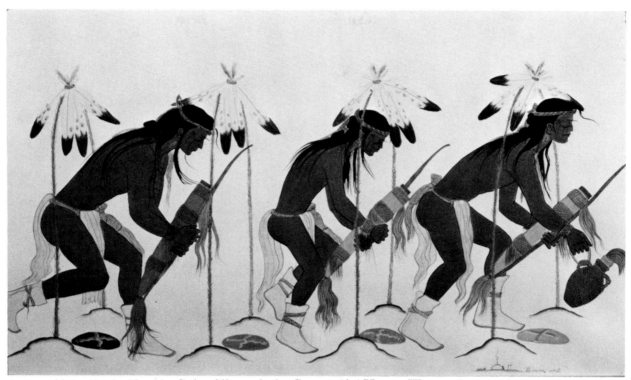

Andrew Tsinajinnie, Navajo. Going Through the Ceremonial Hoops. *Watercolor on paper. Courtesy Philbrook Art Center, Tulsa. At five, the artist asked his mother to buy him a pencil at the trading post, and he began to draw on wrapping paper and the backs of tin can labels. Since 1940 he has been an important Navajo painter, known for his "color periods"—blue, pink, etc. He is a musician as well as an artist.*

Of this early Navajo group, Begay was the most productive and also the most contradictory. His paintings for tourists, which he turned out at a terrific pace, were the epitome of Disney-like cuteness, and they created the widespread impression that Indian painting was sentimental, commercial, and purely decorative. But to judge Begay by these works is much like judging Picasso by the things he obviously did for the market. In Begay's painting at its best there was an impeccably rendered ceremony, a stillness and gentleness reminiscent of Japanese landscape prints.

Andrew Tsinajinnie had a distinctive style; his human figures were painted with a formal boldness which brought to mind the African influences on Picasso's primitive period. His flesh colors were often ruddy, and he was inclined to crowd the surface with figures which barely fitted into the perimeters of the background. His work was as paradoxical as Begay's, by turns rather banal and finely artistic. His

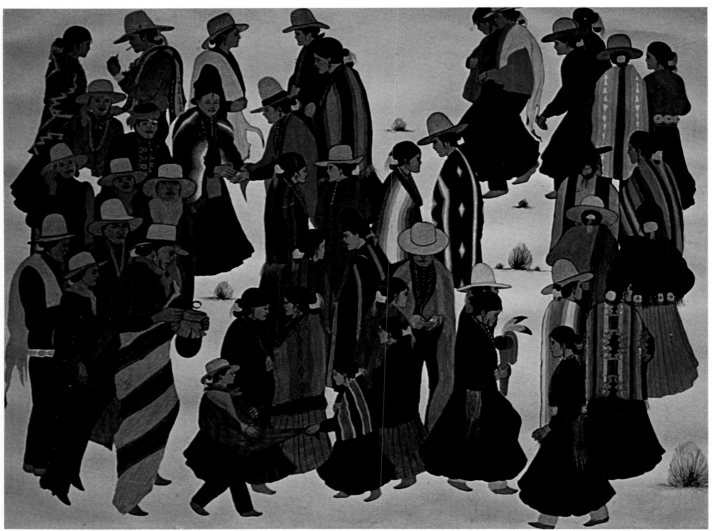

Andrew Tsinajinnie, Navajo. Navajo N'Da-a, 1938. Courtesy Dorothy Dunn and the Museum of New Mexico. As Dorothy Dunn explained to the author: "This is Tsinajinnie's marvelous big N'Da-a. He was one of the very first students at the Santa Fe Studio, and [is] still a fine and exciting painter, muralist and illustrator of Navajo tribal books." This handsome depiction of the ceremonial dance is one of the artist's most impressive works, with exquisite detail in the costumes and bright pastel tones.

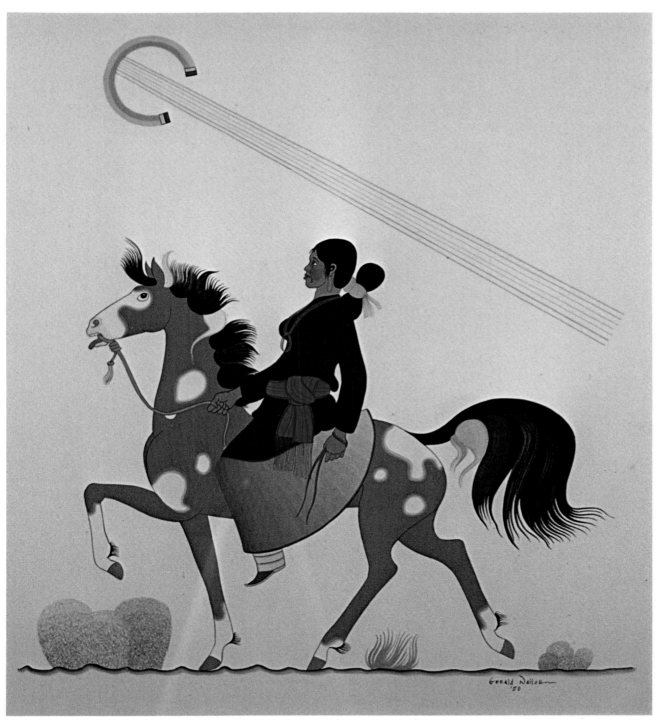

Gerald Nailor, Navajo. Woman on Horse, 1950. Watercolor on paper. Courtesy private collection. Nailor was one of the foremost Navajo painters, with a distinctive and inventive style. His subjects usually combined symbolic motifs (sun symbols, cloud symbols, etc.) with aspects of Navajo daily life.

most impressive paintings depicted ceremonial life and captured the rugged beauty of the vast Navajo country and its remote people.

Both Quincy Tahoma and Gerald Nailor were exceptional creators of Navajo painting. Tahoma in particular has had a strong influence on later Plains painters, from Blackbear Bosin to Rance Hood and his many imitators. Until his death in 1956, Tahoma's career vacillated curiously from facile, decorative serenity to ferocious turbulence and near violence. The motion in his paintings of around 1946 was so agitated that it provoked him to devise a "distorted" style. His painting depicts movement as if the surface were a motion picture in which action is convincingly conveyed by a series of static images. Eventually this superdramatic effect was further developed by Bosin and Hood, but in Tahoma it comes entirely unexpectedly out of his early paintings of pastoral scenes and orderly ceremonial patterns. To viewers who think of Indian painting as placid and ritualistic, Tahoma may seem unnecessarily brutal, but what they overlook is the fact that he was not interested in the expression of beauty but in the power of expression. His paintings are not brutal in the least; they are bursting with an expressionistic recreation of the Indian world not as it is "seen" but as it is felt.

Gerald Nailor's work was the most suave and decorative of early Navajo art. His sense of style, which precluded naturalism, resulted in polished, proud, and handsome recreations of deer or of women on horseback as pure design. He created plant forms and reinterpreted small figures and abstract motifs from sand paintings, placing them above and below his main figures. The end result is consciously beautiful in a manner not found elsewhere in Indian painting. Nailor's paintings express a notion of dignity which seems profoundly and uniquely Indian.

The two most impressive Apache artists to attend The Studio were Ignatius Palmer and Allan Houser. Palmer possessed a distinctive sense of line and produced angular figures in a background of serenity. The figures in his paintings seem caught in the midst of an action, still alive and warm.

Houser states that he was a bit of a rebel at The Studio, inclined to go his own way despite Dorothy Dunn's personal ideas about Indian art. As a Chiricahua Apache with a rich knowledge of his own tribal tradition, his paintings were conscious and intelligent in a manner not quite like other Indian works that reflected Dunn's values. Gradually he turned from painting to sculpture. His professional post today at the Santa Fe Institute of American Indian Arts centers on sculpture, but he still paints and has hopes of realizing some large-scale projects in painting.

Of the Sioux painters at The Studio, Oscar Howe was the most outstanding. A Yanktonai born on the Crow-Creek reservation in South Dakota, he was becoming much admired as a Traditionalist of the Northern Plains. In his early works, hunters and warriors of the North

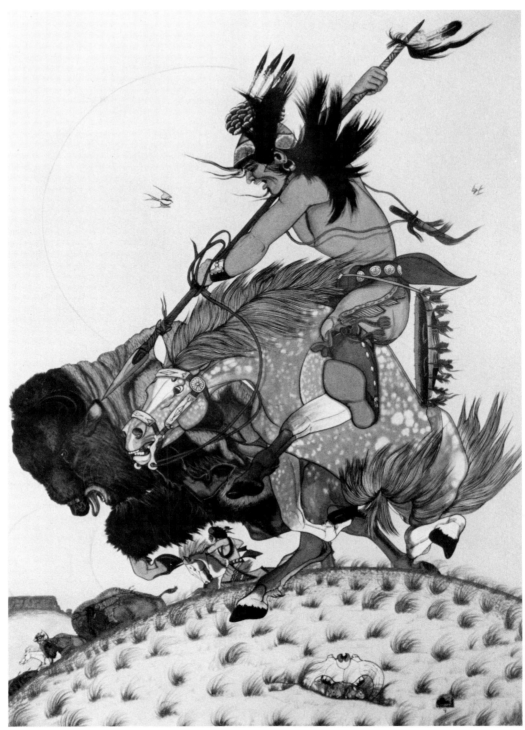

Quincy Tahoma, Navajo. In the Days of Plentiful. *Watercolor on paper.
Courtesy Philbrook Art Center, Tulsa. From an early career of painting serene
landscapes and somewhat cute animal studies, Tahoma launched into a series
of dazzling paintings full of proud people and majestic horses in violent motion.
He soon broke away from the two-dimensional treatment characteristic of
Traditional painters and developed perspective and portraiture detail in which
faces reflect emotional situations and muscles are taut and poised for action.
Through this style he greatly influenced other Indian painters.*

Ignatius Palmer, Mescalero Apache. Woman Gathering Yucca, *1957. Opaque watercolor on paper. Courtesy Museum of New Mexico, Santa Fe. Palmer was born in 1921 and painted as early as 1939. His style has changed considerably in the course of his career. This painting is the most mature and refined of his works, unique in its muted colors and stylized landscape.*

Oscar Howe, Yanktonai Sioux. Victory Dance, 1954. Casein on illustration board. Courtesy Philbrook Art Center, Tulsa. Howe was the first painter to make a major departure from the Traditional style, while still a student of Dorothy Dunn at The Studio in Santa Fe. The influence of European cubism is apparent in his transitional work, which retains the mystic nature of his vision at the same time that it imparts an entirely unexpected experimental thrust to Indian painting. His later influence at the Institute of American Indian Arts on young painters can be credited with starting the Contemporary Indian art movement.

Oscar Howe, Yanktonai Sioux. Dance of the Mourners, ca. 1960. Casein on paper. Courtesy Museum of Northern Arizona. An excellent example of the means by which Howe departed from Traditional realism and imparted experimental concepts to his painting. The buffalo robes worn by the figures merge to form a single, symbolic robe covering all with the images of the one being mourned. The style hardly departs from standard Studio painting, yet Howe has discovered a means of converting The Studio's decorative precision into an expressed form that suits his own experimental purposes.

were of greater interest to him than Southwest dancers. He preferred a large surface, composing on big sheets of paper which provided a field for numerous galloping, varicolored horses in the fashion of Sioux hide painting, but with infinitely finer detail and more stress on naturalistic representation. Howe's importance, however, lies in his highly individual experiments in the 1950s with cubism and a bold palette. This departure from Traditional art has been dimmed by a succeeding generation of experimenters, but in his day Howe was avant-garde both as artist and as teacher at the University of South Dakota, Vermillion. There is hardly a master or student of Indian painting who does not respect him. "At first I couldn't understand a thing he was doing," Archie Blackowl told me. "I'm a strict Traditional painter and I thought Oscar had gone off the deep end. But I'll tell you something — he can talk to you about his painting and you begin to see exactly what he is doing and why he's doing it."

What is central to all of Howe's late paintings is the exercise of a highly personal expression which grows clearly, even pictorially, out of the Traditional style. He was attracted to the surrealist-cubist compositions of European painters and of their American counterparts, the action-painters Adolph Gottlieb, Mark Tobey, and Robert Motherwell, for good reason. What he learned from them he used in an ideal Indian manner: the conveyance of a sense of mystery and a curiously supernatural expression of movement. Just as his early works capture superbly a sense of legendary lives, his later paintings instantly communicate the rich impossibilities of dreams: mystery and motion as a visual experience.

Cecil Dick, a Cherokee, was the most renowned Woodland Plains Indian at The Studio. His paintings were uneven, but at best they combined the impact of richly colored legends with the keen theatricality of a dramatist.

The Pueblo were represented by four important painters: Ben Quintana, Pablita Velarde, Pop-Chalee, and Joe H. Herrera.

Quintana, of Cochiti Pueblo, had a unique gift which was apparent even at twelve, when he painted ceremonials with enough talent to rival the work of masters of Pueblo art. He was killed in combat in World War II when only twenty-one years old. One of his most pleasing paintings is a single ceremonial dancer on the facade of the massive souvenir shop called Maisel's, in Albuquerque.

One of the best-known Indian painters is Pablita Velarde of Santa Clara Pueblo. Her wide-ranging subject matter developed from representational studies of her village to include influences from other tribes and, especially, from the prehistoric relics of the Southwest. At The Studio she was introduced to the use of native earth colors which became, much later, her medium for *fresco secco*. In her depiction of abstract motifs adapted from ceramic designs, murals, and similar prehistoric sources, she employed these natural paints to their best advan-

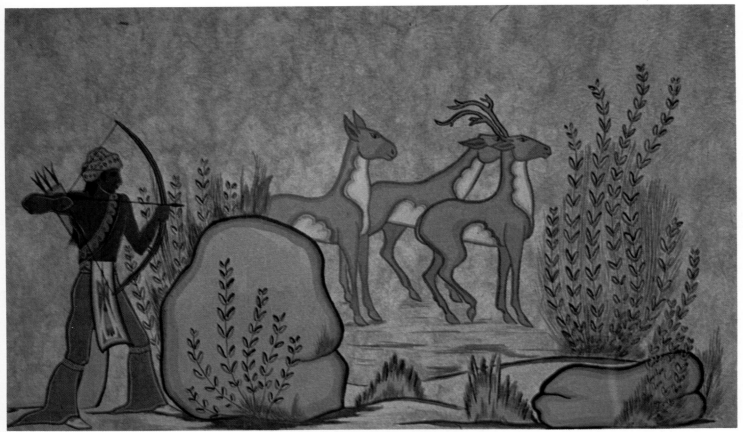

Cecil Dick, Cherokee. Deer Hunt. Watercolor on paper. Courtesy Philbrook Art Center, Tulsa. Cecil Dick's work is a blend of the decorative and formalistic impact of Dunn and The Studio in Sante Fe, and the Bacone School, where he also took art classes. The influence of Woody Crumbo is particularly apparent in this finely drawn muralistic painting.

Ben Quintana, Cochiti Pueblo. Figure, 1939. Mural in casein tempera. Maisel Building, Albuquerque. Quintana had a technique perfectly suited to ceremonial dance figures such as this one from the façade of the famous arts and crafts shop in Albuquerque, Maisel's, for whose walls a number of The Studio artists were commissioned to design and paint murals. Quintana died before he could achieve fame as a painter.

Pablita Velarde, Santa Clara Pueblo. Green Corn Dance, 1956. Opaque watercolor on paper. Courtesy Philbrook Art Center, Tulsa. One of Velarde's most interesting accomplishments in a series of paintings that illustrates aspects of the daily life of her village. Authenticity is a prime virtue in this series: proper costume detail from hairdo to moccasin.

Joe H. Herrera, Cochití Pueblo. Zuni Comanche Dance, ca. 1950. Casein tempera. *Courtesy Museum of Northern Arizona. A strictly Traditional painting, typical of Herrera's early Studio style.*

tage. She often took materials for some of her best representational paintings from Tewa mythology and legend.

Another woman painter is Pop-Chalee, whose art is rather fanciful and decorative compared to Velarde's strong portrayal of Santa Clara Pueblo life. Born in Taos, Pop-Chalee began her career at The Studio and has been much in demand since the 1930s, when she worked in Santa Fe and Scottsdale.

In the fifth year (1936) of Dorothy Dunn's program at The Studio, a very young man, Joe H. Herrera of Cochiti Pueblo, the son of the pioneer Pueblo artist Tonita Peña, was singled out by his teacher for achieving authenticity in his drawings of ceremonial subjects. "His work," Dorothy Dunn explained to me in one of her gracious letters, "was unlike that of his renowned mother, for his was coolly decorative where hers was warmly natural." That mode of painting was to change radically for Herrera as he continued his studies at the University of

Joe H. Herrera, *Cochití Pueblo.* Eagles and Rabbit, *1952. Casein tempera. Courtesy Philbrook Art Center, Tulsa. Under the tutelage of Raymond Jonson of the University of New Mexico, Herrera evolved an entirely new style from the Traditional he learned at The Studio under Dorothy Dunn. It was clearly influenced by European cubism and art deco. Herrera's methods, using casein tempera in a natural-toned palette and a combination of spray and brush application, were totally unfamiliar to Indian painting. Several other Indians have experimented in the same style, including Pablita Velarde, Helen Hardin, and Tony Da.*

New Mexico under Raymond Jonson, a non-Indian teacher and painter with a strong cubist inclination. As a result of his own evolution and the influences of the university, Herrera won renown for his personal style when he held an exciting one-man show at the Museum of New Mexico in 1952. This style was an abstract presentation of antique symbols, taken largely from petroglyphs and pictographs of the Southwest. Coupled with the impact of the prehistoric *kiva* murals which Fred Kabotie had reproduced in 1941, the Herrera idiom immediately became the basis for a new trend among Indian painters, including Pablita Velarde, her daughter Helen Hardin, and Tony Da.

With the success of the show, Herrera received an invitation to exhibit at the Museum of Modern Art, which made him one of the first Indian painters to gain recognition for successfully changing from the Traditional style to the mainstream of Anglo art. Herrera spoke to Dorothy Dunn about his work the year of his show. "My studies in anthropology,"

Raymond Naha, Hopi. Koshare and Watermelon, 1968. Pencil on board. Courtesy private collection. Naha displays a brilliant sense of irony in this sketch of the ceremonial clown of the Hopi, which recalls such European stylists as Félicien Rops and Heinrich Kley.

he explained, "have accented my natural leanings to a more symbolic expression of the aesthetics of my culture."* So he abandoned the deliberate traditionalism of Pueblo art as it was understood at The Studio and gave himself, with Jonson's influence, to the visual theories of Kandinsky, Klee, and the analytic cubists. His paintings were intended to bridge two cultures, to convey to whites something fundamental about Indians. It has been suggested that he failed in this aim because his symbols had no iconographic significance for white viewers. But it is doubtful if the symbols of Klee, Kandinsky, the metaphysical painters, or the surrealists have any more real claim to "universality" than those of Herrera. What these white painters possessed that Herrera did not was a power to astonish the onlooker so that a mysterious painting becomes not a decoding book of mysteries but an active metaphor which unto itself is both mystery and revelation.

* Dorothy Dunn, "The Art of Joe Herrera," *El Palacio*, vol. 59, no. 12, 1952.

Raymond Naha, Hopi. Mixed Kachina Dance, 1970. Acrylic on board. Courtesy private collection. Naha, a Hopi-Tewa Indian, was born at Polacca, Arizona, in 1933, and attended Polacca Day School. His talent was encouraged through a year's study with Fred Kabotie, who teaches art at Oraibi High School, but he had no other formal training. The style shown here is distinct from that of the self-taught Kabotie: dark and theatrical in tone and composition. He is one of the few Southwest Indian painters who did not attend The Studio.

Raymond Naha, Hopi. Snake Dance, *1969. Acrylic on board. Courtesy private collection. The alternative style in which Naha paints is more in the manner of Kabotie, his teacher, but less formal and somewhat more active and realistic. The Snake Dance is the famous Hopi ceremony involving the handling of serpents as a tribute to the Great Snake who controls the waters of the world from his kiva.*

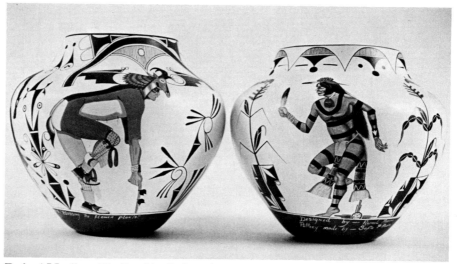

Rafael Medina, Zia Pueblo. Painted Pottery, *1972. Acrylic on pottery. Courtesy private collection. Medina was born in 1929 and studied under Velino Herrera and José Rey Toledo. He was not a product of The Studio but his painting, largely individual in mood, is nonetheless Traditional in manner. His koshare (the sacred clowns of Southwest ritual) are favorite subjects, depicted with a curious blend of realism and surrealism. He normally employed waterbased paints and caseins on illustration board and paper, but he began a set of extremely handsome painted pottery in the early 1970s which shows off his decorative style to great advantage.*

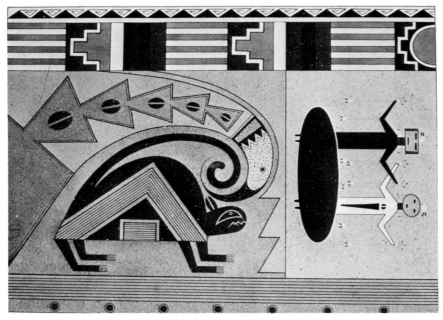

Tony Da, San Ildefonso Pueblo. **Symbols of the Southwest,** *1970.
Casein on paper. Courtesy private collection. Da was born in 1940, the
son of the artist Popovi Da and the grandson of Julian and Maria
Martinez, the famed painter and potter of San Ildefonso. He had no
formal training in art. His late abstract works (which, like this one, tend
to look like pottery decoration) are indebted to the styles of both Joe
Herrera, the first to use a cubistic manner in Indian painting, and to
Gilbert Atencio* (Wah Peen) *who developed an Indian variation of
art deco.*

Herrera stopped painting in 1958 at the peak of his success. According
to an informant of J. J. Brody: "He could only paint when his mind was
at ease . . . he was an Indian in Santa Fe and a White man at Cochiti."*
Few Indian painters who sign themselves to originality can survive the
schism of the worlds which instantly open before them: the intuitive,
traditional, and intellectual are paths which do not easily cross.

Dorothy Dunn had achieved a rather spectacular impact since 1932
when she founded The Studio. Feeling that the scheme for teaching
Indians to paint had been implemented, she retired in 1937. Though
The Studio persisted through the war years and thereafter, it declined
noticeably and produced no major artists after 1940. Eventually its very
buildings would be used for a new departure in the education of Indian
painters, the Institute of American Indian Arts, but for her day there is
no question that Dorothy Dunn had singlehandedly inaugurated and
institutionalized a concept of Indian art education. Her achievements
are best judged by the great percentage of celebrated artists who studied
at The Studio between 1932 and 1937.

* J. J. Brody, *Indian Painters & White Patrons* (Albuquerque: University of New
Mexico Press, 1971).

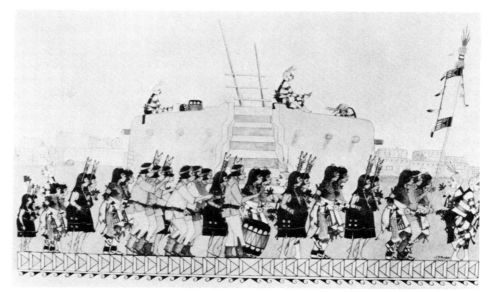

J. D. Roybal, San Ildefonso Pueblo. Corn Dance. Courtesy Red Cloud Indian Art Show of the Red Cloud Indian School, South Dakota. J. D. Roybal, a nephew of Awa Tsireh, started painting seriously rather late, not until the 1950s, though he was born in 1922. He is self-trained in the Traditional manner, but uses realistic and symbolic themes together in an individualistic manner and adds touches of humor. The color in this painting is finely controlled, from the warm hues of the pueblo and kiva walls to the rich and varied tones of costumes and ceremonial objects. The decorative band at the bottom of the painting calls to mind Roybal's famous uncle and recalls a comparable design feature in prehistoric kiva murals.

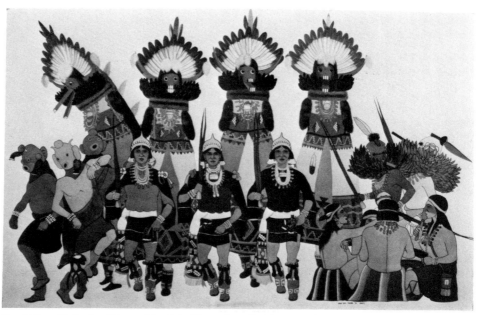

José Rey Toledo, Jémez Pueblo. Dancing Spirits, 1947. Courtesy Philbrook Art Center, Tulsa. Toledo was born in 1915 and was self-taught until he attended the University of New Mexico, where he received an A.B. degree in education. This painting, in the Traditional style, portrays a Zuni Shalako ceremonial dance. In the background are four very tall Shalako figures, the one on the far left bending out of line to break the monotony of the repeated figures and also to peck at one of the "heckler" Mudheads in front of him. Three Mudhead dancers are in the left-hand corner while three unmasked dancers are seen center with yucca whips.

7. THE BACONE PERIOD
Indian Art in Transition

In 1935, at Bacone Junior College of Muskogee, Oklahoma, a program in art was established. Three painters successively directed Bacone's art department over the next thirty-five years: Acee Blue Eagle (Creek/Pawnee), Woody Crumbo (Creek/Potawatomi), and Dick West (Cheyenne). The work of their students demonstrates the gradual evolution of the Traditional style toward an illustrative mode.

Blue Eagle, who had studied with O. B. Jacobson in the art department of the University of Oklahoma, helped to found the Bacone art department and was its chairman from 1935 to 1938. His style was direct and formal, stated in two dimensions. At their best, his works convey much of the winsomeness of the man himself.

Woody Crumbo, who succeeded Blue Eagle as department chairman, was one of the few painters who worked in the Kiowa manner after 1940, since the idiom was no longer in style. He had studied with both Susie Peters and O. B. Jacobson. Eventually he made the transition from Kiowa manner to that of The Studio, which was characteristic of the Bacone group: a combining of qualities from both the Kiowa manner and The Studio style into what has become the Traditional form of Indian painting among most Indians of Oklahoma.

Dick West, somewhat like the Comanche painter Leonard Riddles, is a pictorial historian who has devoted many of his works to an authentic and tribally approved depiction of Cheyenne tribal lore and activities. His style is somewhat flat and highly representative; at its best, it has the kind of complex genre composition (in multifigured landscapes) which recalls Brueghel. An illustrative, nostalgic, and romantic vision dominates Dick West's work — and represents the clearest and most consistent attitude among the Oklahoma painters from the time of Mopope to the present day.

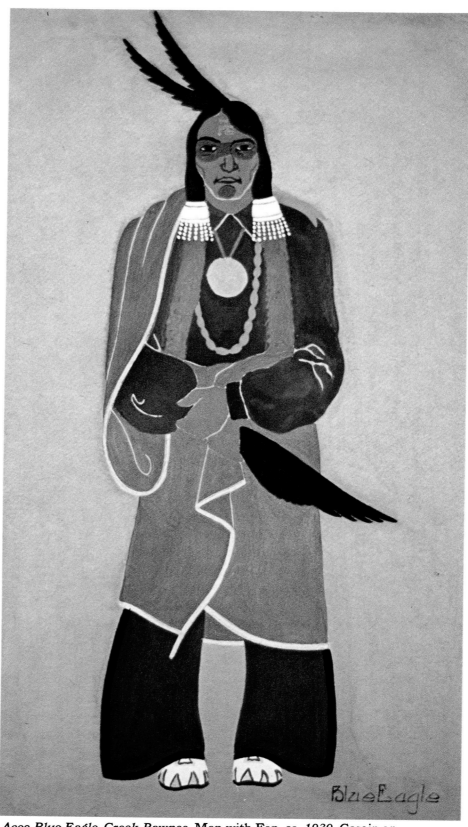

Acee Blue Eagle, Creek-Pawnee. Man with Fan, ca. *1930. Casein on paper. Courtesy private collection. Blue Eagle was a founder of the Bacone art department and chairman from 1935 to 1938. He had studied with Jacobson at the University of Oklahoma and worked in the Kiowa manner, having known all the famous Kiowa Five. He was extremely interested in authenticity and traveled throughout the United States and Europe researching Indian archives at museums.*

Dick West, Southern Cheyenne. Death and New Life. *Courtesy Philbrook Art Center, Tulsa. West, who studied under Blue Eagle at Bacone in 1938, became in 1950 the first Indian to earn an M.F.A. at the University of Oklahoma. He went on to become the chairman of the art department at Bacone. This painting is concerned, like most of his work, with documenting his tribal traditions. It is a stylized depiction of the burial of a warrior, in which the body, carried on the travois behind the horse, is placed atop the burial structure in the Plains Indian manner. Usually the warrior's horses accompanied him into death.*

Dick West, Southern Cheyenne. Winter Games. *Courtesy Philbrook Art Center, Tulsa. Several popular Indian games are pictured here: handball, in the lower left-hand corner; women's football; arrow throwing; wrestling; "swinging around the horn"; and shinny or "knocking the ball." The boys' sleds and toboggans are made from buffalo hide, or slabs split from trees. West often signed his paintings Wah-Pah-Nah-Yah, which is Cheyenne for "Light Foot."*

Woody Crumbo, Creek-Potawatomi. Peyote Ceremony. Courtesy Philbrook Art Center, Tulsa. Crumbo succeeded Blue Eagle as art department chairman at Bacone. There is no strict form of service in peyote ceremonies. The meeting is usually held in a tepee, and begins at sundown with the preparation of a crescent-shaped altar by the Road Chief and the kindling of a ritually laid fire by the Fire Chief. The altar may represent either the universe or the moon, depending on the cult. A line drawn the length of the crescent is symbolic of the Peyote Road.
In the middle of the altar, on a bed of sage, is placed Chief (or Father) Peyote, a peyote button of unusual size.

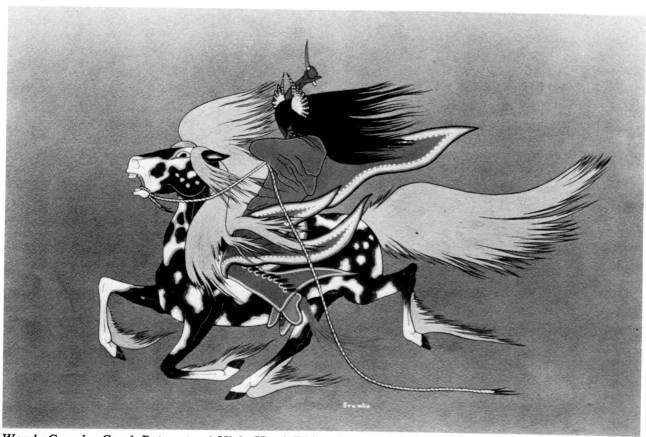

Woody Crumbo, Creek-Potawatomi. Night Hawk Rider. *Courtesy Philbrook Art Center, Tulsa. A warrior of the Night Hawk clan rides his spirit-horse to a mystic rendezvous with the "Great Spirit," covering his face before his deity. Curiously, the theme was suggested to Crumbo by a line from Exodus (3:6): ". . . and Moses hid his face, for he was afraid to look upon God."*

Archie Blackowl, a southern Cheyenne who began painting in the early 1930s, was influenced by the artistic mannerisms of both Crumbo and Blue Eagle. Although not officially part of the Bacone group, his style is so dependent upon their attitudes that his paintings are best discussed in connection with them. *Cheyenne Burial* — a favorite subject during his career — presents a clear example of how the later Kiowa style has merged into the dominant manner of The Studio. Blackowl also painted a series of portrait heads and peyote ceremonies, all with somewhat the same style: like theatrical flats in a stage setting, several planes of depth are placed in sequence one behind each other, providing a sense of perspective through overlapping planes. The figures are usually painted in intense colors on artboard (the favored medium in Oklahoma, while colored or white paper was — for no apparent reason — favored in the Southwest) and are rather placid and static, with emotion suggested by general postures. As with most Oklahoma painters, the subject matter is nostalgic and possesses strong revivalist drama.

Another Bacone student was Fred Beaver (Creek/Seminole), who endured the department's militaristic discipline for only a few weeks. On his own he has developed a distinctive style and gives most of his thematic attention to Seminole lore. At their best, his formalized paintings of village life are subtly colored and possess a muralistic overall composition, with bright details in the typical ribbon appliqué of Seminole costume.

The paintings of C. Terry Saul (Choctaw/Chickasaw), another Bacone student, have won a great deal of attention for their sharply incised lines in dark paint superimposed on a background of light hues or white. Saul has a particular interest in uncommon tribal motifs, and is at his best when depicting the supernatural wonderment of legends.

Three other Traditional painters of the Plains, though not connected with Bacone, epitomize the revivalist, dramatic nature of Oklahoma Indian painting: Blackbear Bosin, Jerome Tiger, and Rance Hood.

Blackbear Bosin (Kiowa/Comanche) is one of the most widely known Indian painters, and for very good reason. His paintings have vast popular appeal, a keen theatricality, and an elaboration of the sense of movement and emotion that first became apparent in Indian art in the work of Quincy Tahoma. Entirely self-taught, Bosin is an exceptional draftsman who creates paintings with the scenic imagination of Pavel Tchelitchew's *Hide and Seek*. In his landscapes there is a curious combination of the complex fantasies of Chagall with the exaggerated semblances of Rousseau, also calling to mind the British painters of "the sublime" like Philip James de Loutherbourg, James Barry, and Henry Fuseli, in their exquisitely excessive emotional tone and grasp of overblown reality.

Jerome Tiger (Creek/Seminole) had an astonishing and short career, ending in 1967 with his accidental death at twenty-six. His painting is

Archie Blackowl, Southern Cheyenne. Cheyenne Burial, *1952. Tempera. Courtesy Tribal Arts Gallery, Oklahoma City. A frequent theme of Blackowl is the burial scene. The Plains Indian buried his dead ceremonially, raised above the earth, toward heaven. The spirit of his horse (seen under the burial structure), food, and clothing for the unknown journey beyond life were left with the warrior. Blackowl has depicted in the sky a vision of the great hunting deeds of the dead brave.*

Blackbear Bosin, Kiowa-Comanche. Of the Owl's Telling, 1965. Gouache on illustration board. Courtesy Blackbear Bosin and U.S. Department of the Interior, Southern Plains Indian Museum and Crafts Center. Here Bosin uses his grasp of the imaginative and theatrical to depict a dramatic situation in terms of form rather than motion. Symbols of the Plains Indians — the great full moon, the owl, and the vision-questing warrior — are used to convey a luminous sense of awe and mystery.

Blackbear Bosin, Kiowa-Comanche. Prairie Fire. Casein on illustration board. Courtesy Blackbear Bosin and Philbrook Art Center, Tulsa. Typical of the vast theatrical viewpoint of Bosin is this atmospheric painting in which antelopes and wolves, their feud forgotten, flee across a fire-raging plain along with mounted Indians. The figure painting is possibly better in other Bosin works, but here the sense of motion and foreboding in the terrain and the sky are exceptional achievements for the normally static style of Traditional Indian painting.

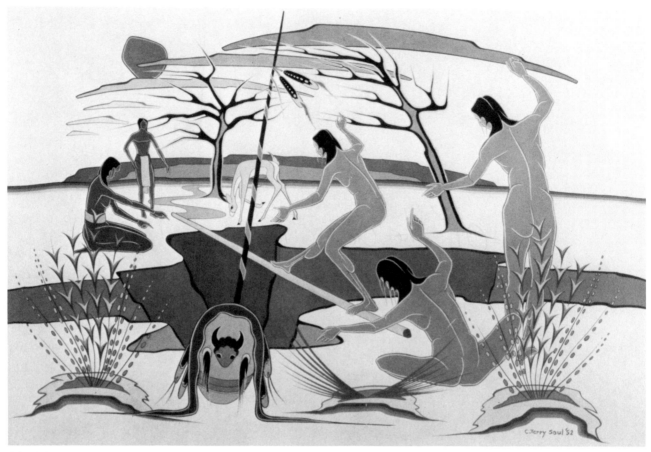

Chief Terry Saul, Choctaw-Chicasaw. Legend of the Dead. *Courtesy Philbrook Art Center, Tulsa. One of the most widely recognized Woodland artists, Saul was graduated from Bacone High School and College in 1940, having studied with both Acee Blue Eagle and Woody Crumbo. His interest in the legends of his people, especially the uncanny and unusual, mark his work, like this depiction of the story of spirits crossing into the world over a chasm.*

Fred Beaver, Creek-Seminole. Tanning Hide, 1971. Gouache on board. Courtesy Tribal Arts Gallery, Oklahoma City. Beaver's highly stylized manner of depicting Seminole life is characteristic of the Bacone and Studio influences on the Kiowa style. In the background the women, since the introduction of the sewing machine, have created the complex appliqué and ribbonwork which decorates Seminole garments like the women's hems and the men's shirts.

Jerome Tiger, Creek-Seminole. The Trail of Tears, 1966. Watercolor on illustration board. Courtesy Peggy Tiger. With characteristic drama within a blue world, the late Jerome Tiger depicted a tragic episode in southeastern Indian history, the removal of the "Five Civilized Tribes" from their homelands to Oklahoma. In his words, "We were driven off like wolves . . . and our people's feet were bleeding with long marches. We are men . . . we have women and children. Why should we become like wild horses?"

obsessed with the unique mysticism of Indians. A devoted authority on Tiger, Arthur Silberman, has summed up the vast popular impact of Tiger in conversations with me: "The Indian artist expresses himself by projecting mind images. Salient features are captured but much else may be left out as irrelevant — foreground, perspective, and shading. Strong composition, use of line, and the instinctive use of color are all characteristic of Indian art." His paintings closely resemble illustrations, but his uncanny technical facility tends to transform them into a unique expressive form. Bodies are delicately drawn in a peculiarly feminine fashion-figure manner; backgrounds are frequently a passive and stylish matte blue. The detail and shading is meticulous, cameolike, and somewhat soft. And always there is in his work an absolutely overwhelming presentation of mood — not specific emotion, but generalized mood.

Both Blackbear Bosin and Jerome Tiger create the same kind of impact but each in a unique manner. Tiger is fragile and somewhat pretty; Bosin is dramatic and robust. Both raise a number of problems concerning taste as it is currently prescribed. There is a good deal of doubt at the moment about the ultimate worth (beyond illustration) of Anglo painters like Andrew Wyeth. There is still some question among tastemakers about the value of figuration in painting. The sophisticated stoics are also unsure just how much emotion is too much emotion in art. At such a moment, it's not easy to assess the works of Bosin and Tiger, except to say that their impact is immediate and popular, that they convey to Indians and non-Indians something both groups want to experience in regard to their "idea of Indians." Tiger and Bosin are neither intellectual (and therefore accessible to the haunts of intellectuals) nor truly primitive (and thereby unthreatening to the avant-garde). To the contrary, they are superb technicians.

Rance Hood is in very much the same position, only more so; his painting stems from the expressionism of Bosin, fairly bursting with surrealistic motion, but also reflects much of the delicate mysticism of Tiger. Together Bosin, Tiger, and Hood represent an idiom which might confound the artistic principles of many viewers. They are the advance-guard of the Traditional artists, having taken their styles (as derived from the early Kiowas and The Studio) to the ultimate limits — infusing their works with extreme theatricality, sublime emotion, exaggerated action, and a surrealistic sense of mysticism. But they are also the rear-rank of the youngest Indian artists who have broken away from Traditional painting. In short, they are in a most uncomfortable position. They are not orthodox enough to be Traditional and not experimental enough to be part of the new wave. Yet their paintings, quite apart from critical perplexities, have marvelously visual impact and a wide popular audience among whom are many discriminating collectors.

In a way, Bosin, Tiger, and Hood are reminiscent of the Pre-Raphaelite painters and artists like Brauer, Fuchs, and Hundertwasser

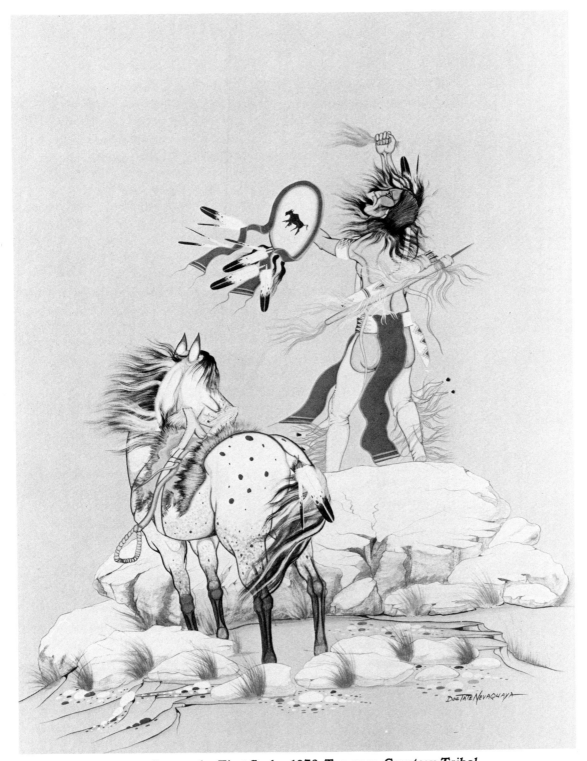

Doc Tate Nevaquaya, Comanche. First Scalp, 1973. Tempera. Courtesy Tribal Arts Gallery, Oklahoma City. The famed Comanche flute player Doc Tate has recently evolved a strong graphic style very much in the tradition of the Bosin/ Hood manner. Doc Tate is one of the great surviving tellers of history, and his painting is often autobiographical. The scalp lock in this painting is blond and resulted from a heated argument that Doc Tate once had with a good friend who owns and operates an art gallery. Born at Apache, Oklahoma, in 1932, he was educated at Fort Sill Indian School. A self-taught artist, he began painting professionally about 1958.

Rance Hood, Comanche. Indian Bar, *1973. Tempera. Courtesy Tribal Arts Gallery, Oklahoma City. Hood normally paints about the heroic past and his turbulent peyote visions, but this work is an interesting autobiographical aside rendered in striking form and color. It is extremely telling in regard to the way many Indians see themselves in somewhat dilapidated heroic profile: the idealized, bronzed Indian with his long, jet black straight hair sitting with his cigarette and can of Coors, installed in the Indian bar for days at a time while his traditionally clad wife and child wait out the cycle of depression.*

of the current Vienna School: they are damned by the avant-garde for their illustrative and decorative simplicity and loved by a very large and growing audience for their sense of mystery and theatricality.

It is curious and significant that all three of these painters are essentially self-taught. It's possible that their exceptional painting may have taken quite a different turn had they, like so many of their contemporaries, at the time of their formative efforts come under the influence of the various Indian art institutions that were being established. Perhaps their stance between two worlds of Indian painting is to be understood as their uniqueness. That dualism of past and future may be what finally distinguishes them from the ranks of young experimental Indian painters who are intent upon a personal style and statement but seem, unfortunately and with but rare exception, to be stamped from the same redundant die, and to possess little that distinguishes one from another or that reaches the aesthetic achievements of non-Indian youths working toward similar idiosyncratic styles of modern painting.

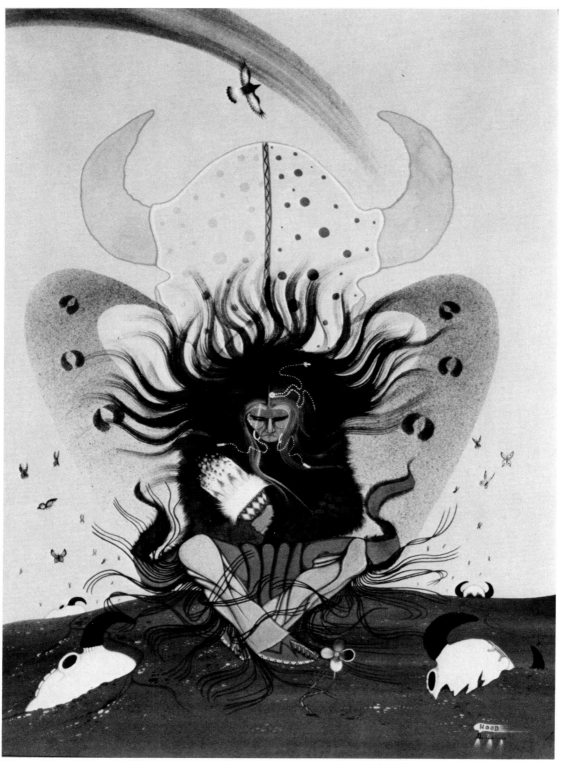

Rance Hood, Comanche. A Prayer. Tempera. Courtesy Tribal Arts Gallery, Oklahoma City. A Hood painting, rich in symbolic detail, furiously flying as if the crest of the moment were permanently imparted on paper. The peyote fan, the butterflies, the ritual skull, the buffalo tracks, the bird and the flower, even the small water birds which decorate the hair ornaments of the seated figure, perfectly reflect the consummation of man and power, portraying the highest contact with the sublime.

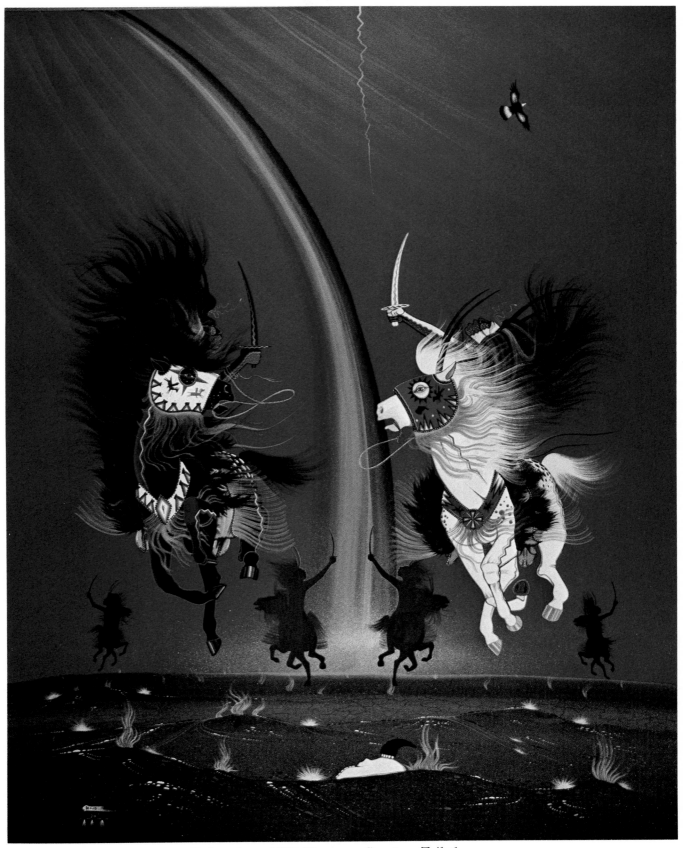

Rance Hood, Comanche. Sioux Rainmakers, 1970. Tempera. Courtesy Tribal Arts Gallery, Oklahoma City. This self-taught Oklahoma artist brings force to his portrayal of ceremonial life with a theatrical use of robust motion. Hood, who is a peyotist, takes great pains to authenticate his paintings, whether they are concerned with his own Comanche rites or with the rituals of other tribes of Oklahoma and the Plains. This impressive ceremony of rainmaking combines the vitality of myth with Hood's turbulent visions — the marriage of dream and drama.

8. CONTEMPORARY INDIAN PAINTING BEGINS
The Institute of American Indian Arts

THE ATTITUDE OF YOUNG INDIAN PAINTERS TOWARD TRADITIONAL painting is very similar to the way youth always looks upon the past. At the competitive exhibits at the Scottsdale National Show in Arizona and at the Philbrook Art Center Annual Competition a strong alternative to Traditional painting has gradually become apparent. R. C. Gorman (Navajo) summarizes the inclination of the young: "Traditional Indian painting is a bore if that's what one becomes stuck with. It becomes meaningless after a while. Stale. Overstated. Pretty. Gimmicky. Dumb. Lazy. I say, and I'm speaking to the young artists, leave Traditional Indian painting to those who brought it to full bloom."*

That is pretty much what young Indian painters have done. Traditional painting has become a closed chapter in their art, admired but not imitated. Ironically, it is not the new Indian art but the old which is now being embraced by an eager public swept up by the current vogue for the Symbolist and Decadent schools of European painting, which has repopularized highly decorative and representational painting. Traditional Indian art fits into this trend and also appeals to the vision/drug orientation of a generation whose frame of reference has been fundamentally altered by psychedelic experience. The heightened interest in artists like Salvador Dali and M. C. Escher, and the reawakening of the notion of the "Noble Savage" inspired by the books of Carlos Castaneda and others, are all aspects of the interest in Traditional Indian art.

The real center of radical experimentation in Indian art, founded in

* Lloyd E. Oxendine, "Twenty-three Contemporary Indian Artists," *Art In America,* July-August, 1972.

1962, is the Institute of American Indian Arts in Santa Fe, generally referred to as IAIA. The Institute is the result of a conference set up at the University of Arizona and funded by the Rockefeller Foundation to explore the future of American Indian art. The conference gave rise first to the Indian Art Project held at the University of Arizona for three summers, 1960–1962. Finally, the conference and the project led to the founding of the IAIA, which offers broad training from crafts to dramatics but which has essentially turned out most of the important young Indian painters of the 1960s and 1970s. In theory, the students of painting at the IAIA are given both Traditional and Contemporary instruction, but the fact is that the temperament of both faculty and students is inclined to the new wave of individualistic Indian art.

Lloyd Kiva New (Cherokee), a commissioner of the Indian Arts and Crafts Board of the United States Department of the Interior and the director of the IAIA since 1967, has outlined the institute's aims:

> I believe that *young* Indians should be trained to the point where they will be able to make up their minds as adults of the future how they will want to present their culture to the outside world. I don't think these decisions about what Indians should do in capturing the beauties of their rich past in contemporary dramatic forms should be made by [older] people. But I do believe that I can, with the assistance of others, help Indians have the experiences that will lead them toward making sound decisions about the evolution of those institutions that will be needed to support Indian culture into the future. I am frustrated that Indians cannot gain access to at least one major educational institution where they can have an opportunity to get themselves together with the help of sympathetic mentors and attack the problem of how to go about furthering those cultural values that should not be lost, particularly as they apply to performing arts experiences. . . . I feel that the first steps that need to be taken are those that will help [Indians] become involved educationally in the problems so that they can eventually decide what they would like to do. Until this is done, I fear we risk a kind of paternalism that is rapidly going out of style.*

The prospects for Indian painting which Lloyd New envisions started with a breakthrough in 1932, when the legal prohibition against native arts by the federal government changed and the B.I.A. reorganized the Santa Fe Indian School as the arts and crafts school for the entire Indian Service, putting Dorothy Dunn at the head of the painting department. The following year a Santa Fe Indian School student exhibit was held at the Museum of New Mexico, the first of thirty-three such shows from 1933 to 1938. The most important nationwide focus

* L. K. New in a letter to the author, August 1974.

on Indian art came with shows at the Golden Gate Exposition in 1939
in San Francisco and at the Museum of Modern Art in 1941. This
gradual exposure was described in an interview with Jean Snodgrass,
a leading biographical researcher on Indian painters and Indian arts
curator from 1956 to 1969 of the Philbrook Art Center:

> A decline in productivity accompanied World War II and it was
> not until 1946 that Indian art emerged from its slump. It was in that
> year that Philbrook Art Center in Tulsa, Oklahoma, inaugurated an
> annual, competitive, nation-wide exhibit for Indian painters. Similar
> exhibits were soon instituted by other museums. Scottsdale became a
> lucrative annual exhibition center and recently the fine Heye Foun-
> dation [now the Museum of the American Indian, New York] under
> Frederick J. Dockstader started to present one-man shows by Indian
> artists. The Institute of American Indian Arts may serve to alleviate
> the problems created by poor business education by stressing cultural
> roots as a basis for individual creativity, coupled with sound business
> training in marketing and management. The Institute, located where
> the Santa Fe Indian School once stood, seeks to assist young Indian
> people to find new levels of pride in their own heritage and enable
> these young people to enter today's society with confidence and with
> pride. In 1959, three years prior to the opening of the Institute,
> Philbrook Art Center presented paintings generally considered to be
> taking a *new direction.* Thus Philbrook provided the first major
> endorsement of the evolution in Indian art and acknowledged the
> ever-increasing desire of artists to experiment — not to break from
> their culture, but to explore it and improvise upon it — to effect an
> integration with the demands of the present. Even the purist, if he is
> honest and knowledgeable, must admit that from the very beginnings
> of Indian art, there have been many styles, many techniques, and
> many approaches. The *new direction* treatment, first accepted by the
> Philbrook, later by more recent annual exhibitions, and certainly
> encouraged by the IAIA, is but one more phase in the continuous
> development of Indian art.*

The battle, however, goes on. There is little harmony between the
Traditional and Contemporary painters, and each year the annual
exhibits are tossed by controversy over the reactionary or radical view-
point of juries. The pressure against the highly Traditional style, the
artistic experiments of the IAIA, and the inevitable allure of new tech-
niques and media have brought about numerous storm centers.

One of these, unquestionably, is the Mission Indian painter Fritz
Scholder, who has become a symbol to many young artists of artistic
validity and mainstream success at the same time that some Contem-

* From an interview with the author, Tulsa, Oklahoma, April 1975.

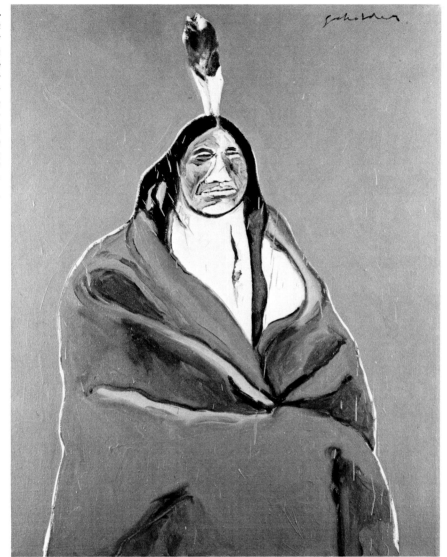

*Fritz Scholder, Mission-Luiseño.
Dartmouth Portrait #6, 1973. Oil on
canvas. Courtesy of the artist. Probably
more than any other single Indian
painter, Fritz Scholder epitomizes the
convergence of Indian subject matter
and contemporary techniques. Greatly
admiring the English painter Francis
Bacon and encouraged in his early
career by both Oscar Howe (Sioux)
and the Anglo pop artist Wayne
Thiebaud, Scholder has in turn
influenced the whole generation of
young painters who are the focus of
Contemporary Indian painting.*

porary and most Traditional painters see Scholder as the Pandora's Box
of Indian art. By and large his major sin appears to be his success. He
is one of the few Indian painters who has a major reputation in the
leading art cities. His shows in smaller galleries have sometimes brought
demonstrations by Indians who see in his brilliantly ironic canvases
something insultingly grotesque in the depiction of native Americans.
The accusation is entirely off target, well intended at the same time that
it is visibly an expression of supreme naïveté. "I do not call myself an
Indian artist," Scholder has said recently, ". . . everyone else does. I
happen to be one-quarter Luiseño [Mission Indian of California] descent
and I use the American Indian as subject matter for my paintings."*
There is far more to it than that — Scholder has succeeded in combining
the influences of European expressionism, specifically the style of the
English artist Francis Bacon, and some ingredients of pop art, into a

* From an interview with the author, January 1976.

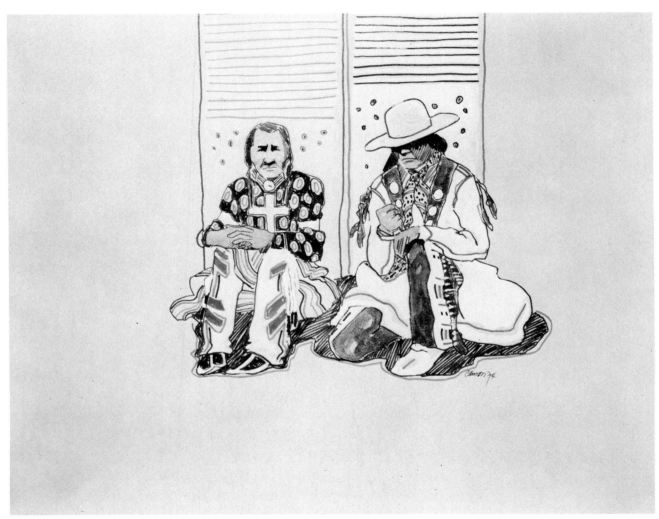

T. C. Cannon, Caddo-Kiowa. Gamblers, *1974. Mixed media on colored paper.*
Courtesy of the artist and Aberbach Fine Art, New York. Cannon is one of the
most talented of the young painters, concerned here with a development of the
Traditional style into a contemporary expressive form. The relatively unmodeled
figures are in Traditonal poses, and there is no foreground or background; but in
the foreshortening, coloration, and attitude a new purpose is apparent in this
painting, which clearly is a departure from decorative mannerism.

personal and political attitude about Indians that is entirely legible to both whites and Indians young and experienced enough to respond to any art more complex than calendar illustration or more modern than Norman Rockwell.

From the major rift which Scholder has made in the status quo of Indian painting has tumbled some very impressive young artists — in fact, these conscious and unconscious protégés of Scholder represent almost everything notable about the Contemporary trend in Indian art.

One of them is T. C. Cannon (Caddo/Kiowa), who comes from Lawton, Oklahoma, and studied at the Institute. "I dream of a great breadth of Indian art to develop that ranges through the whole region of our past, present and future," he explains, "something that doesn't lack the ultimate power that we possess. I am tired of cartoon paintings, of Bambi-like deer reproduced over and over. From the poisons and passions of technology arises a great force with which we must deal as present-day painters. We are not prophets — we are merely potters, painters and sculptors dealing with and living in the later twentieth century!"*

Donald Montileaux (Oglala Sioux) was born on the Pine Ridge Reservation in South Dakota and also studied painting at the Institute. He has worked in many styles but his geometric paintings derived from parfleche designs have won him especial critical acknowledgment.

Another IAIA alumnus is Earl Eder (Yanktonai/Sioux) who continued his studies at the San Francisco Art Institute, and has painted some impressive canvases essentially in the manner of the action painters.

Among other Institute painters doing good work are Earl Biss (Crow), Linda Lomahaftewa (Tewa), Austin Rave (Sioux), Bill Soza (Mission), Dominick La Ducer (Chippewa), and Alfred Young Man (Cree).

Young Man is a particularly interesting young painter who was born in Browning, Montana. He was awarded a four-year scholarship in 1968 through the B.I.A. to study at the Slade School of Fine Arts in London. His paintings are striking autobiographical notes, often with sardonic overtones and political ironies. The earliest works are illustrative, controlled, and rather in the manner of abstract political cartoons. The latest efforts are bold, brash, and highly distinctive. "I am concerned with autobiographical expression," he says. "I look, perceive, and express my particular view of the world I live in and the world we all live in. I am an individual in this world. My work is both Indian and non-Indian. Today the line between 'our' culture and 'their' culture is almost invisible, and the influences we all feel is what my work is concerned with. Some Indian artists live for the past, others for the present. I live for the past, present and future."†

* In an interview with the author, Santa Fe, May 1975.

† From a letter to the author, July 1975.

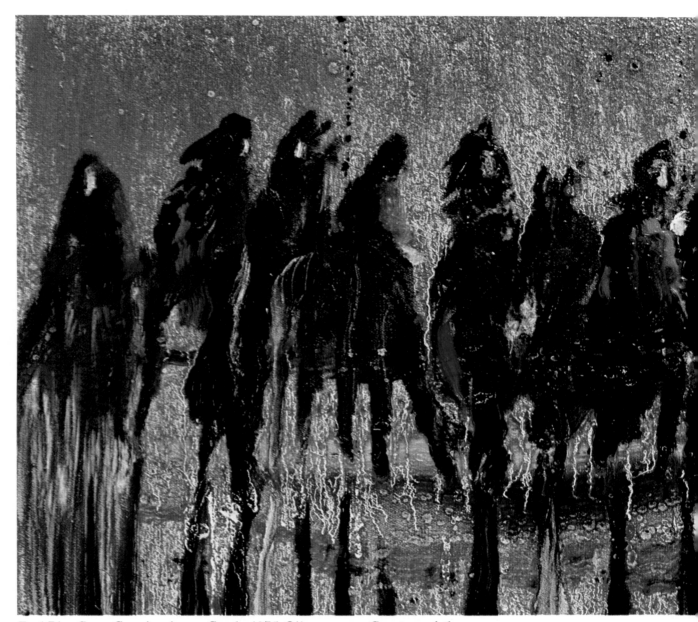

*Earl Biss, Crow. Crossing Arrow Creek, 1975. Oil on canvas. Courtesy of the
artist. Born in Renton, Washington, in 1947, Biss studied both at the Institute of
American Indian Arts and at the San Francisco Art Institute. Biss says that he
"loves to move paint" and is primarily concerned with the medium — a tendency
among the young painters who find a potential stereotype in so-called Indian
subject matter. Recently Biss has completed a phase of nonobjective painting
and returned to objective material drawn from his ancestral heritage. His
fascination with the romance of the chase, moonlight raiding parties, stealing
horses from rival Indian camps, and bearing up under the severity of winter in
the Big Horn mountains provides dominant themes in his current cycle of
paintings.*

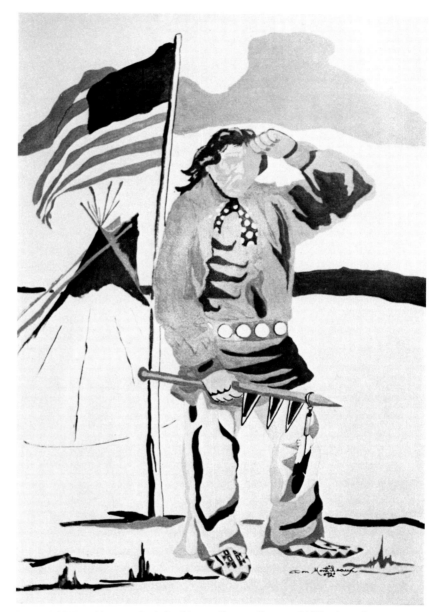

Donald Montileaux, Oglala Sioux. Camp Cryer, 1973. Acrylic on canvas. Rapid City Public Collection, South Dakota. Courtesy of the artist. One of the luminaries of the Institute of American Indian Arts, Montileaux has painted a number of geometric canvases that borrow from the design of pre-Columbian parfleches. His figurative painting, though less known, carries strong expressive purpose as well as the coloristic approach to object art which dominates the manner of the Institute alumni.

*Alfred Young Man, Cree. Peyote Vision, 1974. Oil on canvas. Courtesy of the
artist. An alumnus of the Institute of American Indian Arts and the Slade School
of Fine Arts of London, Young Man is one of the top Indian painters, with a
strong individual view politically and artistically.*

Alfred Young Man, Cree. **Six Whites — One Indian.** *Courtesy Institute of American Indian Arts and the artist. An early political painting which carries its message without interrupting the imaginative effect of paint as an expressive medium.*

R. C. Gorman (Navajo) is the son of Carl Gorman, who studied at the Otis Art Institute in Los Angeles after World War II and, like Oscar Howe, attempted at an early stage of modern Indian painting to paint in a personal, expressive manner using contemporary art tools. Like his father, R. C. Gorman studied sophisticated art — with the Mexican muralist Carlos Merida at Mexico City College. The result is a strongly Mexican-style figurative painting which resides somewhere between the trading posts (where it is too modern to be acceptable) and the contemporary art galleries (where it is not sufficiently modern by some tastes). It is a solitary art with great beauty at its best — especially in the simply sketched folk figures of seated women. R. C. Gorman is perhaps a transitional artist, like his father, between the world of Traditional Indian art and the Contemporary mode. A painter who works sometimes in abstract idioms but who also reflects the cultural images of his Navajo heritage, Gorman is at home in urban America and with the symbolism of Navajo sand painting, but belongs to neither. Originally he spoke out against the restrictions of the Traditionalists' hold on the art market, but lately he seems to appreciate paintings which are good regardless of the "school" represented. He has partially solved his economic problem by opening his own gallery in Taos.

Among the most interesting young painters is Benny Buffalo (Cheyenne), whose work tends to run the spectrum in style but who achieves his most original works when dealing with traditional subject matter reoriented to a modernist irony and technique. Joan Hill (Cherokee/Creek) has achieved a very considerable reputation, one of the few

Indian painters who successfully moves between Traditional and Contemporary styles, and one who has done more painting of nudes than is typical of Indian artists. Also reflecting the past more than the present are young painters like Chebon Dacon (Creek/Choctaw) who is developing quickly into a fine Traditionalist. Johnny Tiger is determined to carry forward the career of his late brother Jerome. Alfred Whiteman, Jr. (Cheyenne/Arapaho) is one of the most interesting of Traditional painters who often bases his imagery on peyote visions and produces some very intriguing works. Some other young painters are Robert Annesley (Cherokee), King Kuka (Blackfoot), George Burdeau (Blackfoot/Winnebago), Arthur Amiotte (Oglala Sioux), Frank Big Bear, Jr. (Chippewa), and Phyllis Fife (Creek).

All of these artists regularly compete in several prominent annual exhibits which specialize in Indian painting (see Appendix). Each year the conflict of interests between Traditional and Contemporary art becomes more pronounced. The major battles which are being fought on the virtues of the old against the new are hardly restricted to Indian art. Most cultures are facing the same conflict, but in the case of Indian painting the touting of judgment presumed to spring from a "mystical and racial memory" clouds all the issues.

R. C. Gorman, Navajo. Navajo Woman. *Courtesy of the artist. Gorman, who was partially trained by Mexican muralists, is at his best in these direct and lineal studies of women. The Mexican style and anatomical precision are unorthodox for Indian painting.*

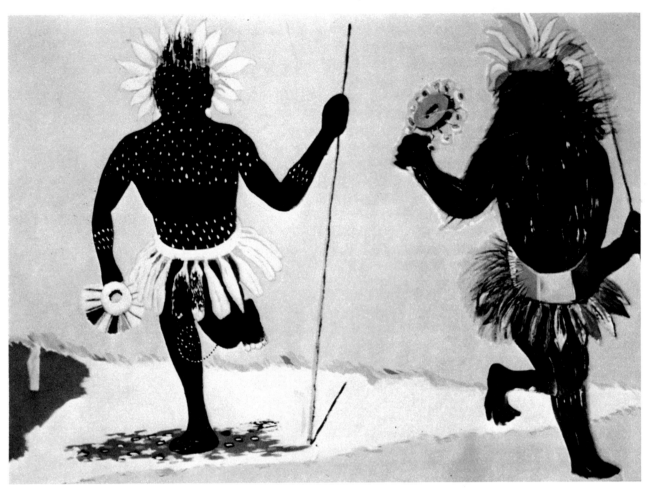

Alfred Young Man, Cree. George Catlin–Fritz Scholder, Indian Rip-Off, *1972.*
Acrylic on canvas. Courtesy of the artist. Borrowing thematically from two
famous painters of Indians, Young Man makes an ironic statement while
composing a strong departure from his usual "pop" approach to figurative
painting.

Benjamin Buffalo, Cheyenne. Painting, 1975. One *of the most promising of the young painters, Buffalo studied at the Institute of American Indian Arts, the San Francisco Art Institute, and Southwestern State College. He is currently majoring in film at the University of Oklahoma.*

Benjamin Buffalo, Cheyenne. Powwow. Acrylic on canvas. From the collection of the author. Irony is a major factor in recent Buffalo works, a departure from the Contemporary treatment of Traditional subjects that dominated his work through 1974, the year his When Mother Was Renewed *won an award at the Philbrook Art Center Annual Exhibition.*

Benjamin Buffalo, Cheyenne. Portrait. *Courtesy Institute of American Indian Arts and the artist. An early semi-Traditional portrait.*

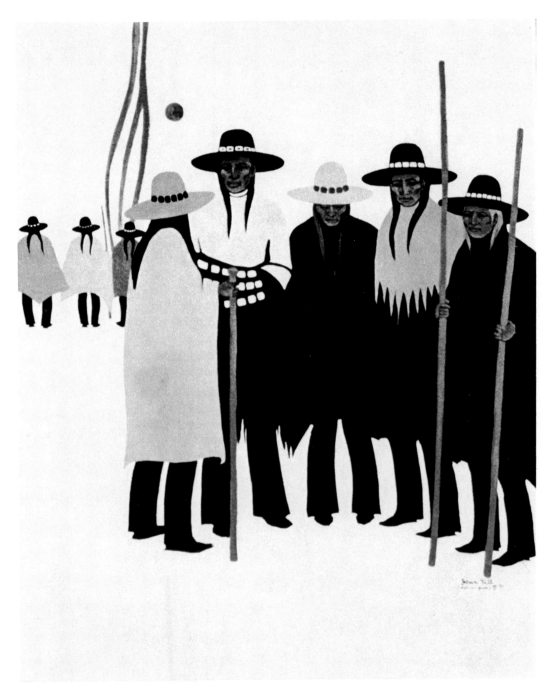

Joan Hill, Creek-Cherokee. Wars and Rumors of Wars. *Acrylic on canvas.*
Courtesy of the artist. This painting by the famed woman Indian artist won
First Award at the Scottsdale Indian Show and the Philbrook Art Center Annual
Exhibition. Hill studied under Dick West at Bacone College. Her work is known
internationally and she has traveled extensively as a goodwill artist.

R. H. Annesley, Cherokee. Hopewell Shaman.
*Courtesy of the artist. An exceptional
imaginary portrait of the holy man of the
ancient mound culture of the Southeast.*

*Frank Big Bear, Jr., Chippewa. Fawn Baby,
1974. Pencil and colored pencils on paper.
From the author's collection. Big Bear,
essentially a self-taught painter, was born in
1953 and raised on the White Earth
Reservation in Minnesota. Although his work
in color is still developing, his drawings are
already of considerable interest. The young
artist favors surrealism but wants to experiment
in many manners.*

What seems to disturb many Anglo and Indian observers is that many Indians truly detest Contemporary Indian painting. They find it grotesque, insulting, racist, and a sellout to Anglo fashions in art which should have nothing to do with Indians. These accusations are unquestionably sincere, even those very unfair and unkind comments leveled at some Indian painters as "rip-offs" and "con-men." Indians, however, who know nothing about art (their own or anybody else's) have no more reason to declare racial dogma than the uninformed visitor to the Museum of Modern Art who finds Bacon grotesque, Picasso insulting, Grosz racist, and Pollock a sellout to trendy artistic jibberish.

Most Indians have not had the opportunity to see and know Anglo art sufficiently to make authentic comments on it or on its impact on Indian painting. As for the large Anglo audience that has cultivated an interest in Indian painting, it has never been highly literate. The cultists and Indian groupies suffer the same deficiencies as all camp followers: they are believers who don't know very much about the things they claim to believe in. Their experience of art is limited and so is their art education — otherwise they wouldn't be cultists, groupies, and followers.

Except for the cultists, few Anglos know much of Indian art or its history. And the truth is that very few Indians in Montana and the Dakotas have ever heard of Blackbear Bosin, Rance Hood, or Fritz Scholder and, for that matter, quite sadly, they have also not heard of Oscar Howe though he teaches in Vermillion, South Dakota, and is one of the cornerstones of Indian painting.

It would be unreasonable to take to heart the commentary of an average Spaniard on the works of Picasso. It is also peculiar, to say the least, that both Anglos and Indians believe in some kind of inborn, native mystique with which they presume Indians know everything there is to know about being Indian. Interviews with American Indians in all walks of life and with the masters of painting have indicated quite the opposite. Again and again the artists admitted that they often knew little or nothing about the culture they wanted to represent in their early paintings and that they had to go to the old people for advice, criticism, research, and information about their customs.

Lloyd New said it very clearly when he indicated that young Indians must gain a sense of both their history and that of Anglos to decide how their culture should be presented in the modern world. But we cannot in the meantime assume that painters can rest their careers on the judgment of hobbyists who collect Indian painting or on Indians who are ill trained in their own cultural transition from the past to the present.

In discussions of influences and painting in general with major Indian painters (excluding the young artists whose education is essentially indistinct from that of any trained Anglo), the only references the artists made to outside influences on their work were to Dali, Toulouse-Lautrec, and Gauguin, plus the examples shown them at The Studio by Dorothy

Grey Cohoe, Navajo. Warriors Returning in the Winter's Snow. *Pen and ink on paper. Courtesy of the artist and the Institute of American Indian Arts, Santa Fe. Born in Tocito, New Mexico, in 1944, Cohoe studied at the Institute and received a B. F. A. degree from the University of Arizona.*

Phyllis Fife, Creek. Buffalo Two Chips, *1972. Mixed media. Courtesy of the artist and the Institute of American Indian Arts, Santa Fe. Born in Dustin, Oklahoma, in 1948, Fife studied at the Institute and the University of California at Santa Barbara as well as the University of Oklahoma.*

Ray Winters, Sioux. Somewhere in South Dakota. *A surrealistic view of the Northwest by a young graduate of the Institute who did a few impressive paintings and then dropped out of sight.*

Dunn: Chinese landscapes and animal prints of the Sung Dynasty; Paleolithic drawings from the Altamira caves; Persian miniatures of the Safavid school; and Indian miniatures in the Moghul style. These examples are fascinating, but they also betray a lack of historical perspective in Anglo art among artists who have been very greatly influenced (perhaps unconsciously) by other aspects of Anglo culture.

In the latter half of the twentieth century it becomes apparent that the answer to the question "What is Indian art?" is more confounding than the question itself. And that is what the bitter conflict of "schools" is all about. Indian art is probably no more or less than art created by someone who happens to be an Indian. That answer, however, presumes a good deal more than the short history of Indian painting since 1900 currently warrants. At the moment there is little Indian art which is modern in the contemporary sense of that word. Indian painting is a

Johnny Tiger, Creek-Seminole. Guidance from Above. Tempera on paper. Courtesy Mr. and Mrs. Hale Schalben. Johnny is the brother of the late Jerome Tiger and has dedicated himself to the continuation of his brother's career. Though his style in many ways duplicates the efforts of Jerome, Johnny has recently evolved a personal manner of great delicacy and refined detail.

very specific generic term, referring to the schools of art created in the past by Indians who were self-taught or who were tutored by Anglo teachers. If the notion of painting by Indians were not based on this fifty or sixty years of the immediate past, there wouldn't be all the torrents of controversy over the Traditional versus the new Contemporary styles. For the moment it's hopeless to think of Indian art outside its immediate and short-lived evolution. It therefore becomes both simplest and historically most accurate to think of Indian painting as the depiction by Indians of things Indian in a manner which was developed through Anglo instruction and from roots that are distinctly Indian. That definition is obviously transient, for even as we look at today's latest paintings the notion of "things Indian" is changing so fundamentally that all lines of distinction become both transparent and tangential.

Bert D. Seabourn, Cherokee. A Brother to Dragons and a Companion to Owls. *Watercolor on paper. Courtesy of the artist. An Oklahoma painter who has won honors at the Philbrook Art Center.*

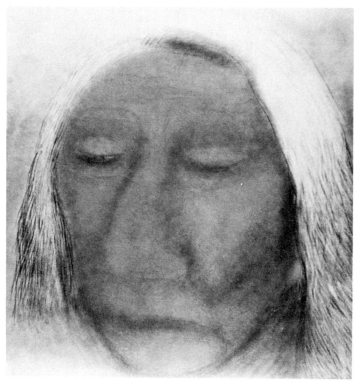

Yeffe Kimball, Osage. Chief Red Cloud, *1971. Acrylic resin on canvas. Courtesy of the artist. Ms. Kimball was born in Oklahoma and studied at the Art Students League in New York City and in France and Italy with Fernand Léger, Corbino, Bridgman and others. Her solitary career has spanned more than fifty years, during which time she has been very widely exhibited and collected. Her painting suggests a stretch of time across which the modern Indian must view his once vital link to an heroic past. The image appears to be diminishing and fading into the air, like a mirage, and yet its remoteness is reminiscent of a ghost which persistently returns and walks among us.*

Delmar Boni, Apache. Great Native American Dream #1, *1973. Acrylic on canvas. Courtesy of the artist. Boni has developed his own "Indian symbols" in an effort to convey the ironies of the ancient people caught up in the flux and consumer society of non-Indian America.*

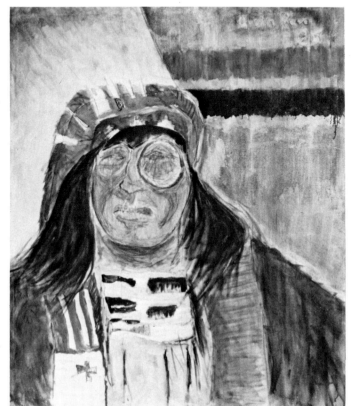

Austin Rave, Sioux. Two Smokes, *1967. Oil on canvas. Courtesy of the artist and the Institute of American Indian Arts, Santa Fe. Rave, a Miniconjou Sioux, was born on the Cheyenne River Reservation in South Dakota in 1946. He studied at the Institute in Santa Fe and also at the San Francisco Art Institute. He was awarded the Governor's Trophy at the Scottsdale National Indian Art Show in 1966 but has necessarily dropped out of sight in order to earn a living in non-art fields. When last heard from he was working in the Alaskan oil fields.*

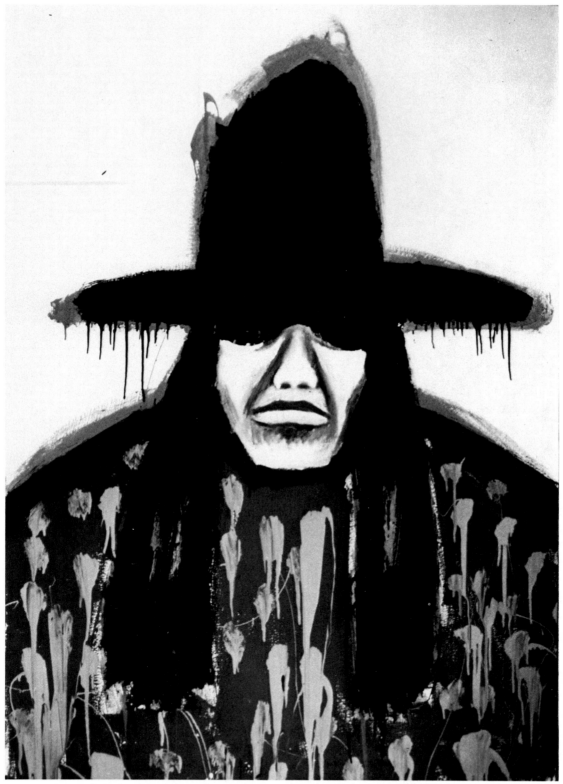

Delmar Boni, Apache. Portrait, 1974. Acrylic on canvas. Courtesy of the artist.
One of the youngest Institute painters, Boni started his impressive career with
rich coloristic experiments and has moved from self-portraiture to Pop Art irony
in depicting the Indian situation.

9. THE SINGERS OF THE SONGS
Painters in Profile

A JOURNALIST ONCE ASKED ANNA PAVLOVA IF SHE COULD EXPLAIN TO him the significance of her famous solo ballet *The Dying Swan*. Madame Pavlova smiled politely and said, "My dear fellow, if I could tell you what it means I wouldn't dance it." This bit of wisdom should be kept in mind when journalists pursue their ceaseless business of asking questions. These interviews of nine leading American Indian painters (preceded by a rare, 1880 account by one of the Indian artists who had been among those imprisoned at Fort Marion) contain paradoxes, inconsistencies, and some fairly outrageous rewrites of orthodox Anglo history. They also come close to the nerve center from which art and ideas emerge. As Jean Cocteau told us: "The artist is a mirror. When you look into an artist you are likely to find out more about yourself than you will about him or his art."

BEAR'S HEART

In May of 1880 a Cheyenne Indian spoke before a large audience in the school auditorium of the Hampton Normal and Agricultural Institute in Virginia. The Indian, named Bear's Heart, was one of seventeen young men from Plains Indian tribes accepted at Hampton in 1878 as students in the all-black institution. Prior to entrance at Hampton, Bear's Heart had spent three years imprisoned at Fort Marion, Florida, as one of seventy-two Indians confined without the benefit of trial or due process

*as an aftermath of Indian wars on the Southern Plains. He became one
of the first Indian artists while a prisoner. A correspondent from the
Boston Journal reported on May 24, 1880:*

> He is a tall, unpleasant looking fellow of 34 years, with high cheek
> bones, and he spoke in imperfect English, which he supplemented
> now and then with gestures. . . . He spoke with hesitation and ner-
> vousness, but straight on, without repetition or any doubling back on
> his course. . . . There could scarcely have been a more unpromising
> subject [for education] than this hard-featured young brave, fresh
> from waging war on the white when he was taken to St. Augustine
> [Fort Marion].

*Bear's Heart's speech was taken down and printed in the school's
newspaper. It is a very rare and sad account, the autobiography of a
buffalo-hunting nomad who was never confined to a reservation, recorded
without the interventions of interpreters, and seen sharply with the
memory of youth and not through the vague recall of old age and the
unconscious compromise of partial assimilation which marks so much of
the narrative of Indians whose words were published in subsequent
years. A complete and excellent insight into the prisoner-artists of Fort
Marion is available in two books by Karen Daniels Petersen:* Plains
Indian Art from Fort Marion *and* Howling Wolf, *as well as in the book
by Dorothy Dunn,* 1877: Plains Indian Sketch Books *(Flagstaff:
Northland Press, 1969).*

When I was a little boy, I got out of bed, maybe six o'clock every
morning. I got out Wigwam, wash face, go back in Wigwam. My father
comb my hair and he tie it then he paint my face good. Then my father
said you go shoot; my little friend come and I said to him let us go and
shoot. When finish cooking, my mother say *Come here, Bear's Heart,
breakfast.* Then I told my friend after breakfast you come again we
go shooting again. I had buffalo meat just one [?] for breakfast. I will
tell you how my home look, Indian bed just on ground. My father and
my mother have a bed one side of the wigwam; I and my brother other
side, and my sister another side, and the door on one side. The fire is in
middle. My people sit on bed, and my mother she give us a tin plate and
cut meat, we have one knife no fork hold the meat by hand, eat with
knife. After breakfast I go shooting with my friend. I eat three times
every day. Sometimes two times when not much meat. All the time meat,
that is all. I no work, I play all the time. After a while I big boy. My
father he said, Bear's Heart you try kill buffalo now, I say yes. When
Indians went buffalo hunting I go too. One time I shoot twice and kill
buffalo. I skin buffalo and put skin and beef on my horse. I took to my
wigwam. My father he say Bear's Heart, how many times you shoot. I

say one time. He say good. When I big boy my father give me gun and
I shoot deer. All the time I shoot, I done no work. When my father
died I was a bad man [a depth of sorrow which traditionally requires
pacification by taking a life]. By and by about twenty Indian young men
went to fight Utes. I told my mother I want to fight to, and she said yes.
I go and fight all day first time, we killed one Ute and four Cheyenne.
Sundown we stop. In Texas I fight again. In Texas all time fight no stop,
some fight, some take horses. In the summer I fight, in the winter no
fight. I fight then I got tired, I say my two friends let us go back to
agency; my friends they say yes. We went to Agency [tribal centers
created by Anglo supervisors], the Capt. [talk] to us, he say, Bear's
Heart what you want to do, fight or stay here. I said stay here; all right
say he "go to wigwam." About one month after, Cheyenne chief he tell
agent Bear's Heart had been fighting so he is bad, then the Captain put
me in the guard house. By and by the Captain he sent my two friends
to tell all Indians to stop fight and come to agency. All Indians come
back then Cheyenne chief he look at all Indians and told Captain what
Indians fight, the Captain put bad Indians in guard house, and colored
soldiers put chains on their legs. One man he got mad and run, the
soldiers shoot but no kill him. By and by good many soldiers come from
Fort Sill and took us to Fort Sill, where I saw Capt. Pratt. Good many
Kiowas, Comanches, and Arapahoes, Cheyenne all together with soldiers
and Capt. Pratt take us to Florida. When I ride to Florida all the time
I think by and by he kill me. When I been to St. Augustine some time
and womans and mans come to see me and shake hand, I think soldiers
no kill me. After awhile Capt. Pratt took off all Indian chains, but not
too quick. Capt. Pratt he see boys no have money. He got sea-beans, he
say make sea-beans shine, he told us how and when we make sea-beans
good we take to him, he give us money. First time we made sea-beans,
then bow and arrows, then paint pictures. By and by teacher she come
with pictures of dog, cat, cow and tell us every day nine o'clock morning
we go to school stop at twelve o'clock, afternoon just make sea-beans.
Before Indians went to school, Capt. Pratt he gave Indians clothes just
like white men, but Indians no want hair cut. Sunday Indians go to
church St. Augustine: down from head, Indians same as white men; but
head, long hair just like Indians. By and by after Indians go to church,
they say I want my hair cut; my teachers very good. Two years I stay at
St. Augustine, then come Hampton School. At Hampton I go to school
and I work. I like school and work. I don't want to go home just now.
I want learn more English, more work and more of the good way. When
I finish my school here, I go home to teach my people to work also, I
want my mother and sisters to work house, and I and brother to work
farm. When they put chains on me to take me from my home, I felt
sorry, but I glad now, for I good boy now.

FRED KABOTIE

*His Hopi name is Nakayoma (Day After Day) and he was born on
February 20, 1900 at Shungopovi, Second Mesa (Hopiland) in Arizona.
In 1906, Kabotie's family, trying to escape the efforts of the federal
government to force them to abandon their customs, joined other people
of old Oraibi and established the village of Hotevilla. Eventually they
were forced to return to Oraibi and Shungopovi, where, in 1913, the
children were placed in schools for the first time. Later, as a disciplinary
measure, Kabotie was sent to Santa Fe Indian School. There he was
encouraged by Mr. and Mrs. John D. DeHuff to develop his artistic
talents. Since 1920 he has been considered the leading Traditional Indian
painter of the Southwest. His work in teaching has prevented him from
devoting himself full-time to painting. But as the art instructor at Oraibi
High School (1937–1959) he has had an immense impact on Hopi paint-
ing. He was also former manager of the Hopi Silvercraft Cooperative
Guild. The following interview took place in March 1975.*

I started painting back in 1918. I was the first Indian studying at
Santa Fe Indian School who was allowed to paint. The superintendent
and his wife, their name was DeHuff . . . they let me paint what I wanted
to paint . . . mainly the *kachinas*. At that time the Bureau of Indian
Affairs policy was against doing anything with your own culture . . . the
Indian culture. The aim of this was to make the Indians become exactly
like the white man. But the superintendent was from the Philippine
Islands and spoke Spanish fluently, so he got along very well with the
Indian people and understood that we could not be changed into white
men. John DeHuff and his wife were world travelers, so naturally they
understood that not all people are the same, and they were much more
broadminded than the bureaucrats in Washington at that time.

Something bad happened in those days. There was an old lady who
was the librarian at the Indian school — she made a report to Washing-
ton and told them that Mr. and Mrs. DeHuff were allowing me to paint
the things which were true in my life . . . like the *kachinas*. So what
happened to them was that he was demoted from superintendent to
principal, and they were transferred to Riverside, California. The consul
of the Pueblos wrote many times to Washington to ask for the reinstate-
ment of John DeHuff but to no avail. I was the only one allowed to paint.
The rest had to try to become white men.

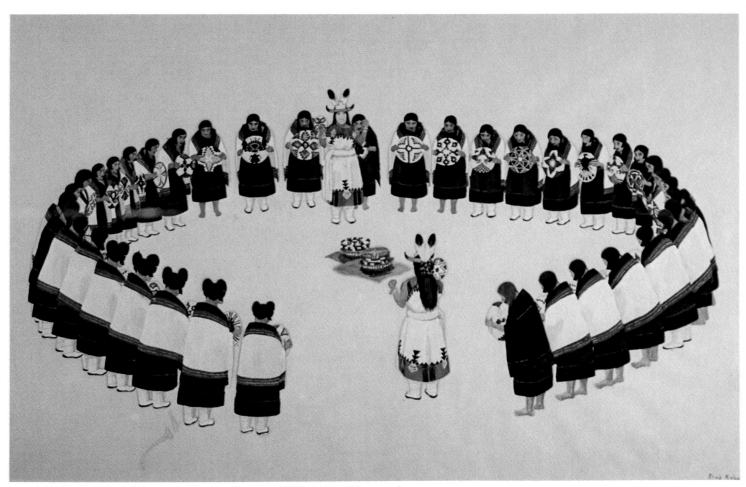

Fred Kabotie, Hopi. Women's Basket Dance, *1917–1922. Watercolor on paper.
Courtesy Museum of Northern Arizona. The dance is actually a Lakon ritual
performed by women, who form a semicircle to sing and dance. At the end of each
song they throw gifts to the men, who engage in a noisy free-for-all and grab at
the prizes. Baskets are the most sought-after gifts, thus the name "Basket Dance";
however, an ear of corn or a box of matches are equally prized since it is the lady
and not the gift that counts.*

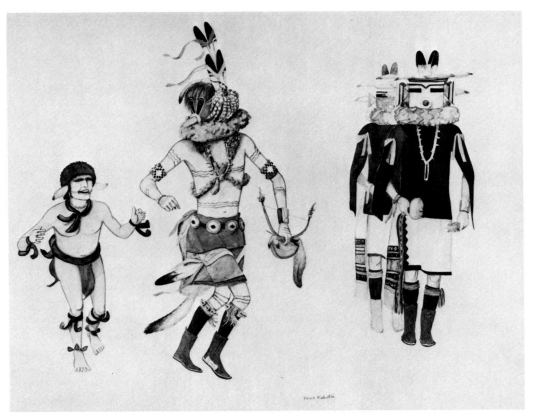

Fred Kabotie, Hopi. Tsuku Clown. *Watercolor on paper. Courtesy Museum of Northern Arizona.* The tsuku, tcuku koyemsi *or* koshare *is the clown who appears between the dances to entertain the native spectators with games and antics, often very ribald in mood. The clowns are always a source of great amusement, mimicking the white visitors and villagers whose behavior has not been proper. They are also permitted to torment the* kachinas *when they are not performing.*

In the beginning there were only three of us that I know about . . . there were three painters: me and Velino Shije who later called himself *Má Pe Wi* [Velino Herrera] and Otis Polelonema. Velino was ostracized by his pueblo [Zia] because he painted the secret *kachinas.*

I never studied art under anybody. DeHuff just told me that I should go ahead and paint as I wanted to paint . . . the way I had been painting since 1915. Mrs. DeHuff, she was a very good lady and she talked to a man from Denmark who was the teacher of carpentry at the Indian school and asked him to let me out of class so I could come to her house and paint. So he would let me go and I would sit in a little room in the house and, using school paints and common papers, I would paint for many hours.

I painted because I was kind of lonely at the Indian school away from home and I would think about my Hopi village and about the cere-monials and it made me feel much better to paint them. But never did I once paint anything secret and never was I ostracized by my pueblo.

The first person to buy any of my paintings was my carpentry teacher, Mr. Jenson, from Denmark. And he sent them to his home in Denmark because at that time Europeans were more interested in the Indians than the white people here in America.

Later on, when I was out of school, I came home for a while. And when I was in my pueblo doing some painting an elderly woman — a nurse named Miss Peters; she was a nurse for the government agency and she was visiting from Oklahoma — well, she bought some of my paintings and took them back with her, thinking that they would be interesting to some Kiowas she was helping in Oklahoma. So it was Miss Susie Peters who took some of my paintings to the Kiowas to give them inspiration or perhaps to interest them in something that a Hopi painter was doing in his pueblo . . . because no one at that time understood that Indians could be painters.

The next person who took interest in my painting was Mr. Edgar Lee Hewett who was then the president of the Archaeological Institute of America and the head of the museum in Santa Fe. He would let me come into the museum and work during the summer months. And in the mornings he had me do the book bindings as a kind of job. But I think that maybe he was expecting too much of me because what he tried to do was book binding in the mornings down in the basement where I had my own office; then in the afternoon I had a studio up on top, on the second floor, where I painted. Then later on he wanted me to run the linotype because at that time the museum magazine called *El Palacio* was printed right there.

When I finished the eighth grade at Santa Fe Indian School it was the policy that you could then go on to other advanced Indian schools, but I was still close to Mr. DeHuff [through correspondence] and he suggested that I would learn English much faster if I went to the public school in Santa Fe. So that is what I did: I went to Santa Fe Public High School for four years. I graduated about 1923 and started working at the museum for Mr. Hewett, as I told you.

All my life I have tried to be perfect in my painting. I also want to do my painting realistically. At first I only painted the public ceremonies of my people. But then, about 1940, the Peabody Museum staff from Harvard University started the excavations at Awatovi. And it is there that they found the ancient *kiva* murals. Well, Mr. Smith was in charge of the murals at that time and I used to go over there every Saturday and Sunday and this Mr. Smith allowed me to watch them work. I was very interested in these old murals and the way they had been painted. Then I was assigned to reproduce those *kiva* murals . . . for an exhibit at the Museum of Modern Art in New York City [1941]. So they gave me panels about four feet wide by eight feet high and they joined them together. The Peabody Museum sent me the cartoons that I was supposed to work from. And since I had seen the excavation I knew the

correct style in which to reproduce the sketches of the whole murals they sent [as cartoons] from the museum.

I do not know where those mural reproductions are today. I wish I did because I would like them for the museum that we are making here at Second Mesa.

The murals were very important to me. I had never seen anything like that before and it changed my painting. But today there are people who look at my work and they say that I am influenced by Picasso. And I say to them: No, it is Picasso who was influenced by the Hopis. [Kabotie stops abruptly and giggles.]

At the beginning there were not very many of us. Velino and Awa Tsireh . . . there were just the three of us. Then years later Dorothy Dunn started The Studio in Santa Fe and there were all kinds of painters. But that was much later. We had no teachers. We knew how to paint by ourselves. It was as if we remembered our paintings, as if they had come before us like the plants from out of the ground.

ALLAN HOUSER

His Chiricahua Apache name is Haozous *(Pulling Roots) and he was born in Apache, Oklahoma, on June 30, 1915. His granduncle was Geronimo, who was imprisoned at Fort Sill, Oklahoma. Houser's parents were taken to Fort Sill and held prisoners with Geronimo's band. Later, after his father started to farm, young Allan helped at home and attended school intermittently. He began painting about 1924 after a childhood of great hardship. Midcourse in his career as a painter, Houser became increasingly interested in sculpture and has devoted most of his time during the past decade to sculpting, although he continues painting from time to time. Houser's education was centered at The Studio where he worked with Dorothy Dunn. Since 1962 he has taught sculpture and painting at the Institute of American Indian Arts. In 1939, he received a commission to create murals for the U.S. Department of the Interior in Washington, D.C., partly as a result of his study of mural art under Olle Nordmark at Fort Sill. His awards are numerous and he has been a constant prize winner at the Philbrook Art Center's annuals. He was the recipient of the Palmes d'Academiques from the French Government for his contribution to the advancement of Indian art. Today he is generally regarded as the leading Indian sculptor in the United States. This interview took place in his home in Santa Fe in July 1975.*

I'm always getting into discussions about this controversy between Traditional Indian art and these new things that are happening. I was

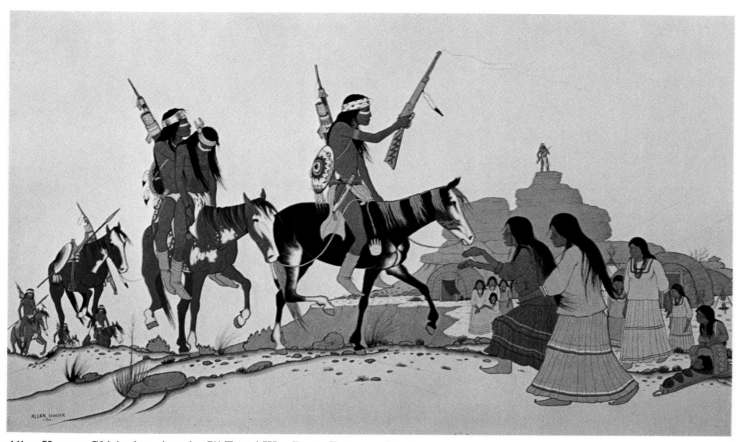

Allan Houser, Chiricahua Apache. Ill-Fated War Party Returns. *Courtesy Philbrook Art Center, Tulsa.*

on a panel at the Denver Art Museum, and people tried to feel you out on the subject. It worries them and they want to know where you stand. It comes up all the time. Lots of talk about R. C. Gorman and Fritz Scholder and the whole modern trend. To some people it seems as if people like Scholder are belittling the ideas that Dorothy Dunn started here in Santa Fe. But I don't put the kids down because I think that this Contemporary art is a very good way of doing it and that's their way of interpreting what they feel. And I don't put down anybody, young or old, who doesn't like the modern approach and stays with the old ways that Dunn introduced. That may be the *only* way they can do it. They simply don't know any other form of art and they haven't been exposed to it. But I can't go around and look at somebody's work and just because it might look old-fashioned, I can't say "That stinks!" I've heard too many other people say that, and frankly I think it's too harsh to discourage people like that when all they are doing is what they feel.

If I'm going to do something in the Contemporary style or if I want to stick to the old way, I think that's nobody's business but my own.

Lots of people ask me if in the final analysis there is anything that can really be called "Indian painting." They want to know if it's possible for an Indian to reach the point where he's assimilated so much European technique that nothing is left which distinguishes his art from any other kind of art. I know people who look at the art of the students at the institute [IAIA] and because so much of it is very new they ask me if there's anything that makes it Indian art besides the fact that an Indian painted it. Well, I'll tell you the truth, I really don't think so. I think that something always comes through . . . and that's the fact that Indian people still have this very deep feeling and they still have traditional backgrounds. Certainly some of the old ways are gone but to a very great extent the old ways are still important. Maybe they are even more important to us today because we realize how much has been lost.

Young people know that they're Indian and they hear the stories and I think that these young painters are using some of the symbols and the stories . . . but in a very abstract way. Another thing I can see them relying on is some of the color, a distinctive kind of color which has its roots in the Indian arts and crafts. Time and again in class I see them reverting to these colors which their parents and their parents' parents like. No matter how abstract their composition I still see those familiar Indian colors being used. They may not even know they're doing it. Now that's part of being Indians.

However I'll admit that you can walk into a gallery today and not know that among maybe a dozen Anglo artists there are two or three Indians represented . . . because some Indians are doing painting that is so abstract it's undistinguishable from Anglo art. Now I'll give you an example, the young artist Earl Biss. He's going the other way now. I was just talking to him the other day, and he was wondering why he can't

Allan Houser is seen in this photograph of 1939 working on his mural Breaking Camp During Wartime, *which he was painting on the north wall of the then-new Indian Arts and Crafts Room of the Department of the Interior Building, Washington, D.C. Courtesy of the artist.*

sell. His wife was very concerned because she thought he was doing work that was just as good as anybody else. But he was almost entirely abstract . . . something like Scholder . . . the same thing has happened to Biss. Now for years Scholder was doing stripes and nudes and everything else. But he just couldn't get by. He was sleeping over here in a garage near Alameida. And he suddenly turned to what he always rejected, doing something with the Indian subject. So Earl Biss is doing the same thing; he's turned around now and he's doing horses and riders. They're kind of suggested rather than straight realism — you can make out a partial contour of the horse's head — and he's selling everything he can paint. It seems to me to be a turning point just like it was for Scholder. I'm not saying that they paint Indian subjects just so they can sell. It may be something quite the opposite: they may simply do their best work when they are dealing with something they feel deeply and know more intimately than the ideas behind experimental art that originated in New York and Europe.

I think I can understand to some extent why there's so much hostile reaction to experimental Indian painting. Most Indians have grown up to have great pride in being Indian. They believe in showing Indians in the best possible way. And then if somebody comes along and makes distorted Indians with buckteeth . . . well, it makes them mad. Now I know that maybe Scholder doesn't want to do realistic things and maybe he's saying something that doesn't count on accuracy.

I'm very much like Bosin and Blackowl; when I do something related to Indians in my work it's authentic. If I'm not sure, I go to one of the old people and I find out. We have these people we can go to and get the kind of truth that just can't be found in books and museums. When I was doing the dioramas at the Southern Plains Museum I worked with an old Cheyenne lady 'cause, I'll admit it, I'm Apache and I wasn't too familiar with the Cheyenne culture, and I learned an awful lot from her.

On the other hand I'm not against Contemporary Indian art. I simply tell my students that they shouldn't go about it as if they're willing to starve to death. While they're doing something which is very personal they should also do something that can be available in their exhibits so people can buy something. Like my son, well, he does some pretty strange things in his art. But he also does other things to get by. He does masks and some small carvings that are fairly realistic. But he's determined to do the things that are personal to him . . . the art which most people can't understand. And I admire his determination.

I think that if I were young right now, I'd still be doing what I did in the past. I explored, I experimented, I didn't like to feel limited. So I'm not an old man who is criticizing the young for doing things their own way. I simply believe in an artist's being a bit sensible about doing enough things to get by at the same time that he's exploring his personal visions. After all, my sculpture is pretty unusual. And if I were young it would probably be more unusual. So don't misunderstand what I've told you about Fritz Scholder. I admire his daring and I like the fact that he's adventurous. I just think that I also understand why some of the Traditional Indians get up in arms about the way he depicts Indians.

Maybe I sound like I'm too concerned about money, but remember that I deal with art students and I have to help them realize that you can't live on air. Considering how precious little money Indians have had and how little they earn in comparison to Anglos, it's amazing how many Indians dedicate themselves to art. You'd think they'd be so busy scratching out a living that they'd hardly have time to do much of anything else. But it's gotten a little easier for Indians. There are more grants and scholarships. It's a lot easier today for a young Indian artist. I couldn't go to college when I was a kid. I was working on the farm with my dad. We worked hard. We farmed a hundred and sixty acres with horses.

I was twenty years old when I finally decided that I really wanted to

paint. I had learned a great deal about my tribal customs from my father and my mother, and the more I learned the more I wanted to put it down on canvas or something. That's pretty much how it started. So when The Studio opened here in Santa Fe, they ran an ad in the papers and I saw it up at home, in Oklahoma. I had a friend and the two of us wanted to come down and study with Dorothy Dunn. Well, it really didn't work out as I had wanted it to because I was interested in exploring realistic painting. But when I got to The Studio it was the old Traditional style they wanted from you or none at all. Dorothy Dunn told me that if I was going to do things that are realistic, then you better go on out and take the next bus home. Well, some of the kids did just that. That's what my friend who had come to Santa Fe with me did . . . he left because he couldn't get along with Miss Dunn.

What Dunn did was this — and I can tell you because I was right here at The Studio when it was beginning. Everyone was encouraged to search their background for traditional things. That's all she permitted us to do. If you did a landscape or something, she wouldn't accept it. Eventually she and I didn't get along too well because she found that I was doing a type of Charles Russell technique with watercolors. She told me that she didn't like my work anymore. So I said: OK. But that didn't discourage me because I was already hooked on being an artist and the Russell-type of work was just a phase I was going through. It didn't hurt anything. In fact it taught me quite a few things about watercolors.

I was a little too late to get in on the Susie Peters and Dr. Jacobson activity in Oklahoma. And anybody who had any interest in art and didn't have any money — the only place for you to come was The Studio. Everybody came here; you had to come here. Oscar Howe came here. So did Harrison Begay and Quincy Tahoma. Everybody was at The Studio. And fortunately all of these guys were in my class. Some of us had problems with Miss Dunn and some of us didn't. It was a bit limited. You had to pretty much focus in on what she had in mind. I went along with it: she was trying to bring something back which was important. But I think I was held down. She should have given me the chance to study anatomy for instance. But she said: "No, Indians have a natural feeling for action and rhythm." Now it's a good idea, this belief that being Indian is something that you're born into. But it didn't help me learn anything about anatomy. Well, she played on that notion of hers and lectured about it and, finally, she put it across.

My only objection to Dorothy Dunn was this: she trained us all the same way. "You either paint like this, Mr. Houser, or it's not Indian art." But what the hell, you have to have your own interpretation of things. I happen to think I'm a pretty good draftsman, but she didn't think much of that. And what happened was that almost everybody was painting identically for a while. If somebody like Begay made a new kind of tree, everybody else started doing it. And if somebody started a little Bambi-

like deer, everyone else had to paint it. Harrison Begay, I remember, would do a horse. He'd draw it in pencil and trace it off on paper and it would sell just like that. So he'd trace it the other way, and then a few months later he'd do it again in some other slight variation. Eventually someone would say: "Hey, I saw your painting in *Arizona Highways* magazine." And you'd have to tell them: "No you did not — that wasn't me."

Now it's fine to be influenced by each other. That was part of the good thing about being at The Studio with all the guys who became the big Indian artists. But you've got to do it creatively and make something personal out of it. Like Blackbear Bosin got a lot from Quincy Tahoma, but it's original. Blackbear made it his own. And now Rance Hood has gotten something from Bosin. That's fine. But originally we were all copying each other so you just couldn't tell one of us from another. It took us time to realize that we had to find ourselves as artists. And when we realized that we started to become the kind of artists that we are today.

A lot of people want to know where that cuteness in some of the art came from, like the Bambi-deer. It came from Walt Disney. The one who did those the most was Pop-Chalee. She even had the little Bambi eyes with the curly lashes. They were trying to relate those Disney animals to the outdoors. They were all right for Christmas cards. But it wasn't a good idea for artists who are serious about their work.

I put everything that I have into all that I do and if it's not right, then you won't see it on the market. I use all that I know, for I feel that I must make progress, I must not stay in one place. Growing up with Dad, hearing him talk, I've managed to keep a very strong feeling for my people. He relived the early days. People came from all over to hear my dad sing, not for his voice but for his memories. He knew all of Geronimo's medicine songs. I can remember old people with tears running down their cheeks when he sang about things they remembered. Being around my Indian friends makes the difference in the way I live and the way I paint. I always tell my students, "be an Indian but allow for something creative too."

OSCAR HOWE

A Yanktonai Sioux born in 1915 on the Crow-Creek reservation in South Dakota, Oscar Howe earned his M.F.A. degree at the University of Oklahoma in 1953 and has been a professor of art at the University of South Dakota since 1957. Prior to his university training, Howe had studied at The Studio in Santa Fe under Dorothy Dunn. While there and

for several years after leaving, he dealt with Traditional subjects in the nostalgic manner of The Studio, occasionally basing his works on nineteenth-century Plains hide paintings.

During World War II he spent almost four years in Europe with the U.S. Armed Forces, where his exposure to European art had a very strong impact on his view of art. He returned to attend the university, continuing to use a modified Studio style in his paintings, but what also began to be evident in his work was a rather improbable kind of neocubism — improbable because this kind of painting had never before appeared in the work of an Indian artist. Oscar Howe unmistakably bridged the gap between Indian art and mainstream art; along with Joe H. Herrera he was the avant-garde of American Indian painters. Why, then, didn't he cause the kind of controversy that has surrounded Fritz Scholder?

There is no question that Howe was every bit as influenced by European modern painting as Scholder. Howe, however, sees a relationship between his personal vision as an Indian painter and the concept of nature as it is understood by European cubists. He expresses this view of reality in the formal reconstruction of the same romantic world which is visible in Traditional Indian painting: the reshaping of images into structural planes, coloristically pleasing combinations, tastefully centered on the familiar heroic and mystical view of Indians. This view of Indians, though structurally revolutionary for Indian painting, hasn't deeply disturbed the most avid Traditional painters who seem to approve of Howe though he has brought off a radical departure from "art" as they know it.

Scholder, on the other hand, is essentially motivated by an expressionistic concept which not only reshapes nature but does so in a non-Romantic style which abandons idealization and embraces what is often seen as "distortion." Howe sees nature differently from the way Scholder sees it. That distinction is as diverse as the reality of Francis Bacon and Lyonel Feininger.

Howe has been capable of explaining, perhaps of justifying his idea of reality, because the objects he depicts are not offensive, whereas the subjects in Scholder's work have been acted upon by the artist in a way that impairs them as suitable "objects" for an audience primarily interested in "objects" and not with "painting" (for paintings deal not with "objects" but with "subjects.")

The interview was scheduled for late July 1975 in Vermillion, South Dakota, but a heart attack curtailed all of Mr. Howe's activities. Dr. John Milton, the editor of the South Dakota Review, *was kind enough to permit the excerpting of an article by Howe from* South Dakota Review, *Vol. 7, No. 2 (Summer 1969).*

The Traditional Dakota Indian [Sioux] painting was called "The

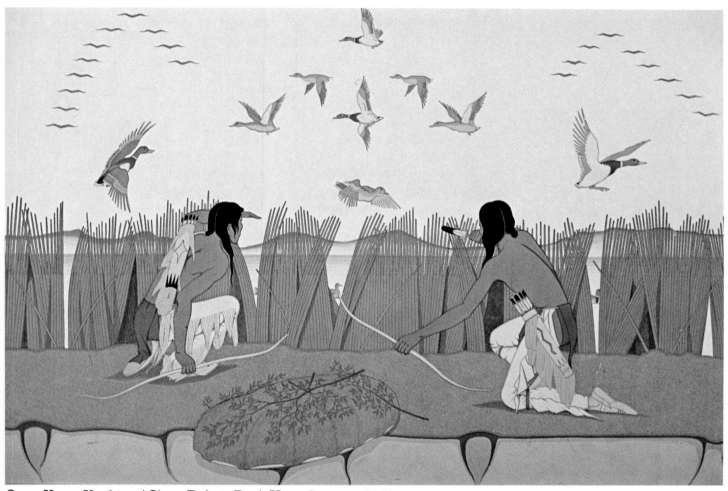

Oscar Howe, Yanktonai Sioux. Dakota Duck Hunt. Courtesy Philbrook Art Center, Tulsa. An example of Howe's early Traditional painting prior to the rise of neocubism in his work.

painting of the truth," a painting ceremony in which the participants were the artist, the relater, and the selected witnesses (the one who paints, the one who recounts the events, and those who witness the way the artist interprets what is told).

The drawing-painting of the semi-abstract art is a two-dimensional rendering of object-idea. Soft and plastic to hard line is used, depending on whether it is abstract or objective art. Symbolic painting is geometric and in symmetric balance while the objective is more or less occult in the balance of the composition. The qualitative and physical aspects [of the painting] are indigenous, so [they] are not [truly] abstract but are meaningful and comprehensive [to the viewer] — so decorative art is never [really] private but usually has a definite idea or story in a visual form [which it conveys]. Therefore it can be understood by the [Indian] group.

Colors usually take their meanings from nature: blue (sky) peace; red (fire, blood) war; yellow (light) religion; dark (no light) evil; green (flora) growth; and white (clean-new) purity. These are the basic color meanings. Each group, society, or clan has its own color meanings, so meanings vary from group to group [to that extent they are private].

Line is visually dominant but its function and movement depends entirely on esthetic points. "Owa" not only means drawing-painting, it also means writing with a point-to-point movement, always esthetic or kinesthetic. For economy of time and space and clarity of meanings, simple but effective esthetic movements are used to objectify ideas [in a painting]. Distortions in drawing-painting are used for building the composition and clarity of expression.

Ceremonial paintings have an emotional value in addition to their purpose as artistic records. The formal execution of a documentary painting by an authorized artist shows that the artist takes part in community life and affairs as a contributing member in a community, working to fulfill the need for his services. If he satisfies or fulfills the community needs, he is accepted as one of the officials. His work deals entirely with art-related activities in the community.

In Contemporary Dakota Indian painting, more often than not abstract elements are combined with the pictorial for meaning but kept separate within a single composition. Pictorially the objective area of the composition is at a maximum while the symbolic is minimized. The degree of emphasis varies with individual artists.

The underlying design [a symbol] may be superimposed by an object or by an abstraction. The symbol not only functions as part of the composition but also extends the meaning of the painting beyond the apparent. It is a compositional device to enhance pictorial quality. The symbols may be versional but are usually drawn close to the original Dakota designs — so the symbolic is aligned with the total painting in both design and meaning.

Oscar Howe, Yanktonai Sioux.
Dance of the Double Woman,
*1950. Courtesy Philbrook
Art Center, Tulsa.*

The evolvement from the Dakota skin-painting technique, such as the
utilization of esthetic points, seems paramount in modern painting. Flat-
patterning stimuli of points evolve to shapes of Dakota cultural mean-
ings. Nature (ceremonies, dances, genre scenes, legends, etc.,) is now
presented on a subjective basis. Colors can now be private and indi-
vidualistic or traditional. The abstractions are now individualistic with
slight modifications of the tribal symbolic designs. Styles can embody
dimensional qualities. The Indian "geometry" with its characteristic
eye-measuring and linear pattern-structuring is more esthetic than the
mechanical forms both in the total scheme and in detail. Even in con-
structing objects, body-lines are more emphatic and real because
experiencing-lines happened during the creative process.

Traditional means of expressing forms in the manner and the spirit
of the old art is a criterion at the onset of my work. It is a school of art
that deals primarily with true or versional use of historical forms and
their qualitative aspects. Eclecticism precedes individualism in this
Indian art expression.

My reason for painting is to record visually and artistically the culture of the American Indian, particularly the Dakota Indian. My reason for painting is to carry on what is traditional and conventional in art.

The medium of casein not only is allied to the Dakota Indian medium of tempera (water, glue and egg base) but also to the technique of applying — quick drying and the easy flow of the tempera from brush to surface allowing longer stroke lines in application or quick line, at will.

My first knowledge of expression was line abstractions as a boy of about three years old when the only language I knew was Dakota. Now I seem to work toward that same abstract-symbolism, but I know the symbolic meanings now.

The Indian painter's relationship to his Indian society is one of delicate and deep understanding. Individualistic art can change traditional art and become private and personal, but if the change is a natural transition, I believe that new art would be accepted by the majority of Indians. As long as the artist is living according to standards, he is "right" within the Indian society. Knowing that the source of inspiration for the artist stems from "sacred" dances, ceremonies, etc., the Indians accept the artist as a member of their society. He creates an image of the Indian as one meaningful to them, so the acceptance depends on how and what the artist portrays.

The Indian painter's relationship to the white society depends on what kind of life he leads and what kind of people he associates with. He is like a pioneer stepping from one society into another. If he retains some of the finer points or good parts of the Indian culture then he can compare the good experiences of one culture with those of the other. I think a person is better for knowing and *experiencing* (not just understanding) two cultures.

At the beginning of my art work I was in the wrong place and wrong time to start my painting. I was in South Dakota in the late thirties. I sensed the need for art here but my kind of art was Indian. That seemed a mistake at the time, but the dream of painting was my life's ambition. To find a market for art was another problem. I taught Indian art to Indian children; my pay was room and board. The idea to start an Indian art movement fizzled as I realized the futility for art here. Art was not wanted, at least in this part of the Midwest. Indian art seemed not part of life at that time.

So I had to concede that if Indian art were to exist I must do it as an individual effort. Indian art became an individualistic art. Versions of the old forms were defined for personal expression.

I believe natural art expressions are true reflections of culture, and not by any means of projections, like snobbery, use of drugs, etc. The intellectual approach of the traditional manner and method of composing through esthetic points has become part of my working process, though in my work it is not a formal ceremony. My art is eclectic. The

line in different degrees of curvature is Dakota symbolic form. Part of my work stems from these meanings. The Dakota execution of lines were ceremonial strokes of truth. Dakota pictograph-writing, sign language, and their art trends bear out part of the Dakota Indian philosophy of esthetics, as exemplified by their use of lines. The old Dakota proved a point in art that line does come from nature, and he made use of the truth-line to chronicle his environmental happenings. Being mindful of this and other manifestations of the Dakota Indian, I have worked to add dimensions to Dakota art, the use of esthetic lines and less use of kinesthetic lines meaning objectifying with experiencing lines and colors used to define form-composition. I remember when I was a child my first drawings were complete abstractions and not Indian abstract symbols or recognizable objects. I thought my first lines were beautiful, plastic and full of tension; I even sensed live quality in them. I remember my parents saw these lines and told me never to draw them again. I still made these lines when no one was watching — three-dimensional lines in space, but they appeared two-dimensional so I had to imagine them moving in and out of space. Eventually I came in contact with other children who drew recognizable objects. I drew objects too, but I always managed to keep my drawings more linear.

In my life I have known through experience hunger, poverty, poor health, half blindness, slum life, racial prejudices, war, thirties' depression, life under bureaucratic rule, stupidity of people. I don't think these reversals touched my art. My determination for Indian art expression overshadows those times of trial. I am not bitterly hardened by them nor did I shut them out of my mind. Through it all I drew and painted the Indian.

The Indian verbal form is given visual form in Indian art. The language is beautiful and poetic. When the Indian speaks of nature it is like one of the elements speaking of another element. The Indian lived in nature so long that he became part of it. He is one of the balancers of nature; and he created a true god, but that god, Wakan Tanka, is not an image of man, he is a supreme spirit, God of the other spirits and the living beings. The Indian was a very religious man, his altars were the unusual formations in nature: the sun, moon, trees, hills, rocks. I try to paint the Indian's true identity as an intellectual being. I am doing this with my experiences of being with the Dakota Indians who hunted the buffalo, lived in tipis, even some who fought the white men. I heard them speak in their formal language. The Indians tell of their culture and activities, being actually there and experiencing and enjoying their lives in nature. They described in detail a beautiful culture — a clear picture made with words and songs. I have never read a book on Indians that equaled what I heard from these Dakota Indians. I heard the truth from them and responded by painting them in like manner of their words. So you see what my painting is — a visual response to the Dakota language

to known facts: the Dakota Indian, his culture and activities, Indian art and processes.

Art expresses better than anything else.

BLACKBEAR BOSIN

His Kiowa name is Tsate Kongia *(Blackbear) and he was born on June 5, 1921 near Anadarko, Oklahoma, the grandson of a Kiowa sub-chief also named* Tsate Kongia. *He was the eldest of four children. At seventeen, he worked on the farm in order to support his family, painting in his free time. He was unable to accept two university art scholarships because of his obligations to his family, yet he achieved the most wide-spread success of any Traditional painter, without any formal training. He was the only American Indian artist who was represented in the 1965 White House Festival of the Arts. He is a man of uncommon eloquence and dignity, and is probably the most aware and sophisticated of Traditional painters. He is fully conscious of the implications of his art against the background of Anglo art history and has intentionally created a unique style from roots and influences he carefully studied. What results is a controlled theatricality in the best sense of that word, a vast stage upon which Blackbear proudly parades the glorious pageants of an Indian America in which no white man has ever set foot. This interview took place in the home of Jim and Beverly Baum in Oklahoma City in March 1975.*

I think a good place to begin is with the idea that Traditional painters who depict worlds that are strange and dreamlike depend upon visions from peyote. That simply is not true. Peyote is not a necessary stimulus for the painter. I doubt very seriously that any Indian artists rely on hallucinations — of course, there are maybe one or two, but I know these men and I don't think it is the major factor in their art. From a purely religious standpoint, yes, it's true that Indians are involved in the peyote cult, but the visions of our paintings are not simply the drugged hallucinations of a bunch of escapists. That is an important distinction I'm trying to make. The drug is not used as an artistic crutch. Indian painters may try to recreate things that they have envisioned in their authentic religious experiences with peyote, but they don't take the drug and then rush off to their studio to paint. I don't think that we need a stimulus which is any different from the inspiration of any artist, contemporary or otherwise.

I've often wondered exactly where my visions, my inspirations come from, and I've thought about it since I was a young man. Perhaps the

explanation is simpler than it should be: I have always worked in almost complete isolation. Yes, fifteen or sixteen years ago I used to go to the exhibits and competitions to see what other people were doing, but since then I have been alone. It was then that I developed a style which I hope is uniquely my own. That is all I can really tell you. I was alone and gradually a certain attitude about painting evolved.

You must remember that I had no formal training whatsoever. My contemporaries, though they were older, were Mopope, Auchiah, and Tsatoke. And I frankly admit that they were my idols when I was a young man. They were the only painters I recognized in my heritage. I was privileged, in the truest sense, to have gone to a mission school where a priest had a very large collection of the early Kiowa art. And I poured over it with astonishment and excitement. I was very young and I thought these guys were absolutely *tremendous!* They were heroes. They were the only Indians I knew who had risen out of the gloom and achieved something important and beautiful despite their subjugation and poverty.

You should know something else: the collection was kept by the priest in a library, and the books and the paintings became somehow connected. I became a voracious reader. So learning, reading, and the achievements of the Kiowa painters became correlated, creating enthusiasm enough to drive me to read and learn.

Seeing other illustrations, seeing European painting, learning that there was an ancient culture behind me and my people — all of this combined into a personal education. I began to realize that there was a certain problem in the proportions of bodies in drawings. I was not certain how to improve my rendering of anatomy but I experimented and made discoveries. It was from that premise that I started painting.

I was not alone in school. There were perhaps three or four other youngsters who were trying to paint. But unfortunately my teacher, who had five or six different grades in one room, didn't recognize my ability. She could see the talent in some of the other boys who were making drawings, but she didn't seem to think much of me as an artist. It's an old story. I wanted so badly to attract her attention and win her praise that I really did try hard. But [and he laughs] she never did recognize me . . .

What first attracted me to the Kiowa painters was their color. To this day I still paint feathers very much the way they did — perhaps with a bit more elaboration and realism. But don't misunderstand, I would not put too much realism into a painting or I would ruin its vision.

When Anglo children start making drawings they seem to want to duplicate what they see exactly. That's realism as I understand it. For some reason, and I don't understand why, most Indian children are not interested in simply duplicating what they see. They want to capture something else. Rather than try to create something as the Great Spirit

Artist Blackbear Bosin with his painting Death Went Riding, *which is a clear statement of his highly theatrical approach to Traditional Indian painting. Courtesy of the artist.*

created it, they want to do something entirely human. They want to create the essence of it. Their whole tradition teaches them this — language and figures of speech and even jokes. Indians are very poetic people by virtue of the most fundamental elements of their life. So they paint the symbols around them: the pulse and the essence. And they leave things alone beyond that, because they know that they can never be as great as the Spirit which created everything. I fear that may sound a bit trite, but I believe it. Indians simply do not want to take the real world into their hands and shape it. They respect what has been created and they only want to sing about it in their painting, not duplicate it as if they were playing the role of gods.

I'm quite capable of doing decent painting in the European style, but I find it empty. I simply don't care to do it. I would rather stay within the limitations of Traditional Indian painting. I constantly try to shape and change it but I also try to stay within the general confines of that tradition. It can reach the point of utter frustration at times, but I

Blackbear Bosin, Kiowa-Comanche. And They Moved without Him, *Courtesy Philbrook Art Center, Tulsa. The Plains Indian burial scene is here depicted with dramatic surrealism: the platform is raised above the earth with the wrapped body of the dead held up to the sky. The spirit of his horse, food, and clothing for the long journey are left with the departed . . . while the friends must move on alone without him.*

always find a new course to take, a new way of expressing something
that I haven't expressed before in the Traditional idiom. I have learned
to combine transparent and opaque watercolors in the same painting, for
instance, and that suddenly opens a whole new world of possibilities for
me without basically changing the Traditional framework of my art.
The limitations are very stringent, but I find a tremendous challenge in
the restrictions — as a composer must feel when he composes variations
on a theme.

I do not have an epic history. What I mean is that my people, the
Kiowas, came here to ally with the Comanches. We don't have a religious
dogma like the Sioux or the Pueblo tribes. Perhaps it was because we
were such a vast tribe, always on the move. We had given up our Sun
Dance. Other tribes have a spiritual background that the painter can
relate to, but not the Kiowa/Comanche. Not really. So that's why I say
that I really don't have an epic to relate to.

I recall that a white man looked at a painting of mine about twenty
years ago, and he asked me what particular tribe was depicted in it. I
didn't really know the answer, so I said the first thing that came into my
head. I told him that I had drawn my own peoples, the Kiowa and the
Comanche. He smiled a bit and then he asked me why in that case I had
Sioux designs on the moccasins.

I can tell you I retreated into my little shell in a hurry. I had never
thought about authenticity. So from that day on I started doing some
real research, trying to find out something about my people that doesn't
come with inspiration, but that has to be learned through talking to the
old people and reading. Do you see, it was very much like the library
of the mission school again: my painting and my reading were correlated
all over again.

The older Indian painters may have already mentioned this to you.
I don't think the young ones are aware of it, but people like Blackowl
may mention it. There was a time when we didn't have anywhere to
retreat. We had backed off as far as we could. We were at the end of our
world and yet we were still being pushed. We made no attempt to fight
anymore. The only thing left for us was our imaginations and our visions
and memories of the past when we were free. My grandmother remem-
bered it clearly. It isn't a myth or something fantasized. It was very real
and very near to the old people. When I was growing up it was a very
trying time. I must admit I still have feelings from my childhood prob-
lems. I was the first generation after the end of us. Painting was a way
of looking at the past. It kept our dignity alive.

I suppose I am a little bitter. But in my painting there is no room for
bitterness. In fact, in my paintings there is *absolutely* no recognition —
none — of our defeat. I am describing America as if 1492 simply had
never happened.

The idea of combining the *fact* that Indians lived here for thousands of
years and the *fantasy* of their persistence isn't very peculiar. After all,

the Plains tribes had a dream epic which directed their personal approach to just about everything in life. I hope to hell that I'm not having some kind of messianic complex in my paintings, but Indian art definitely has a relationship to the ideals of the Ghost Dance. It can happen you know, Indians can become very confused about this dream of a messiah — Blue Eagle and Mopope did just that, in my opinion. They can begin to see themselves as a sort of painter-messiah, bringing back the old days with thunder and vanquishing the intruders, just like the Ghost Dance was supposed to do. Many artists can have such an enormous belief in their personal vision that they simply can't tell after a while that it is a vision.

There is a good deal of battle between the Contemporary Indian painters and the Traditional artists. But I can't honestly see it — there is enough room for both idioms. I can go along with someone like R. C. Gorman more easily than I can with someone like Fritz Scholder, but that's only because Gorman does things in his paintings I can relate to. Scholder may be brilliant, he may be a satirist — I really don't know. I simply can't relate to what he's doing. But I don't doubt his right to do it or the fact that for many people he is a very important artist. But there is something about his paintings of Indians which offends me. I have no argument with him or Gorman or anybody else. There has to be room for everyone's vision when you've been pushed into so little space. Indians have to live with each other.

I'm trying to be honest with you. I think I might resent the jargon of the new Indians because I'm not as articulate as they are and I wasn't lucky enough to be academically trained. I draw back; I retreat if they push me. And finally, I'll leave if they push too hard. I'm not against their training or their academic jargon, I just think they sometimes use it to make a case where they can't do it on a plain gut level. They out-talk me but they may not be making any better sense than I am. Education seems to give people the ability to argue, but it doesn't always give them a good argument.

I don't knock the modern painter's success. I admire it. But I believe that they're lazy. That's how I see it. I look at their paintings and I can't see anything but stylish stances. Even Picasso admitted he was doing the same damn thing again and again. I'm not sure how much of his work he *really* felt and believed in as personal vision.

I'm not much of an admirer of Salvador Dali, but I see a certain similarity in his mystic world and that of Traditional Indian painting. In his backgrounds and the finely detailed painting, the draftsmanship and the indifference to European realism. Perhaps Miró has things in his work which I can also relate to our Traditional painting. I don't know why the surrealists always seem to emphasize painstaking control and clarity of detail, but they do. And that reminds me of Traditional painting.

I am not certain why Indians arts and crafts have always been executed with such care for precision and detail. Perhaps it's because eventually some spiritual ideas were involved in the creation of things and they would be ruined if the objects weren't perfect. It was the same in the sacred dances — each step had to be perfect or the spiritual value of the dance was lost and the harmony of things might be upset and cause grave problems for everyone.

There are a great many stories about the way Indians keep hundreds of designs in their minds and can paint pottery or weave a blanket or paint a painting without any sketches. With some very special designs this perhaps is true, if they are repeated often enough and the craftsman has a *limited* scheme of variations clearly in mind, I guess he can work without any sketches. But that isn't the case with the painters I have known. Everyone in Traditional painting works from pencil sketches. I get angry with myself for the amount of work I put into my sketches. I work on tracing paper until I get a good sketch. Then I turn it over and looking through the paper I improve the original, drawing on the back and making corrections. It may take eight or nine tracings until I feel the sketch is correct. At that point I turn the tracing over and rub it onto the painting surface. That provides me with the outline I need. Then I start to lay in the color like some sort of very complicated coloring book. After you make your first overlay of paint most of the features and details are obscured, so actually you're very much on your own. The tracing gives you little more than an anatomical shape. From that point you're really starting to sketch again, but you've done it so many times by this point that you know what you want.

Originally I was painting like Blue Eagle or Fred Beaver, I mean that I composed my central images and the rest was left blank. But gradually I began to put in elements until the background was entirely filled. That was one of the progressions I made within the limitations of the Traditional ideal of Indian painting. Probably my sense of drama is what led me to develop the background. I wasn't just putting mountains behind the *Mona Lisa,* I was developing a dramatic image in which everything was essential to what I was trying to express in the painting.

Traditional painting is two-dimensional. It's difficult to paint the two-dimensional figure and show action. It has to be achieved by the movement of hair, fringes, and things like that, and I think that perhaps this is where this style you've noticed in Tahoma and me and Rance Hood comes from. We have used motion to help us express what is essentially our dramatic sense.

I think that you will get a very different picture of Indian painting depending on the artist you're talking to: those who were trained in the old techniques at The Studio in Santa Fe or at Bacone will have a different attitude from the ones who were trained in the modern techniques at the institute, like T. C. Cannon. All of these ideas are important.

Personally I speak as an untrained artist without the conscious influences that other painters may understand. As I already told you, I think I am the kind of painter I am because I grew up in a situation of almost complete isolation. My painting is dramatic — it has force and strong feelings — because it was my way of breaking out of my confinement, of making people respond. In that way perhaps my own situation is similar to the Indian's situation: he needs to be heard and his ideas need to be felt. If I could sing probably I would have been a singer. But I'm a painter and so I have tried to sing with my paintings.

FRED BEAVER

His Creek/Seminole name is Eka La Nee (Brown Head) *and he was born July 2, 1911, in Eufaula, Oklahoma. His parental grandfather was* Itshaus Micco, *subchief of the Akfuskee town group in Alabama, who during the days of the removal moved his people to Oklahoma where the town of Eufaula now stands. Beaver didn't begin to paint seriously until 1945. In a short time he has achieved an outstanding reputation. His original interest was in music and he studied both voice and art in Italy in 1944. He also studied art very briefly at Bacone College. He has become one of the principal Woodland artists: his themes are more often taken from Seminole life than from the culture of the Creeks. Beaver has a thorough knowledge of the legends and folklore which gives impetus to his narrative painting. His style is distinctive and one soon learns to identify his flat, motionless, and colorful works. Southeast Indian life is probably better interpreted by him than by any other artist. He's a quiet, extremely gentle man with a realistic view of his world and its problems. This interview took place at the Tribal Arts Gallery in Oklahoma City in March 1975.*

I've known Acee Blue Eagle since about 1927 when we both went to the Chilocco Indian School. But he wasn't known as Acee Blue Eagle back then. His name was A. C. McIntosh. [He laughs good-naturedly.] Well, anyway, he started painting once he left school and he made a name for himself and ended up as director of the art school at Bacone. Personally, I got started rather late with serious painting even though I had been doing pencil drawings ever since my Indian school days with Acee. About the time that he was at Bacone I married his cousin and so he'd come on by to see us all the time.

One day he happened to notice that I had some pencil drawings that I'd done and he asked me why I didn't try painting them. Well, I told him, I don't have the time. And that was that.

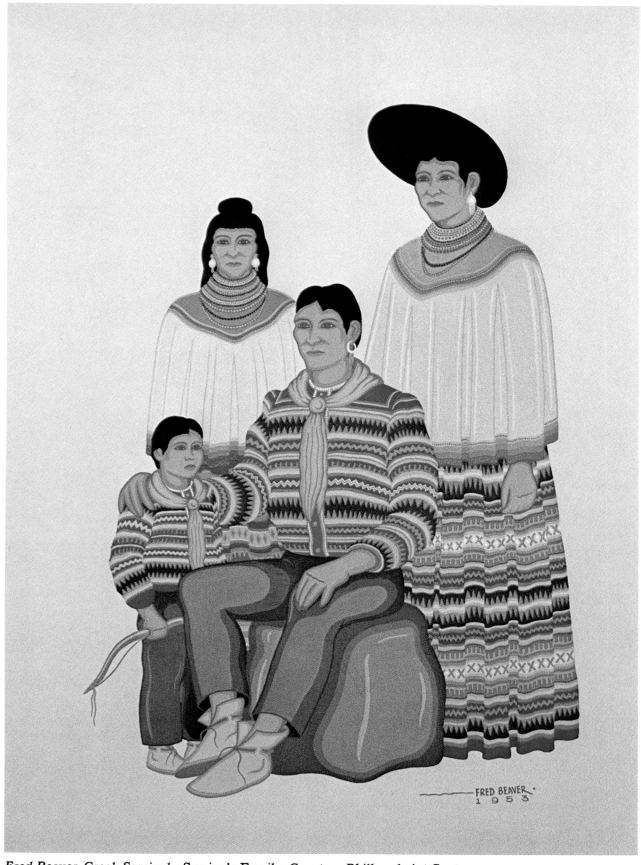

Fred Beaver, Creek-Seminole. Seminole Family. Courtesy Philbrook Art Center, Tulsa. Probably the best painting ever done by Beaver, this family group epitomizes his sense of color, the depiction of the typical Seminole ribbonwork in the skirt and blouse and collars, and a composition at once lyrical and static.

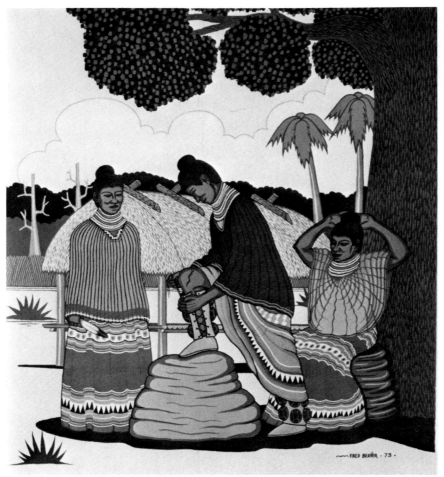

Fred Beaver, Creek-Seminole. Creek Women Preparing Sofke. Gouache. Courtesy David Connor. Sofke is a type of food made from cornmeal. The ground corn is placed in a pot of hot water and cooled. Ground nuts are added and also some bone marrow. It is a favorite food of the tribes along the Gulf Coast.

A little later, just before World War II, he gave me three sketches that he had done and he said: "Paint these and see how you do it." So I did. With watercolors, y'know. And I showed it to him. "You ought to take it up," he says. "Well," I told him, "I don't know." I'd been thinking about painting landscapes and things like that with watercolors. But that was the end of that for a while. I went off to Italy and when I came back I used to see these girls in *Esquire* magazine . . . the pinup girls, y'know. And I thought about it and said to myself: now I should do an Indian girl like that. So I did several paintings of these pinup Indian girls, and when I heard that the Philbrook Art Center was announcing its first Indian art competition I sent my pinups to them. After all, I didn't have the slightest idea what they meant by Indian painting. The Philbrook had just started that year, 1946, and nobody at that point really knew what it was all about. Anyway, they sent them back [he laughs] and said that that wasn't exactly what they had in mind.

That was my first experience as a painter. And that was my first contribution to the Philbrook show in its first year! [He smiles.] By the next year I knew a lot more about painting and art exhibits. I submitted one little painting on a Seminole subject. Sure enough they accepted it and ended up giving me honorable mention. That encouraged me quite a bit.

So the next year I submitted one Seminole and two Creek paintings, and by golly I got third prize for one of them! Well, as far as I was concerned that made me a painter. After that I managed to win first prize for the next five years!

At first I was doing it pretty much for the fun of it. But as I started getting more interested and visited shows all over the Southwest and Midwest, I noticed something that bothered me a little. It seemed to me that there were a lot of misunderstandings about Indian life in the paintings I saw. That got me interested in doing something to straighten it out. And I've been doing it ever since.

In 1960 I quit my job. I was a clerk in the B.I.A. and I got disgusted with it and quit. I just never got anywhere. That's what teed me off. And I got mad and just quit on them. Well, I thought I'd really starve. And I almost did for a while. [He laughs again.] But I submitted paintings to every show I could find, Indian and non-Indian. And after about eight years I started to get a name and my paintings were selling pretty good.

I taught myself how to paint, by looking at other people's work and by experimenting constantly. I don't know much about European art, but I've seen reproductions of this fella Toulouse-Lautrec. And it seemed to me that his paintings have a lot in common with the things that are typical about Indian art. Flat colors, a peculiar kind of line, and a style that isn't really very keen on realism but gets down to the spirit of things and of places and, especially, of people. Now it seems to me that I saw these Kiowa boys here in Oklahoma using the same techniques back before they died. Not much detail in the hands or the faces. No shadows. Very similar to Toulouse-Lautrec.

As far as I'm concerned this tradition of Indian art, at least here in Oklahoma, was created by people who trained themselves and didn't have very much influence from European art and knew almost nothing about it. The paints and the papers, sure, that came from the whites. But the way we paint, that came from us. Just like I taught myself to paint; so did Mopope and Tsatoke and all those Kiowa boys.

I know this as a fact cause I saw those Kiowas and I knew Dr. Jacobson pretty well. In fact, when Jacobson made the two folios of Indian paintings in France, he included one of my paintings in them. That's right. You know, that first painting I told you about that got honorable mention from the Philbrook? Well, Dr. Jacobson saw that painting at the Philbrook and he asked me to work on it a little bit, and then he went

and put it into those very first books of Indian art. So, you see, I really
knew those Kiowa boys and I know that Miss Peters pretty much let
them do what they wanted to do. Their art was their own, all the way.
That was *true* Indian art. And as far as I'm concerned that's what's
influenced all the rest of us ever since the Kiowas became famous. Once
when I was feeling like I wasn't making much progress, I asked Dr.
Jacobson what he thought, if maybe I should come to his classes and try
to learn some formal technique. But he advised against it and told me
to just keep on doing whatever I was doing. So I never did take any
classes in academic painting. Whatever I did I did by myself.

ARCHIE BLACKOWL

He is Cheyenne and his tribal name is Mis Ta Moo To Va *(Flying
Hawk). He was born in Custer County, Oklahoma on November 23,
1911. His great grandfather was Crow Necklace, the chief of the Chey-
ennes, and he is also a descendant of Roman Nose (Cheyenne). Blackowl
discovered art at the age of six when he saw old Red Tooth painting the
skin lining of a tepee. Encouraged later by Woody Crumbo, he began
to paint seriously in the early 1930s. He studied mural techniques at the
Indian Art Center at Fort Sill, Oklahoma, under Olle Nordmark. He also
studied art at the University of Oklahoma, the University of Kansas, the
Chicago Art Institute, the Rockefeller Art Center, and the School of
Fine Arts in Washington, D.C.*
*Blackowl is a man of great sincerity and candor. He speaks with a
rural naturalness but his comments reveal a keen intelligence and clever-
ness. His discussion ranges over the whole field of Indian painting and
culture and he talks about art with great ease. He also likes to discuss
the relationship between his paintings and his religious convictions. He
is a member of the Native American Church which is centered upon
peyotism. This interview took place in Oklahoma City in July 1975.*

We're kind of clannish, the Cheyenne people. We're the only tribe of
Indians in this area with all our traditions. And we still are governed by
those traditions. We have our chiefs, our clansmen, everything. I was
initiated into chiefhood in 1945. But I resigned 'cause I had to go off
and work. I told them I just wanted to get out so I could make a living
for my family, and they understood. Then I sort of lost track of what
was happening at home. And when I came back they wanted to reinstate
me, but I said, "No, I don't want to get involved in tribal affairs and
politics. I just want to be *me*."
What I want to do with being Indian is to paint. That's the best way

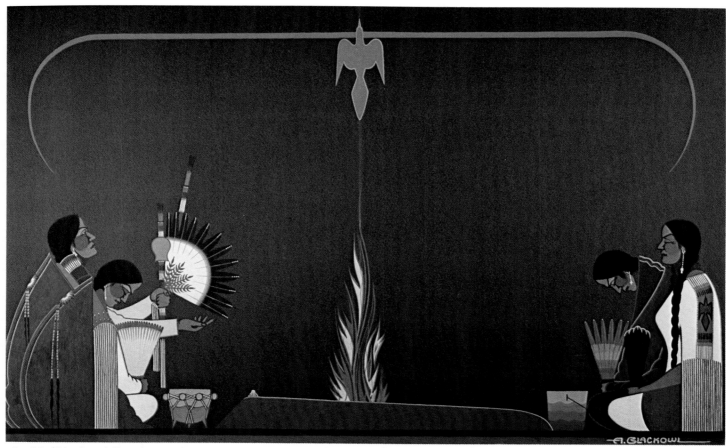

*Archie Blackowl, Southern Cheyenne. A Prayer for a Mother. Tempera. Courtesy
private collection. Probably one of Blackowl's best recent works, this painting
depicts a peyote ceremony. The long-necked bird is the anhinga, commonly
called a snake bird or water turkey, a cormorantlike bird of the Gulf Coast.
Its feathers are highly prized for peyote fans (which the women hold). The
peyote bird carries the prayers of the worshipers to the Supreme Being.*

for me to be an Indian and the best thing I can do for my people. I started painting when I was in college. I originally wanted to be an engineer. I was especially interested in diesel engineering, and I went the whole dog for it. I got a good set up for it at Riverside, California — that was the only Indian school teaching that kind of engineering. So my uncle gave me a Model A Ford and enough money to get out there, and I went.

I was out there about three months and just getting started and I got awful disappointed. Mr. [Frank] Phillips, y'know, the oil man, offered me a grant to study Traditional Indian art — but *only* Traditional. Well, I wasn't happy at engineering school and my drawings which I had always done as sort of a hobby seemed to be getting me further ahead than my schooling. I was kind of confused but I was really happy that I had finally been a success at *something!*

My art was always getting me into trouble. When I was young it was always getting me into trouble. My grandfolks raised me. I was the oldest child. My grandparents took me when I was about six months old and they raised me in the ancient customs. I was my grandfather's tail . . . in other words I was just a nuisance. I followed him everywhere and if he did something I had to do it too. They raised me in the true Indian ways. And then when I was about seven years old they took me to this damn Indian school of the government's and we all had to stand in line and they cut my hair off. They just cut my braids off and threw them into a box with all the other children's braids! My old grandmother went over there and got them. And they took all my homemade clothes away from me. And that's when I became a student.

My grandfolks stayed at the winter camp *all* that winter to be near me. And when I got awful hungry I used to run down there and they'd feed me.

It was hard being Indian in them days.

Later I learned to be proud. When I was initiated into chiefdom I had to go through four Sun Dances. And I was eligible to get my pipe — one of the youngest. But I couldn't just sit back and be a big shot in the tribe. I had to go and do what I needed to do: to paint and to show people something about the Cheyenne.

But you can't just go off and do whatever you want to do. Dick West — you know his paintings? — well, he's Cheyenne too, and we're always discussing the problems of painting the ceremonies. Y'know, we have to go ask permission from the elders. That's right, we got to get their permission. The dances are all right and the buffalo hunt, things like that are all right. But when it comes to ceremonial subjects, that's another matter, 'cause they're sacred. And it's hard to get it over to them what we're trying to accomplish by painting sacred things. They say: "Well, if it's a benefit to you, do *just one* but that's *all.*" So Dick West and me, we're always having to go over there and ask permission of the elders.

Archie Blackowl, Southern Cheyenne. Fancy War Dance. *Tempera. Courtesy Tribal Arts Gallery, Oklahoma City. Blackowl depicts the famous Plains Indian War Dance or, as the steps have become more hectic and the costume more flamboyant, the Fancy Dance.*

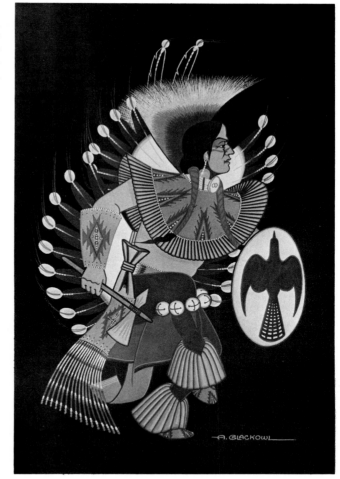

Archie Blackowl, Southern Cheyenne. Cheyenne Sun Dance. *Tempera. Courtesy Tribal Arts Gallery, Oklahoma City. A major ceremony of adult males of the Plains tribes, the Sun Dance is performed annually in a special arbor consisting of a series of posts connected by boughs to a central post. The two-tone painted buffalo skull, usually stuffed with prairie grass, contains the All-Powerful during the ceremony, which last several days and among some of the Plains tribes was climaxed by the dancers pulling free from skewers piercing their breast muscles. Eagle-bone whistles, the sacred pipe, singing, and drumming are part of the ritual.*

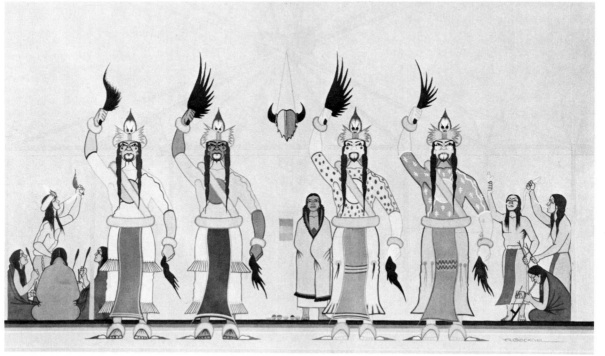

Like the *Burial Scene,* I created that because I saw one of them and I was so impressed by the beauty of it that I made a painting. But then this younger element comes along and they just throw it around and insult the Cheyenne something awful. They don't paint it the way it was and the way it's supposed to be.

Dick West and I talk. We've been working on two paintings for four years, trying to get all the details right. There are twelve different bands of the Cheyenne and every painting has to be authentic, the way all twelve bands understand them. So Dick West and I have to talk a lot to get our paintings right.

In a roundabout way the elders used to object to some of my paintings. There were a lot of things I started but I let them go. Because they didn't like it so I let it go. I was raised in the true Indian way, and you have got to listen to the elders.

Once, for instance, I sketched the Badger Ceremony — but it's not supposed to be seen by any white men, so I had to let it go. And the Arrow Ceremony — I let it go too. Dick West and me worked on some of the paintings secretly 'cause we couldn't do it on the outside; we can't let white people see them. Some day maybe, but right now we have to keep them to ourselves. The old people keep care of them, and maybe one day they'll put them out so other people can see them.

I like to paint the ceremonies. My grandfather used to say to me: "*Leave a mark.* Put something down so that when the young people see it they will understand."

Now Oscar Howe is a good friend of mine and his paintings are very abstract. But if you talk to him about his art he gives you a pretty damn good explanation of what he's after. He influenced my boy a lot. That's right, my son Danny went to college in Santa Fe and he told me that Oscar is kind of a mystic. But he can give you a good idea of what he's thinking about.

Oscar Howe is authentic, and I admire that. But some of these fellas don't know what they're talking about. These peyote fantasies they paint are fakes. Like Al Momaday . . . he never did come to a peyote meeting. I invited him. I said, "Hey, my friend, come to my meeting and I'll have a special place for you. Dick West is going to be there." He never came. And he paints about peyote and even wrote a book — *Peyotism,* he called it — but he never did it.

I've done it. I took part in the ceremonies. What I know is what I've taken part in. I don't just pretend. That's the way we still live today. We have attorneys and doctors but we still live the way we did from the beginning.

R. C. Gorman, Navajo. Kneeling
Woman, *1973. Oil pastel.*
Courtesy of the artist.

R. C. GORMAN

He is a Navajo, born July 26, 1932, at Chinle, Arizona, on the Navajo reservation. His father was the painter Carl Gorman, who studied after World War II at the Otis Institute. Although R. C. majored in literature at Arizona State College, he chose painting as a career. His depictions of Indian women which are done with monumental simplicity are among his best paintings. Dr. Frederick J. Dockstader points out that "Gorman has been experimental and uninhibited with his art and was one of the earliest to break out of the old style Indian School art shell and to create a bridge between the Traditional and the avant-garde. He has developed to a point where he now owns and operates the Navajo Gallery in Taos, one of the very few Native Americans to own his own art gallery." His art shows a strong Mexican influence, probably the result of his being awarded a Navajo tribal scholarship to study art at Mexico City College (University of the Americas) where he became familiar with the works of Orozco, Siqueiros, and Rivera, all of which continue to influence his work along with traditional Navajo themes. This interview took place in Santa Fe in April 1975.

The main question, I suppose, is how it is that I evolved into a different kind of painter from the ones who came before me on the Navajo

Reservation. To begin with, when I was young I studied art — all the great painters and not just the ones who were Indians — like Rembrandt, Michelangelo, Picasso. And I guess they have had a bigger influence on me than the Traditional Indian artists. It's not just a matter of growing up on the reservation, it's also got a great deal to do with what I learned through reading books. Now the Navajo painters, like Begay and Tahoma and Nailor, they essentially copied each other. And they were under the influence of Dorothy Dunn, who had pretty definite ideas about what Indian art is and is not. But I'm not criticizing them. After all, in Mexico I was definitely influenced by the big muralists. Like Fritz Scholder, he was influenced by Francis Bacon but he changed it into something personal. I guess the same thing happened to me with my drawings. They had a certain Mexican flair. But I think that I brought this around to my own style, which is what a good painter is supposed to do.

I was one of the first Indian painters to paint nudes. They came from a different source than Indian painting. I knew about the nudes of the great European painters. But I wanted to do them in my own way. When I was living in San Francisco I worked a lot as a model. God, I couldn't do it now — I've put on more than a bit of weight! Anyway, I would try sketching the other models when I wasn't working. And I got into it and liked it. But I didn't want to use the very dramatic style of the Mexican muralists or the flat primitive look of people like Rivera. I wanted to use a minimum of line to get my effect. That turned into something which has a distinct look about it; it's my own style, I guess. It just evolved slowly out of lots of different influences and efforts.

The reservation is my source of inspiration for what I paint; yet I never came to realize this until I found myself in some far-flung place like the tip of Yucatan or where-have-you. Perhaps when I stay on the reservation I take too much for granted. While I'm there, it is inspiring but I paint very little. When I'm away I realize what I have seen and felt and taken for granted among my own people.

I live with people, the Navajo, who aren't upset about what I do or do not paint. It's totally different from the pueblos where you'll find that people aren't very broad-minded. They practically tell the artist what he can and cannot do. Navajos are not like that.

I don't think about being Indian or not being Indian. I'm an Indian and I paint and that's all there is to it. I'd rather be considered a painter who is Indian than an Indian who paints.

I have been quoted as being very much against Traditional painting. That is not correct. Not at all. What I'm against is young Indians who start to paint Traditionally when they should be exploring other ways of expressing themselves instead of simply doing what has been already done many times before. I'm complaining about their lack of originality and personal pride in their imagination. The old people, that was their

R. C. Gorman, Navajo. Mother and Child, *1969. Oil pastel. Courtesy of the artist.*

form of art. They invented it. Why shouldn't they paint in the Traditional manner? But the young — that's a very different matter. I have a collection of the Traditional paintings myself and I love them very much. These were the artists of the past and they were very original and talented artists in their day. But today is another day and we have to learn how to paint in terms of ourselves. I do this in my way and Fritz Scholder does it in his. That's as it should be. But ultimately what is important is liking art and realizing that it is a very personal part of an artist, like his feelings and his ideas.

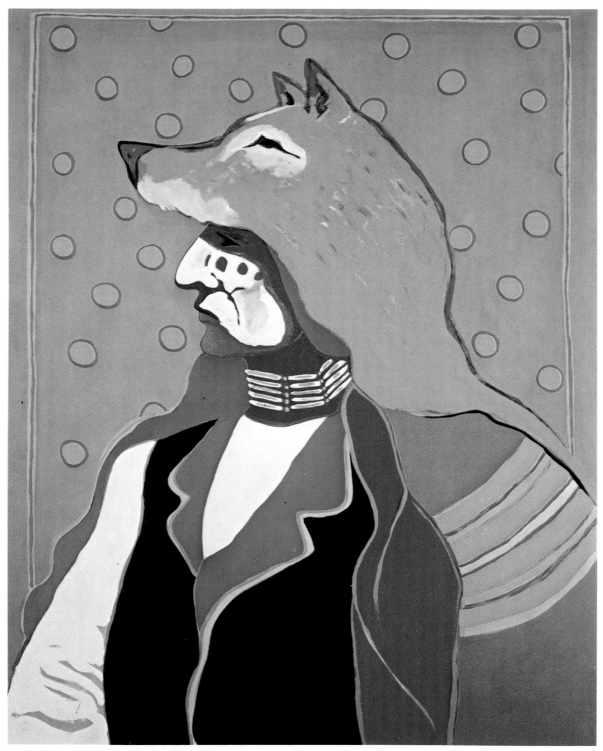

T. C. Cannon, Caddo-Kiowa. His Hair Flows like a River, *1973. Acrylic on canvas. Courtesy of the artist and Aberbach Fine Art, New York.*

T. C. CANNON

He is a Caddo/Kiowa Indian, born September 27, 1946, in Lawton, Oklahoma. His Indian name is Pai-doung-u-day *(One Who Stands In The Sun). Cannon is one of the controversial exponents of the Contemporary idiom of Indian painting. He took two years of postgraduate training at the Institute of American Indian Arts and also studied painting at the San Francisco Art Institute in 1966. Of the young painters of the new wave, T. C. Cannon is probably the most accomplished to date. The interview took place in June 1975.*

First of all, let me say that an Indian painting is any painting that's done by an Indian. Today, however, I really don't think there is such a thing as "an Indian painting." There are so many modes that people are working in that it seems beside the point to call a painting *Indian* just because the artist is an Indian. People don't call a work by Picasso a Spanish painting, they call it a Picasso. After all, Picasso spent most of his life in France anyway. Does that make him a Spanish painter or a French painter? I say it makes him Picasso.

Art is big and there's room for everybody. I used to argue the old argument about the Traditional painters and the modern painters but I don't do it anymore. I don't think that kind of debate makes any sense anymore. There's room for every kind of painter. If those artists in Oklahoma want to paint in their style, why not? Frankly, I wish some of the young people would recognize some of the things that came before us. I think we're missing something by being so much into only our own styles. The past has hardly been talked about. What do we know about Stephen Mopope as an artist and as a person? There are too many legends and not enough real people in Indian painting.

I believe that there is such a thing as Indian sensibility. But I don't believe it necessarily has to show in a person's painting. This has to do with the idea of a collective history. It's reflected in your upbringing and the remarks that you hear every day from birth and the kind of behavior and emotion you see around you. It's probably true of any national or racial group that's sort of inbred; in other words, where Italians marry Italians and live in an Italian community and eat Italian food you can't very easily turn out to be Chinese.

As you move from the oldest to the newest Indian paintings it seems like the things that are specifically Indian, that come out of ceremonies and the old days, begin to dissipate more and more, and the kind of thing that Fritz [Scholder] introduced, which is a kind of political irony, becomes more prominent. And then finally even that seems to be, let's say, outgrown, and what finally appears is a mature artist who is simply

T. C. Cannon, Caddo-Kiowa. Mama and Papa Have the Going Home Shiprock Blues. *Courtesy of the artist and the Institute of American Indian Arts, Santa Fe.*

interested in his medium whatever it happens to be — without any particular interest in being an "Indian painter."

I'm basically a loner and my new painting is a very personal trip. Though our work has been compared, Fritz and I are worlds apart. And that individual thing in my painting is coming out more and more. I wasted a lot of time dealing with momentary political problems. I agree with a great many militant ideas, but I've got to do it from my own studio. If I were a politician, I'd be one all the way, but I'm not a politician. I'm an artist. And I've got to do that all the way. I have something to say about experience that comes out of being an Indian but it is also a lot bigger than just my race. It's got to do with my own mythology, the one I make up myself. That's what I want to express in my painting.

FRITZ SCHOLDER

He was born in Breckenridge, Minnesota, on October 6, 1937, son of a part Mission Indian father and non-Indian Ella Mae Haney. He is probably the single most accomplished and successful Contemporary Indian painter. His French-English-Indian-German background, his various changes of residence and educational systems during his years of growing, and his current exhibitions across the United States and in numerous foreign nations provide every art lover with some area of identification with Scholder.

His early schooling was in South Dakota and Wisconsin. In 1957 he arrived in California where he received his bachelor of arts degree from Sacramento State College. Invited to participate in the Rockefeller Foundation–sponsored Southwest Indian Arts Project at the University of Arizona, he left his day job as a substitute teacher in Sacramento and his night job for the California State Department of Motor Vehicles and attended the project for one year as a student, and became part of the faculty in his second year. It was while at the University of Arizona that he received his M.F.A. and won his first recognition with a series of important awards. It was not until 1964, while teaching at the Institute of American Indian Arts in Santa Fe, that he turned from painting stripes and nudes to Indian subject matter. He was greatly encouraged by Oscar Howe, the Sioux painter who probably more than any other Indian painter first made the transition from Traditional to Contemporary Indian art. Another early influence was the pop artist Wayne Thiebaud. But the greatest impact on his highly original style is clearly the English painter Francis Bacon. What Scholder did, which was quite astonishing, was to portray the Indian in a dramatic and strongly expressionist manner, never previously used with this colorful, folkloric western subject.

His work has been damned by Traditional painters and perhaps misunderstood as an insult to custom rather than a highly ironic expression of the Indian as the metaphoric underdog. Joshua Taylor, director of the National Collection of Fine Arts at the Smithsonian Institution, has made a statement about Scholder which serves as a good introduction to his strongly individual style:

In the past few years Fritz Scholder has emerged as a major young American painter, not because he represents a particular tendency in art or because he has founded a new school of his own, but because of the vitality and personal intensity of his continuously surprising paintings and prints. In fact, a part of his appeal is his resistance to being typecast, his capacity for absorbing all that he needs from contemporary art — sometimes quoting quite openly — without losing

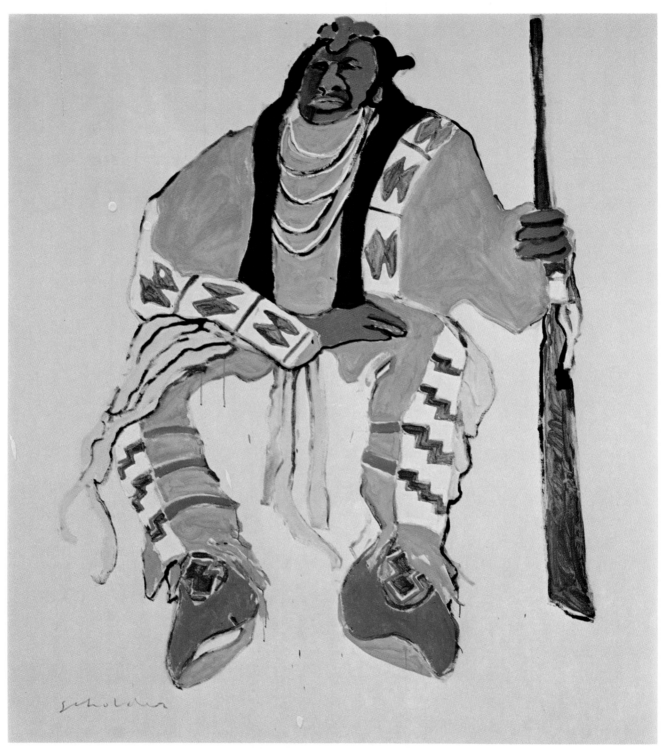

Fritz Scholder, Mission-Luiseño. Indian with Rifle, 1974.
Acrylic on canvas.

himself in the formulas and theories that sometimes masquerade as artistic ends. Scholder's eye ranges freely beyond the modish peripheries of art.

Of course, as is always at once remarked, Scholder is of American Indian ancestry and is quite aware of the fact. The Indian has been his primary subject in recent years, and it might be speculated that this is the source of his power. But to be an "Indian Artist" is not in itself a help to such forceful individual artistic statement. On the contrary, the artist must resist not only the stereotype of race, but the too-eager tendency to be praised for what he is not. Scholder has often protested that he is not an "Indian Artist." He is an artist who is an Indian and draws strength from his Indian associations; there is a difference.*

Today Fritz Scholder lives in Galisteo, New Mexico, in the summer and in Scottsdale, Arizona, in the winter. He has had exhibitions of his paintings and lithographs in New York, San Francisco, Scottsdale, Los Angeles, Minneapolis, Santa Fe, Taos, Berlin, Bucharest, London, Belgrade, Madrid, Warsaw, Athens, and Ankara. He is a man of great style and worldliness, but at the same time his attitude is completely unpretentious and candid. This interview took place at his home in Scottsdale in April 1975.

My perspective is perhaps different from any of the other Indian painters. First of all, I don't consider myself an Indian. Everyone else has called me an Indian, and I haven't denied it — I'm proud of being one-quarter Indian — but I came from a non-Indian background. It's almost by accident that I got into what I call the curious world of Indian art.

I'm not directly involved in the whole way that Indians are thinking currently. It's, for one thing, very nationalistic; and, for another, ingrown. It's also sometimes a bit petty. By saying this I'm not trying to put down Indian people. Let's face it, Indians have gone through such a tragic trauma that it's surprising they have any pride or courage left, considering all the horrors that have been committed against them. I greatly admire Indians and I have a strong and positive feeling about their claims against the federal government. But I am a painter, not a politician.

I don't like generalizations, I have to tell you, but there is something about Indians which I can't deny. Invariably I've discovered that young Indian children are capable of drawing. I don't know the reason why, but it's true. Indians have some kind of special artistic ability. Right from the beginning, in the prisons after the Indian wars, the Indian prisoners adopted a few Anglo tools like paper and pencils and crayons and they

* Catalog, National Collection of Fine Arts, Smithsonian Museum, Washington, D.C., 1971.

started making Indian art — whatever that is. And this has continued
through the years.

What the white man didn't realize is the tenacity of Indians. They
simply don't realize the utter individuality of Indians and their belief in
one thing more than absolutely anything else: being Indian.

There is something curious about Indian painting. It's a story you
already know. Once the government *finally* realized that Indians had
talent, and it took them until 1933, they set up a school in Santa Fe
where art was taught. Dorothy Dunn, who had a preconceived idea of
what Indian art was all about, fresh out of the Chicago Art Institute,
came down to head the school. She believes in what she did and she
seems to be a very nice lady. But out of her classes at The Studio came
a certain type of Indian painting style and the teacher was not Indian.
Now that in itself is curious. Also, it was that style that went back to the
reservations, to the trading posts, and to the Indians. It was that painting
that influenced the traders, the young Indian painters, and everybody
else. It was the only example of painting the young painter had, so if
he didn't paint that way he wasn't an Indian. Now this to me is really
crazy. Here you have an artistic people who were prodded by pressures
and suggestions and exploitation to create an entirely artificial art which
is rather inane and stupid and . . . simply decoration, because you can
hardly call most of it painting. But believe me, I have nothing against
how any artist paints. What's marvelous about today is that people can
approach painting any way they want. And I collect some of the Tradi-
tional paintings and have a high regard for it when it's well painted.

As I told you, I grew up in a non-Indian background. I lived on the
Minnesota–North Dakota border. I actually lived in North Dakota and
then moved to South Dakota. My father was in the Indian Service and
was transferred a great deal. He was a product of the old Indian schools.
He had been thoroughly brainwashed and we didn't have *one* Indian
object in our house. Yet my mother and my father were married on the
Hopi reservation. My mother knew Kabotie very well. She was [Oliver]
La Farge's secretary for a while when he used to come over and sit
cross-legged on the table and try to act like an Indian. My parents got
married on horseback and everybody gave them pottery and blankets
and everything. My father gave them *all* away. Because by then he had
become completely ashamed of being Indian and didn't want *anything*
to do with it. That was the period when the Indians who got anywhere
had accepted assimilation to the point of being ashamed of their heri-
tage. We knew we were part Indian, but we didn't really know what that
meant. Then my father transferred to California and I started college.
I had this wish to be a painter and I was starving along with the rest of
the young painters out there. Then out of the blue comes this letter
from the Rockefeller Foundation. They had looked up the Indian rolls
(I was still on the rolls) and knew I was Indian and had somehow found

out I was also an artist. They invited me to take part in the Rockefeller Project at the University of Arizona. All expenses paid, all material paid, a studio . . . well, lord, I knew nothing about Indian art but the opportunity was so great I had to accept.

At the project we were bombarded with Indian art and European art. It was a tremendous cultural shock. In fact, some of the Indians really couldn't take it and I think it messed some of them up. But what the project opened up was freedom in Indian painting. When people went off to work they were permitted to do whatever they wanted to do. The result was quite amazing. Out of this came a merging of rich Indian heritage with contemporary art. A number of the younger participants began to blossom.

From that experience I grew to understand for the first time in my life the tensions and antagonisms and even the strong jealousies of Indian people.

I got my masters degree, as you know, and I taught for a while at the Institute of American Indian Arts. Then I became a desert rat. I love the Southwest. I became very interested in Indian objects as a collector. That made me look back into my own Indian heritage. And I learned a lot.

At Santa Fe the thing I noticed most about art was that everybody was painting *Indians*. Earlier there was this tremendous tradition of Santa Fe painters who had come from cities and were very blown up about painting the "noble savage" and all that. *Everybody* was doing it. Well, I said to myself: If there's one thing I'm *not* going to paint it's an Indian! I really believed that. I was more interested as a painter in the land and the light of the Southwest than the Indians. In San Francisco I had been very taken up with dark color, the big black nonobjective approach. So color first came to me in the Southwest. But I didn't get involved in painting Indians. I painted stripes. One of the biggest prizes I ever won was for stripes.

As a teacher, however, I watched my students trying to master their technique and their Indian subject and not quite making it. That's why a student is a student: because he doesn't quite do it. There's a point at which a painting makes it — no one can really say what that point is in so many words — but you know it when you see it. It's just *there!* Students hadn't gotten to that point and it was very frustrating after watching them trying all day to come home at night — I had become a night painter — and try to do my own work. Well, it occurred to me that *somebody* should paint the Indian subject matter that students were trying and do something with it that wasn't a huge cliché. Somebody should take this subject and transcend it *in paint*. So I finally succumbed. And ever since my first Indian painting, everybody screamed! And that's when I became controversial. The traders gasped because I represented everything they disliked. Nobody knew what to do with my work. And then the question "Is he Indian or not?" came up. All of this just because

I changed to the subject matter of the American Indian. Which has always been just that to me: *subject matter,* which has always been about third on the list of what is important about painting.

Painting is different from any other medium. Painting is first *color,* next *image,* a strong image because if you don't have that nobody will want to give it a second look. For me the big influence, and I admit it, is Francis Bacon. *That's* a real influence, but Indians are simply a subject.

What I've tried to say is that Traditional Indian painting was not nearly as *Indian* or related to Indian heritage as people want us to believe. I can't defend my painting for not being sufficiently or authentically Indian since it's not intended to be anything but painting.

I don't really know what Indian painting is. Is it painting done by an Indian or is it a particular style? Is it a painting of an Indian? Or is it any painting which happens to be done by somebody who is Indian? And if so, how much Indian is enough Indian?

I'm one-quarter Indian, one-quarter German, one-quarter French, and one-quarter English, and in a way that is what my painting is. I truly believe that if somebody is going to reach a point of expressing himself he has to find out who he is and accept it. I consider myself a painter. I'm happy that I seem to have influenced a few Indian painters. I'm also glad that I'm part Indian. But what I most want is to be known as a painter.

I revel in the fact that I'm a painter and that I'm able to live and function on my work and do exactly what I want. Which is exactly what I'm doing.

Fritz Scholder, Mission-Luiseño. Three Indian Dancers, 1974.
Acrylic on canvas.

10. WHAT IS INDIAN ABOUT INDIAN ART?

"A CULTURE," ANTHROPOLOGIST PETER FARB HAS SAID, "THAT IS IN the process of being swamped by another often reacts defensively." The reactions of a people overpowered by Eurasian colonial empires are usually extreme. Their lands taken away, their social system torn open, their customs suppressed, and their holy places profaned, they try to fight back but are inevitably defeated by the superior firepower of the invaders. "As hopelessness and apathy settle over these people, the ground is prepared for revivalist and messianic movements that promise the return of the good old days," Farb comments in his splendid book *Man's Rise to Civilization*.

Wounded Knee and other recent Indian protests are only the most recent in a long series of sociopolitical movements. Some of these defensive actions by Indians have been physical, but most were efforts to wage a cultural war. And that is where Indian painting comes in. Native American painting and all the other actions by Indians have had one thing in common: they have been part of the response of the Indian to the Anglo's invasion and domination of his ancient world.

The purely historical facts about Indian painting, the individual commentaries by masterful Indian artists, even the controversy of Traditional versus Contemporary Indian styles, and the subject matter and viewpoint implicit in Indian painting no matter what the style are given an important, unifying vantage if we look at them in relation to Indian activism.

At first this activism was militant and physical. In 1680 the Pueblo Indians, led by Popé, expelled the Spaniards. This Pueblo rebellion was

a revolt against alien authority, but the next major Indian uprising, in 1762, was messianic rather than anti-authoritarian. It was led by a prophet of the Delawares who preached a vision-inspired message of the unity of the tribes and for a holy war against the whites. The prophet was not the instrument of his own vision: he left that to Pontiac, chief of the Ottawas, who rose to lead the enraged people of the Great Lakes against the English forts of the district. Pontiac and his warriors were very nearly successful.

Forty years later the Shawnee prophet Laulewasika, twin brother of the great Chief Tecumseh, repeated the promises of his Delaware forebear: a return to the old ways. Tecumseh established the most important Indian alliance that ever existed north of Mexico. Eventually, after numerous battles, he was killed in 1813. His body was spirited away, however, and for years the frontier was continually aroused by rumors of his mysterious return. But he never appeared and the prophecy of his brother was tragically disproved by the bullets of the white man. Yet the belief in a messianic revival of tradition continued.

Kanakuk, one of the followers of Laulewasika, taught among the Kickapoo a message of peace and moderation. But his peaceableness did not save his followers from being pushed off their land into a tiny reserve in Kansas where Kanakuk died in 1852 of smallpox. His band of faithful, convinced that he would rise like Jesus on the third day and save them, gathered around his body despite warnings of the dangers of infection. They had inherited only naïve conviction from the Christian missionaries, and that, coupled with their dream of their lost heritage, made them more valiant than their enemies — and more vulnerable. The cult, almost to the man, was wiped out by the disease.

The American Indian's response to the troubled encounters with Anglos has often been a search for solace in the occult — a preoccupation far removed from physical violence and warfare, yet a force of rebellion which greatly influences the whole Indian population even today. Typical of the spiritual conception of ultimate victory over the white invaders is the Dreamers Cult, which spread along the lower branches of the Columbia River in Washington and Oregon. This cult differed from previous Indian revivalistic movements insofar as it borrowed heavily from the Roman Catholic church. Its leader, Smohalla ("Preacher"), was born about 1860 in the Rocky Mountains and was educated by Catholic missionaries. Because he went into frequent trances, Smohalla became known as "The Dreamer," and his followers were thus "The Dreamers." It was recapitulation of the quest of visions and dreams that had been basic to all Indian tradition, particularly that of the Plains tribes. Smohalla's belief — arrived at through revelation while in trances — was that the earth belonged to the first men, the Indians, who must never be guilty of defiling it as the Anglos had. His teachings inspired Chief Joseph of the Nez Perces to lead a rebellion in Idaho in 1877.

Chief Joseph was defeated, but other Indian leaders were inspired by Smohalla. The cult had a small resurgence in 1883 when Indians were especially outraged by the building of the Northern Pacific Railroad which trespassed on their dwindling lands.

The climax of the numerous revivalist movements was the famous Ghost Dance of 1890. The cult originated among the Northern Paiute about 1870, on the California-Nevada border. The prophet Wodziwob had an amazing vision of a great train belching fire and smoke, which would bring back his dead ancestors and announce their arrival with an immense explosion, ideas probably inspired by the recently completed Union Pacific Railroad. He proclaimed that a great disaster would swallow up the Anglos and that the Indians would again reign in North America. These miracles were to be realized by ceremonial dancing around a pole and by singing the songs Wodziwob learned during a vision. Although this prophet's cult rapidly faded away, it was the basis for the Ghost Dance which became a prime Indian force in 1890. Wovoka, formerly an assistant of Wodziwob, began having visions himself. As Wovoka the prophet, he became the leader of the most powerful cultist rebellion in Anglo-Indian history.

The Ghost Dance spread across the Rockies to the Plains tribes like a forest fire. The Cheyennes and the Arapahos in Oklahoma started dancing fervently. This excitement struck other Plains tribes with equal virulence, particularly the Sioux who were the most numerous and unified of the tribes at that time. They danced in symbolically painted Ghost Dance shirts which they believed to be impervious to the white man's bullets. Eventually the Sioux rebelled and waged war until Sitting Bull was killed and a group of unarmed Indians en route to a Ghost Dance ceremony was massacred (despite the "protection" of their ghost shirts) at Wounded Knee in 1890.

The Indians' dream of reviving the old days had proved futile, but many tribes envisioned a second, positive response to their predicament — a superficial adaptation, firmly rooted in the native ideals, to the alien white world. The earliest example of this kind of nonmilitant accommodation occurred in 1799 when a Seneca named Handsome Lake founded what Anglos called "The New Religion" of the Iroquois.

The most vigorous Indian religion today, peyotism, is a spiritual continuation of the ideals of the ritualistic Ghost Dance. Whereas the Ghost Dance had been a powerful influence when Indians were still anxious for rebellion and hopeful of victory, the peyote cult spread when they were ready to admit defeat. It emerged at a time when the Indian no longer had to fight off the United States Army, but when he had to wage a subtler war with Anglos who were trying to exterminate Indian culture and substitute their own. The conflict that peyotism, or any other Indian religious movement, must resolve is how to coexist with white men while remaining spiritually independent. That is exactly the same dilemma

Rance Hood, Comanche. Fire Dance, 1974. Tempera. Courtesy Tribal Arts Gallery, Oklahoma City. Night has come. A small fire burns in the pit of the medicine tepee on the west. Small cooking fires smolder in the arbor on the south ... a group of singers starts an age-old chant. Into the circle from the east stamp five figures, swaying, posturing, gesticulating. Their bodies are painted black, with symbols in white on their chests and backs. Each wears a headpiece and a skirt and leggings of buckskin. Each brandishes a broad wooden sword in each hand. The Mountain Spirits, the Fire Dancers prance around the great fire, charge into the flames, thrust with their swords at each other.

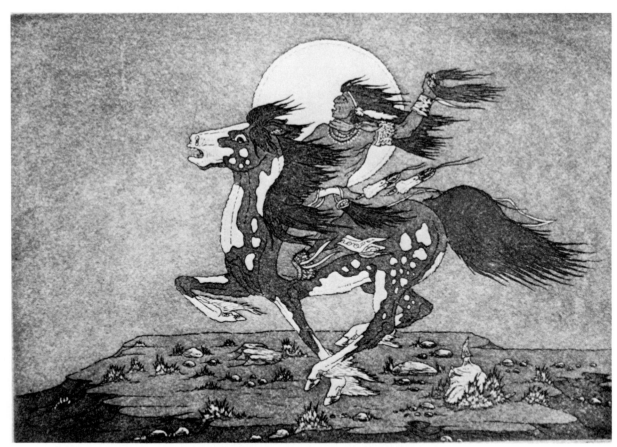

Woody Crumbo, Creek-Potawatomi. Night Rider, ca. 1950. Etching on paper. Courtesy private collection. The imagination of the Indian still rides against an enormous moon into a mystic night in which there are no highways or Departments of the Interior. In part dream, in part memory and even self-delusion . . . but a very proud fantasy, which has sustained a subjugated people since Columbus stumbled upon an ancient land to be named America.

which Traditional Indian painting served to rectify from the time of the imprisonment of the Kiowas at Fort Marion until the revival of artistic expression among the self-taught Indians of the Pueblos and Oklahoma about 1918.

Lloyd Goodrich, former director of the Whitney Museum of American Art in New York, has observed that "one of the most American traits is our urge to define what is American." It stands to reason that the heated discussions of what is Indian about Indian art and what is the validity of Traditional or Contemporary Indian art are part of this same American affinity for definition. We want to know what it is that makes a painting Indian — in subject matter, in viewpoint, in emotional and intellectual content, in artistic concepts, in style. But these questions largely reflect transitional problems which arise out of the newness of the Indian involvement in art in the predominantly Anglo world. These are the questions that always preoccupy a nationalistic moment in the history of a people trying to recover their heritage, when that heritage is lost through military defeats, or when it is (as for white Americans

and for the many culturally dissimilar Indian tribes) heterogeneous
and indebted to many contradictory and diversified sources.

Goodrich has tried to put the American mind at ease about the orig-
inality of American Anglo art by telling us that

> National characteristics in themselves have no absolute value. The
> intrinsic values of art lie in its universal and timeless elements. But
> national character has an importance like that of the individual artist's
> personality in relation to his art. The essentials of man's art come from
> his inborn gifts, his inner life and his relations to his world. Influences
> from other art cannot create his art; but they can change it, can help
> it to grow — or the reverse! Similarly, native elements in the art of a
> country contribute fundamentals, which can be modified by influences
> from other countries and other ages.*

Adaption is the real issue since authenticity and originality are neither
compatible nor incompatible but are essentially the same thing: the
expression through an individual of all the elements of his experience —
direct or indirect — in forms and techniques which are indistinct from
his subject matter. As the literary critic Mark Schorer has put it, "tech-
nique is discovery." Or as another critic, Percy Lubbock, stated, "the
matter is all used up in the form, the form expresses all the matter." The
American painter Albert Ryder said it more poetically: "What avails a
storm cloud accurate in form and in color if the storm is not therein?"

The Traditional painter is at considerable odds with the Contempo-
rary Indian painter, despite the fact that both styles of art are clearly
influenced by non-Indian, European ideas. The Contemporary painter
sometimes sees the Traditionalist as an illustrator of clichés; at least that
used to be the principal basis for disapproving of Traditional painting.
Another premise for criticism is that Traditional painting is unquestion-
ably an anachronism at the end of the twentieth century, an idiom out of
step with European and American experimental art. But that is a prob-
lem only for those who can see the contrast; and Traditionalists are
clearly not very aware of alternative views of painting.

Pre-modern American art was filled with romantic ideals, with nos-
talgia for the Old World that enfeebled painters like Allston, and literal-
ism that encumbered the Hudson River painters. Personally, I see no less
and no greater flaw in Traditional Indian painting than I see in the paint-
ing of white Americans through the nineteenth century — yet that is an
art which deserves and receives our attention and enthusiasm. What is
important about Traditional Indian painting is that it was a perfect form
of cultural accommodation by which Indians retained a focus on their
freedom prior to defeat, a process which, as we've seen in the history of

* Lloyd Goodrich, "Common Denominators from the Pilgrims to Pollock," *Art in
America,* 1963.

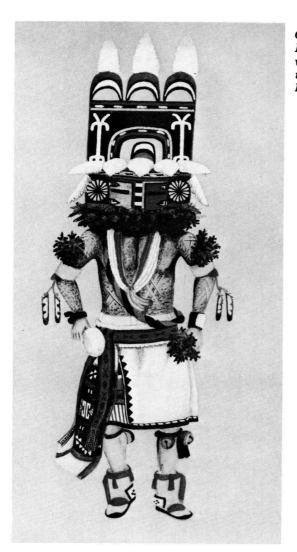

Otis Polelonema, Hopi. Hemis Kachina. *Courtesy Museum of Northern Arizona. Among the most resistant tribal people in a world in which ancient man is becoming a threatened species, the people of the pueblos look into the face of deities which have hardly changed since Persia conquered Egypt.*

revivalistic and accommodational adaptation, was essential to the sanity and dignity of native Americans after their defeat. The painting which grew out of this complex subjugation resulted in a unique blending of native and foreign influences and an art, at its best, which is both significant and beautiful.

Contemporary Indian painting, by contrast, has grown out of a more compatible relationship between the Indian and his invaders. The younger Indian has retained his Indian tradition, but more important, it seems to me, is that he has evolved a viewpoint that reflects current and global ideals that necessarily influence the way he sees the world and expresses his feelings. To what extent these ideals are "Indian" in character is strictly a matter of how immersed the individual Indian happens to be in his culture, either directly through growing up in an Indian environment or indirectly by having studied his culture in relationship to world culture. Gorman is a native of the Navajo reservation and yet his painting shows clear European and Mexican influences; Scholder never lived on a reservation and yet his painting is more graphically

Indian in subject than that of Gorman. Bosin had to retrace his native roots due to the destruction of much Oklahoma Indian tradition caused by the Removal, but his art is Traditional both in technique and subject matter. It could not be clearer that the situation of the artist and his relationship to his tribe, even the degree to which he claims Indian descent, are not the central issues in making his work "Indian."

As for the endless wrangling over white influences on Indian art, that again is a peculiarly unimportant issue when we look at the history of world art and realize that the patron or buyer of art has never been a prime factor in any discussion of the aesthetic validity of European art. In Italy until the middle of the fifteenth century the church was virtually the only patron of art, and art was required to make statements about Catholic beliefs of universal truths, morality, and cosmology. The Renaissance grandees who later dominated the art market had little interest in philosophies, but were inclined to use art to promote their own reputations. Each patron endeavored to commission work which would outshine that sponsored by rivals. It is pretty clear that this shift in patronage had a strong influence not only on the subject matter, but also on the style of late Renaissance art. Yet no one has ever suggested that western painting declined because Renaissance patrons altered its fundamental subjects, uses, viewpoint, and media.

The same must be said of American Indian painting which by virtue of Indian sensibility (if not always a persistent lineage of cultural data) represents a tradition no less continuous and centered upon a unique viewpoint than that of western civilization. As for the contention that white patrons altered the motives of making art from one of sacred ceremonial use to economic gain, there seems almost no reason to argue the point. The market is a major factor in the work of all great painters. A commission does not necessarily preclude the artist's initiative or capacity for invention if invention is his purpose. Is ballet not a commercial form of dance? Yet there is nothing fundamentally wrong with painting dances simply because patrons like dance paintings. Degas devoted a great deal of time to doing just that and his ballet paintings are not instantly damned as touristic illustrations of a dance form which was demoted by patrons into commercialism. If there is something wrong with the influence of white patrons on Indian painters it is the fact that these patrons essentially lacked the taste and experience that the great European art patrons possessed in the Renaissance and thereafter. Collectors of Indian art tend to promote the shallowest elements of the painters' sensibilities. Gradually this commercialization has brought about the decay of any reason for Indians to paint for other Indians or for themselves. The result is often a technique which does not support expressive content.

However the white teacher or trader influenced the elder Indian painter hasn't fundamentally changed the Indian's expression as an

Indian; it may have changed his personal psychology but not necessarily his Indian tradition. It is entirely false to say that the new developments in Indian painting are in any way freer of white leadership, influences, and suggestions than the Traditional Indian art. On the contrary, Contemporary Indian painters are far more dominated by white attitudes. It is, in fact, their education as whites rather than as Indians that has put contemporary European painting within their grasp, otherwise they would probably be as baffled by it as the average ill-educated rural Frenchman is baffled by Eskimo folk art or as confused as the central Brazilian tribesman would be by his first encounter with Picasso or Miró.

What is important are the aesthetic achievements of the painter, despite his idiom and influence. In this regard the statistics are not very impressive. Very few Contemporary Indian painters have achieved much, in comparison to non-Indian painters of the same idiom, probably because the idiom is new to them. There is also a decline among Traditional painters whose work has rapidly become mediocre even though the market for it has never been better. Traditional Indian painters are not sophisticated people, and they do not have any real feeling for Anglo art as such. Their interest in painting seems to arise mainly because of their concern for things Indian. Without better guidance and an access to informed artistic judgment, Traditional painters tend to imitate the worst Anglo art rather than the best in a misguided effort to appeal to the market. However, the great Traditional painters have left a collection of outstanding works of a unique style. Nothing can dim their achievements — even the most radical young Indian painter seems to agree with that fact. But Traditional painting is sinking because so many of the well-informed people who could be elevating it through criticism are instead damning it because it is not pursuing contemporary European-American techniques.

What kind of yardstick does the Traditional Indian artist have? The Anglo yardstick doesn't work — even if Indians grasped its significance — because it is based on principles that do not take Indian artistic motives into consideration and would see Traditional painting very much as the art of the Hudson River school was once viewed: as decorative, literary, and illustrative at best.

After talking to most of the important Traditionalists I think I see some of the basis on which they judge their own work. For instance, as a rule they ignore shadowing and the use of detail. The outline of forms is more important to them because they are dealing with essences and not with specifics such as portraiture or verité. They feel that their work should capture the "feeling" of a thing, but not necessarily look like it. This they see as "the power" of all the things in creation.

This viewpoint originated as a tenacious method of keeping alive what older Indians (since about 1880) thought was the essence of being Indian. The Indian artist had to discover not only what it was to be an Indian

painter, but also what it was to be an Indian in a white world. In looking at the best expressions of these ideals, in the art of Mopope, Tsatoke, Kabotie, Awa Tsireh, and many of the other Traditional painters, there is no question of the uniqueness, expressive vitality, and significance of this entirely individual art form.

In listening to young Indian painters, however, something else becomes clear. To them the accommodating nature of the Traditionalists is as obsolescent as the faith in the Ghost Dance. The iconography of Traditional Indian painting, the visions of a real and of a mythic past, has not protected the Indian people from the white man's ideas, mechanisms, and customs. The "new Indian" has arisen out of that assimilation and nothing can reverse the process. The New Indian may seem to the Traditional Indian like a poor substitute for the nostalgic ideals he has tenaciously held in his mind, his art, and his attitudes, but the new Indian may be a great deal better than the great majority of professional Indians who for years were steadily reducing everything Indian to a suit and tie and the most mediocre mentality of the American middle class.

That does not mean that young Indians are not painting Traditionally. They are. But not very many of them, and most of them who are painting in the old manner are doing so, I would guess, because their parents did so or because the only Indian painters they know did so and because they have not been confronted by the alternative and dominant contemporary idioms of painting.

Traditional Indian painting was an amazing artistic flowering of a nationalistic spirit among the American Indians, which was necessary for their survival. That nationalism is taking an active political turn among young Indians, a fact which provokes them to satirize their situation in a personal art form which inevitably gives birth to personal techniques. Gradually, as T. C. Cannon has said, this political cartooning has been "outgrown," and the Indian painter is now undertaking an individual expressive career which makes him almost indistinct from any other contemporary painter.

Like other nationalistic art forms, such as the music of Russia in the nineteenth century, Indian painting is an important moment in native American history. It is, like nationalism in the art of any people, a transitional period which is rapidly passing.

The word art comes into existence only at the moment when art ceases to be the carrier of a unified ideology of a people, when a society's belief in itself and its central mythology is shaken by invaders, radicals within its own ranks, or military subjugators. When art is detached from its central mythology, it becomes its own ideology. The illusions that man uses to disguise his social condition from himself are translated into a new reality — the so-called work of art. In the process of fleeing from the uncertainty of the visible world, a new world is created which becomes visible through art. The artist is then forced to create objective reality in

Buzzard, Cheyenne. Five
Soldiers, *1879. Watercolor.
Courtesy C. P. Wickmiller
Collection, Oklahoma Historical
Society. Learning how to paint
with the white man's tools, the
Indian appears to have been
generally benevolent in his
depiction of his captors and
jailers, like this portrait of five
soldiers from Fort Marion.*

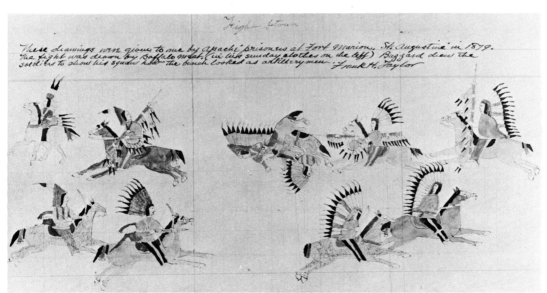

Unknown artist. Battle Scene, *1879. Watercolor and crayon in ledger book.
Courtesy C. P. Wickmiller Collection, Oklahoma Historical Society. Starting
with heroic graphic autobiographies, the American Indian has retained his sense
of identity and pride through the metaphor of an untarnished, undimmed Indian
past that, like these astonishingly naïve warriors of crayon and watercolors,
charges into a hostile future.*

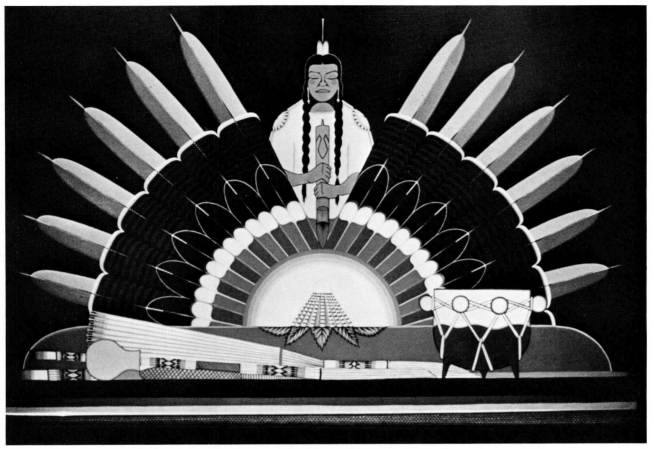

Archie Blackowl, Southern Cheyenne. Mother's Prayer. *Tempera. Courtesy private collection. The peyote cult provides the native American with a rainbow bridge that links him with the past and that soars above the present. It is a magic employing simple objects of great beauty: the peyote rattle, the fan, the water drum. It is a new religion which is devoted to keeping the old ways alive.*

the very process of denying it. This process may be seen as the dialectic of negation, where the escape becomes the arrival.

Arthur Silberman has well described that compensative act in art: "All you have to do is go to a reservation if you want to understand where the imagery of Traditional Indian painting really comes from. See an Indian ceremony, just take a look at it. Look at these basically miserable, often underfed Indians wracked by alcoholism, poverty-stricken — the unemployment rate is simply not to be believed; the suicides even among children; the personal family histories are all disasters! So what can be important to these people? They put on their dance costumes . . . the Deer Dance at a pueblo. They look like princes! They're transformed. That is the single most important thing in their lives. They can shut off all that poverty, all of their disasters, because that is their moment. Is it any wonder that that is what they want to paint?"*

* From an interview with the author, May 1975.

Rance Hood, Comanche. A Prayer. Tempera. Courtesy Tribal Arts Gallery, Oklahoma City. The Peyote Road — the evening spent in contemplation and communion with the All-Power, with peyote as the sacrament. "Let us see, is this real, this life I am living? You, gods, who dwell everywhere, let us see, is this real, this life I am living?"

Silverhorn (Ho-Goon), Kiowa. Sketchbook drawing, ca. 1887. Crayon and pencil on buff paper. Courtesy Marion Koogler McNay Art Institute, San Antonio (Gift of Mrs. Terrell Bartlett). A young Kiowa brave as seen by the famous Kiowa who was one of a delegation of Indians taken to the Congress of the United States. "Let the White Man be just and deal kindly with my people, for the dead are not powerless. Dead, did I say? There is no death, only a change of worlds. Our world goes on!"

The only wonder is their tenacity in being themselves in the face of such torturous odds. But, as Blackbear Bosin said, there is no room in his painting for bitterness: "In my paintings there is absolutely no recognition — none — of our defeat. I am describing America as if 1492 simply had never happened. . . . If I could sing probably I would have been a singer. But I'm a painter and so I have tried to sing with my paintings."

APPENDIX
Looking at Indian Painting

TRAVEL NOTES

Every year more and more Americans and Europeans are discovering Indian America. Quite apart from the marvels of the landscape of the United States and the exotic experience of visiting the original inhabitants of monumental deserts, canyons, mountains, and river valleys, there is also the exceptional opportunity to see Indian art at first hand. Everywhere in America are outstanding collections of arts and artifacts related to Indians. Scouting them out and getting to them were topics of my previous book *Fodor's Indian America* (New York: David McKay, 1975). Perhaps a few words here might help to point travelers in some interesting directions, though neither these travel notes nor the directory of museums and galleries where Indian painting can be seen is by any means complete.

If you don't want to waste precious time and if you want comfort, if you want to spend less time getting to a destination so you can spend more time being there, you had better use the airlines. A plane can get you where you're going quickly and you save enough en route expenses to justify the rental of a car, which can be waiting at the airport. In a class by itself, the pioneer of community transportation, Frontier Airlines is just about the only airline that serves virtually the whole of Indian America with a variety of excellently maintained coach-only equipment. For information, write Customer Service, Frontier Airlines, 8250 Smith Road, Denver, Colorado 80207. An interesting Frontier offer is perfect for campers who want to fly to a destination and then forage out in the countryside in a house-on-wheels. It's called "Open Road Mini-Motor Home" and has facilities for four adults or two adults and three children. It comes fully equipped; you supply only the gas and food.

Not all of the museums and galleries which feature Indian painting are at the end of a canyon road; many are located in major cities where urbanites can find them. The following list offers the location of some of the best collections of native American painting.

MUSEUMS AND GALLERIES

Arizona: The Heard Museum (Phoenix); Museum of Northern Arizona (Flagstaff); University of Arizona State Museum (Tucson).

California: Southwest Museum (Los Angeles).

Colorado: Denver Art Museum; Koshare Indian Kiva Museum (Koshare).

District of Columbia: Museum, Department of the Interior; Smithsonian Institute; National Gallery of Art.

Kansas: Wichita Art Association Galleries; Wichita Art Museum; Kansas City Museum.

Massachusetts: Bronson Museum (Attleboro); Peabody Museum (Harvard University, Cambridge).

Minnesota: Bemidji Community Museum (Bemidji); Bureau of Indian Affairs Regional Office (Bemidji).

Missouri: St. Joseph Museum (St. Joseph).

Montana: Museum of the Plains (Browning).

New Mexico: Gallup Museum of Indian Arts; Museum of Navajo Ceremonial Art (Santa Fe); Museum of New Mexico (Santa Fe); Institute of American Indian Arts (Santa Fe); Cassidy Museum (Albuquerque); Navajo Gallery (Taos).

Nebraska: Joslyn Art Museum (Omaha).

New York: Brooklyn Museum; American Museum of Natural History (New York); Museum of the American Indian (Heye Foundation) (New York).

North Dakota: State Historical Museum (Bismarck).

Oklahoma: Southern Plains Indian Museum (Anadarko); Five Civilized Tribes Museum (Muskogee); University of Oklahoma Museum of Art (Norman); Bacone College (Bacone); Philbrook Art Center (Tulsa); Oklahoma Historical Society (Oklahoma City); Gilcrease Museum (Oklahoma City).

South Dakota: Sioux Indian Museum (Rapid City); Museum of the University of South Dakota (Vermillion); Red Cloud Mission School (Pine Ridge); South Dakota Historical Museum (Pierre).

Texas: Museum of Fine Arts (Houston); Marion Koogler McNay Art Institute (San Antonio); Dallas Museum of Fine Arts.

Wyoming: Museum of the Plains Indian (Cody).

ANNUAL EXHIBITIONS

There are a number of excellent annual exhibitions, shows, and retrospectives that can be used as targets while touring Indian America:

All-American Indian Days, Sheridan, Wyoming — held annually in August.

Inter-Tribal Indian Ceremonials, Gallup, New Mexico — held annually for five days in August.

New Mexico State Fair, Albuquerque — held annually for eleven days in September.

Navajo Tribal Fair and Rodeo, Window Rock, Arizona — held annually in the summer.

Philbrook Art Center Exhibition, Tulsa, Oklahoma — held annually in May.

Scottsdale National Indian Art Exhibition, Scottsdale, Arizona — held annually in February.

CHRONOLOGY

PRE-COLUMBIAN ANTECEDENTS

EAST	SOUTHWEST	NORTHWEST	WEST	PLAINS
1500 B.C.–A.D. 1850 — Rock Art — petroglyphs and pictographs — discovered on a continent-wide range.				
800 B.C.–1492 — Adena, Hopewellian, and Mississippian Mound-building — sculpture, effigies.			1000 B.C. — Elaborate rock art in California.	
800 B.C. — Woodland pottery.			900 B.C. — Geometric design Catlow Twined basketry begins.	
300 B.C. — Simple incised Hopewellian pottery.	300 B.C.–1400 — Hohokam villages.			
100 B.C. — Incised and painted Temple Mound pottery.	300 B.C. — Mogollon pottery begins.			
	A.D. 100–1250 — Mimbres black/white Mogollon pottery.			

EAST	SOUTHWEST	NORTHWEST	WEST	PLAINS
	A.D. 300–1542 — The Basket Makers culture.			A.D. 500 — Pictograph Cave, Billings, Montana.
	A.D. 1000 — Red Mesa black/white Anasazi pottery.			A.D. 1300 — Painted hide shields.
	A.D. 1400 — Murals begin in *kivas* at Awatovi and Pottery Mound.	No archaeological chronology has yet been developed. First evidence: A.D. 1867 — Beginning of monumental wooden sculpture.		
	A.D. 1400 — Sikyatki polychrome Anasazi pottery.			

TRANSITIONAL PHASE (ca. 1492–1915)

SOUTHWEST

PLAINS

1541 — Coronado sees painted buffalo robes and tepee linings.

1600 — Horse culture reaches the Plains.

1819 — Long Expedition introduces illustrated books to Indians near present-day Omaha, Missouri.

1832 — George Catlin (artist) painting in Northern Plains to astonishment of Indians.

1833 — Karl Bodmer (painter) gives Indians paper, pencils and watercolors and at least two Mandan leaders try to paint.

1849 — Government surveyors and army officers were among first non-Indians to enter a native *kiva* at Jemez Pueblo where one of Lt. J. H. Simpson's men copied the iconography.

1852 — At Fort Union, Yellowstone, artist Rudolph Friederich Kurtz asks Sioux why he depicts two legs on one side of a horse. The Indian found Kurtz's method of picturing a rider astride, with one leg on each side, "not at all satisfactory," pointing out "you see, a man has two legs." The fact that a man has two legs was more important to the artist than the fact that the far leg of a horseman, pictured naturalistically from the side, is concealed by the body of the horse.

1875–78 — Prisoners of war at Fort Marion, Florida, begin ledger books and drawings.

1887 — First published reproductions of Navajo sand paintings in W. Matthews book *Mountain Chant*.

1880 — Two self-taught Indian artists, Silverhorn and Carl Sweezy, make naïve drawings, from ideas picked up from the Fort Marion artists.

1890 — J. W. Fewkes commissions Hopi men to draw *kachinas*.

SOUTHWEST PLAINS

1900–1913 — Alfredo Montoya (San Ildefonso
 Pueblo) commissioned to draw dances for
 School of American Research.
1902 — Dr. K. Chapman commissions Apie Begay
 (Navajo) to make drawings of sand paint-
 ings.

20TH CENTURY TRANSITIONAL PHASE (1900–)

Legend indicating the artistic training of painters:
S — self-taught
C — some art education in non-Indian classes
St — studied at The Studio of the Santa Fe Indian School under Dorothy Dunn
OU — studied at the University of Oklahoma art department under Dr. Jacobson and Mrs. Peters
B — studied at the art department of the Bacone Junior College in Muskogee, Oklahoma

SOUTHWEST PLAINS

First Puebloan Group (ca. 1910–1920: founding)
1917–1918 — Hewett commissions Crescencio Mar-
tinez (San Ildefonso Pueblo, b. ?–1918) to make
drawings and Martinez becomes founder of "San
Ildefonso School" of painting. [S]

Awa Tsireh (a.k.a. Alfonso Roybal; San Ildefonso
Pueblo, 189?–1955) succeeds Martinez with Hew-
ett commission. [S]

*Second Puebloan Group (ca. 1920–1930: develop-
ment)*
Fred Kabotie (Hopi, 1900–) [S]
Otis Polelonema (Hopi, 1902–1972) [S]
Tomita Peña (Cochiti Pueblo, 1895–1949) [S]
Julian Martinez (San Ildefonso Pueblo, 188?–
1943) [S]
Velino Shije Herrera (a.k.a. *Má Pe Wi;* Zia Pueblo,
1902–) [S]

1918–1925 — School Superintendent John D.
DeHuff encourages Fred Kabotie, Otis Pole-
lonema, and Velino Herrera to paint at Santa Fe
Indian School.
1920 — John Sloan (Society Independant Ar-
tists) organizes New York exhibit of Indian
painting and Santa Fe poet Mary Austin ar-
ranges show at American Museum of Natural
History, N.Y.

1914 — at St. Patrick's Indian School Kiowas get
 art encouragement from Father I. Richlin
 and Sister Olivia Taylor (Choctaw).
1916 — Mrs. Susie Peters arrives in Anadarko as
 Field Matron for Kiowa Agency.
1918 — Mrs. Peters starts art classes for Kiowa
 Five.
1921 — Father Richlin dies.

The Kiowa Five (ca. 1918–1935)
Monroe Tsatoke (Kiowa, 1904–1937) [OU]
Stephen Mopope (Kiowa, 1898–1974) [OU]
Spencer Asah (Kiowa, 1905–1954) [OU]
James Auchiah (Kiowa, 1906–1975) [OU]
Jack Hokeah (Kiowa, 1902–1973) [OU, St]

1926 — First of the Kiowa Five start as special
students at University of Oklahoma under Dr.
Jacobson.
1929 — Memorial Chapel murals at St. Patrick's
Mission School painted by Kiowa Five in mem-
ory of Father Richlin.
1930 — Mrs. Peters starts arranging trips for
Kiowa Five to exhibit at Inter-Tribal Ceremo-
nials in Gallup, N.M.

1932 — Commission of Indian Affairs under John Collier lifts long-
standing ban on permitting Indian students to be instructed in art
or to depict their native culture in painting.
1934 — Indian Reorganization Act makes this new viewpoint
official.

SOUTHWEST

The Studio — the founding by Dorothy Dunn of
of an art department at the Santa Fe Indian School
(1932–1937).
Allan Houser (Apache, 1915–) [St]
Ignatius Palmer (Apache, ?–) [St]
Joe H. Herrera (Cochiti Pueblo, 1920– ·) [St]
Ben Quintana (Cochiti Pueblo, 192?–1944) [St]
Jack Hokeah (*see Kiowa Five*) [St, OU]
Harrison Begay (Navajo, 1917–) [St]
Gerald Nailor (Navajo, 1917–1952) [St]
Quincy Tahoma (Navajo, 1921–1956) [St]
Andy Tsinajinnie (Navajo, 1918–) [St]
Pablita Velarde (Santa Clara Pueblo,
 1918–) [St]
Oscar Howe (Sioux, 1915–) [St, C]
Pop-Chalee (Taos Pueblo, 1908–) [St]

> 1933 — Velino Herrera expelled from his tribe
> for painting secret dances.
> 1937 — Fred Kabotie begins teaching art at Or-
> aibi High School on Hopi reservation.
> 1952 — Joe H. Herrera (Cochiti Pueblo) fuses
> Cubism with Indian painting under tutelage of
> Raymond Jonson at University of New Mexico.
> 1952 — Joe H. Herrera has exhibit at Museum
> of Modern Art, N.Y.
> 1961 — Scottsdale Indian Arts Council starts an-
> nual Indian art shows.

Independent Artists (*ca.* 1940–)
Jose Rey Toledo (Jemez Pueblo, 1915–) [C]
Manuel (Bob) Chavez (Cochiti Pueblo,
 1915–) [C]
Theodore Suina (Cochiti Pueblo, 1918–) [C]
Raymond Naha (Hopi, 1933–) [S]
Rafael Medina (Zia Pueblo, 1929–) [S]

PLAINS

Bacone Junior College — art department for In-
dians founded by Acee Blue Eagle in Muskogee,
Oklahoma (1935–).
Director 1935–1938 Acee Blue Eagle (Creek,
 1907–1959) [B, C]
Director 1938–1941 Woody Crumbo (Potowatomi,
 1912–) [OU, B]
Director 1947–1970 Dick West (Cheyenne,
 1912–) [B, C]
Cecil Dick (Cherokee, 1915–) [B]
Chief Terry Saul (Choctaw, 1921–) [B, C]
Fred Beaver (Creek, 1911–) [B, C]

> 1946 — Philbrook Art Center (Tulsa, Okla.)
> starts annual Indian art shows

Independent Artists (*ca.* 1940–)
Leonard Riddles (Comanche, 1910–) [S]
Jerome Tiger (Creek, 1941–1967) [C]
Blackbear Bosin (Kiowa, 1921–) [S]
Rance Hood (Comanche, 1941–) [S]
Archie Blackowl (So. Cheyenne, 1911–) [S]

Institute of American Indian Arts (1962–)
Under Lloyd Kiva New, the Institute becomes the focus for experimental arts for young Indian painters from
all across the U.S.A. Located in Santa Fe in the same buildings once occupied by The Studio, it attracts much
criticism from older Indians who object to its development of Contemporary Indian art which has entirely
different goals from Traditional Indian art. It is too early to summarize the major alumni of the Institute;
those who have made a strong showing are discussed in the text.

SELECTIVE
BIBLIOGRAPHY

Brody, J. J. *Indian Painters and White Patrons*. Albuquerque: University of New Mexico Press, 1971. One of the first polemics in the field of Indian painting which presents, beyond its fascinating argument, some rare critical views of Indian art from the standpoint of a writer with a grasp of both Indian anthropology and world painting. Brody's premise is that Indian painting is not in fact Indian painting, but a twentieth-century decorative form made essentially for Anglo patrons.

Dawdy, Doris Ostrander. *Annotated Bibliography of American Indian Painting*. Contributions from the Museum of the American Indian. New York: Heye Foundation, 1968. The major bibliographic source on the subject of Indian painting.

Dockstader, Frederick J. *Indian Art in America*. Greenwich, Conn.: New York Graphic Society, 1961. The major sourcebook on the background of Indian arts and crafts in the United States.

Douglas, Frederic H., and d'Harnoncourt, Rene. *Indian Art of the United States*. New York: Museum of Modern Art, 1941 One of the first general appreciations published in America, in coordination with the first major exhibition of Indian painting in America.

Driver, Harold E. *Indians in North America*. Chicago: University of Chicago Press, 1961. The most scholarly approach to Indians from a topical standpoint.

Dufrenne, Mikel. *The Phenomenology of Aesthetic Experience*. Evanston: Northwestern University Press, 1973. An exceptional capper of the decade of modern philosophy which started with Sartre and ended with Dufrenne's application of existentialism to phenomenological aesthetics.

Dunn, Dorothy. "America's First Painters." *National Geographic Magazine*, March 1955, pp. 349–378. A good popular treatment of Indian painting which reached a mass audience and presented a double-page color spread of Blackbear Bosin's *Prairie Fire* which made a strong impression.

Dunn, Dorothy. *American Indian Painting*. Albuquerque: University of New Mexico Press, 1968. The single historical prospectus on native American painting in the Southwest and Plains areas from the viewpoint of the founding director of The

Studio in Santa Fe, where most of the Southwest Traditional painters were trained.

Dutton, Bertha. *Sun Father's Way.* Albuquerque: University of New Mexico Press, 1963. An important book on Southwest tradition by one of the most important curators (now retired from the Museum of Navajo Ceremonial Art, Santa Fe) and experts on Southwest rites and traditions.

Ewers, John Canfield. *Plains Indian Painting.* Palo Alto: Stanford University Press, 1939. The pioneer work on the subject of hide painting by one of the most active educators and curators concerned with Indian painting.

Ewing, Robert A. "The New Indian Art," *El Palacio,* vol. 76, no. 1 (Spring 1969), pp. 33–39. The director of the Museum of New Mexico takes on an argument similar to Brody's views of the emergence of true Indian painting with the Contemporary artists from the Institute of American Indian Arts, commencing about 1962.

Farb, Peter. *Man's Rise to Civilization, as Shown by the Indians of North America from Primeval Times to the Coming of the Industrial State.* New York: E. P. Dutton & Co., 1968. Though it is possible that anthropologist Farb does not succeed in making his complex premise about the evolution of social structures stick, he has nonetheless written what is probably the best general analytical approach to the cultural and social structure of the American Indian.

Fewkes, J. Walter. "Hopi Kachinas, Drawn by Native Artists," U.S. Bureau of American Ethnology, Annual Report, no. 21 (Washington, D.C., 1903), pp. 3–126. The source of the first-known drawings by American Indians on commission.

Hess, Hans. *How Pictures Mean.* New York: Pantheon Books, 1974. An exciting and radical book concerned with the way in which artists speak through their paintings.

Hewett, Edgar L. *Ancient Life in the American Southwest.* Indianapolis: Bobbs-Merrill, 1930. Another pioneer work which formulated from an aesthetic standpoint a firsthand view of Indian art of the Southwest.

Highwater, Jamake. *Fodor's Indian America.* New York: David McKay Co., 1975. The author's synthesis of culture and geography as a cultural and travel guide to America's Indians.

Introduction to American Indian Art, To Accompany the First Exhibition of American Indian Art Selected Entirely with Consideration of Esthetic Value, comprising two scarcely remembered volumes first published in 1931 for the Exposition of Indian Tribal Arts in New York. Consisting of various brief essays, each by an outstanding, early authority on the subject, plus an excellent, very complete bibliography. Three essays are of particular value due to their immediacy in depicting developments in Indian painting by authors who had personally witnessed the evolution: "Introduction to American Indian Art" by John Sloan and Oliver LaFarge; "Fine Art and the First Americans" by Herbert J. Spinder; and "Modern Indian Painting" by Alice Corbin Henderson, the major source from which most subsequent data on the San Ildefonso School (1918–1930) was drawn. Reprinted by Rio Grande Press Inc., Glorieta, New Mexico, 1970.

Jacobson, Oscar Brousse. *Kiowa Indian Art.* Nice, France: C. Szwedzicki, 1929. The first folio of Indian art, organized by the University of Oklahoma art department chairman as part of his work with the Kiowa Five.

Langer, Suzanne K. *Mind, An Essay on Human Feeling.* Vol. 1. Baltimore: Johns Hopkins Press, 1967.

———. *Problems of Art.* New York: Charles Scribner's Sons, 1957. Two works concerned with Langer's theory of expressive form which grew out of her earlier works *Philosophy in a New Key* and *Form and Feeling.*

La Barre, Weston. *The Peyote Cult.* New York: Schocken Books, 1969. The foremost study of peyotism among Mexican and American Indians.

Leach, E. R. "Aesthetics" from "The Institutions of Primitive Society," a Series of Broadcast Talks. London: Basin Blackwell, 1956. An important lecture in comparative aesthetics from the standpoint of primitive art by a renowned lecturer in anthropology at the University of Cambridge.

Mallery, Garrick. *Picture Writing of the American Indians*. New York: Dover Press, 1972. A reproduction of the classic study from the U.S. Bureau of American Ethnology, Annual Report, No. 10.

Petersen, Karen Daniels. *Plains Indian Art from Fort Marion*. Norman: University of Oklahoma Press, 1971.

————. *Howling Wolf*. Palo Alto: American West Publishing Co., 1968. Two essential studies of the Fort Marion painters.

Read, Herbert. *The Philosophy of Modern Art*. New York: Horizon Press, 1953.

————. *Icon and Idea*. New York: Schocken Books, 1972. Two works by a leading spokesman for contemporary Anglo art which has a relation to Traditional and Contemporary Indian painting.

Silberman, Arthur. "Early Kiowa Art." *Oklahoma Today,* vol. 23, no. 1 (Winter 1972/3).

————. "Tiger." *Oklahoma Today,* vol. 21, no. 3 (Summer 1971).

Smith, Watson. "Kiva Mural Decorations at Awatovi and Kawaika-a." *Peabody Museum Papers,* vol. 37 (Reports of Awatovi Expedition No. 5). New Haven, Conn., 1952.

Snodgrass, Jeanne O. "American Indian Painting." *Southwestern Art,* vol. 11, no. 1 (1969). A brief and concise history of the subject by one of the major researchers in the field.

————. *American Indian Painters: A Biographical Directory*. Museum of the American Indian, Heye Foundation, New York, 1968. An assembly of data on virtually every Indian painter in the United States with biographical data and historical notes.

Southwest Indian Art. The University of Arizona, 1960, supported by the Rockefeller Foundation. A report to the Rockefeller Foundation covering the activities of the first exploratory workshop in art for talented younger Indians held at the University of Arizona, summer of 1960.

Tanner, Clara Lee. *Southwest Indian Painting*. Tucson: University of Arizona Press, 1957; rev. ed., 1973. The first full-scale treatment of the history and aesthetics of Southwest Indian painting.

Underhill, Ruth M. *Red Man's Religion*. Chicago: University of Chicago Press, 1965. The contemporary synthesis of its subject.

Zo-Tom. *1877: Plains Indian Sketch Books of Zo-Tom and Howling Wolf*. Introduction by Dorothy Dunn. Flagstaff, Arizona: Northland Press, 1969. A marvelous set of reproductions of ledger book drawings by two masters of the form.

INDEX